TRACES OF FREMONT

TRɑCES OF FREMONT
SOCIETY AND ROCK ART IN ANCIENT UTAH

TEXT BY STEVEN R. SIMMS

PHOTOGRAPHS BY FRANÇOIS GOHIER

THE UNIVERSITY OF UTAH PRESS
Salt Lake City

&

COLLEGE OF EASTERN UTAH PREHISTORIC MUSEUM
Price, Utah

FOR HADLEY LORRAINE SIMMS

AND

FOR AMBRE, EMMA, AND MATHIS GOHIER

The Defiance House Man colophon is a registered trademark
of the University of Utah Press. It is based upon a four-foot-tall,
Ancient Puebloan pictograph (late PIII) near Glen Canyon, Utah.

14 13 12 11 10 1 2 3 4 5

LIBRARY OF CONGRESS CATALOGING-IN-PUBLICATION DATA
Simms, Steven R.
Traces of Fremont : society and rock art in ancient Utah / text by Steven R. Simms;
photographs by François Gohier.
p. cm.
Includes bibliographical references.
ISBN 978-1-60781-011-7 (pbk. : alk. paper)
1. Fremont culture—Utah. 2. Rock paintings—Utah. 3. Petroglyphs—Utah.
4. Utah—Antiquities. I. Gohier, François. II. Title.
E78.U55S35 2010 979.2'01—dc22

 2009046509

The University of Utah Press gratefully acknowledges the
financial support of the College of Eastern Utah Prehistoric
Museum, which helped make this publication possible.

CONTENTS

Engraved and pecked into a sheer cliff of yellow sandstone are six human figures perched high above the valley floor. They have broad shoulders and narrow waists, and the setting sun ignites their elegant costumes of feathered headdresses, masks, antennae, pendants, and beads. With heroic demeanor, one carries a shield and displays a trophy head dangling from a staff. This panel, known as the Sun Carriers and found on the McConkie Ranch near Vernal, Utah, was created a thousand years ago by an ancient people now called Fremont. François Gohier came to Utah in 1991 to photograph dinosaur fossils and went away with photographs of rock art. He found inspiration in Fremont figurines at the Prehistoric Museum in Price. His idea for this book arose from his awe of Utah's ancient rock art, from his contemplations on desert hikes, and from the silence and sounds of being alone in the canyons. The parietal art of the Fremont was not enough for François, and his exploration turned to the people who produced it. His photography followed suit, portraying everyday tools, pottery, the hide and fiber arts, and ornamentation in his pursuit of "traces of Fremont."

We employ the term "Fremont" as a name, not a thing. It refers to a concept that only exists in our world today. We can only know the people now labeled as "Fremont" through an engagement with what they left behind. One way to do that is through the photographic eye of François Gohier.

In 1973 I was in my second season of learning archaeology, and was assigned the single-handed excavation of a Fremont granary, a blockhouse-like adobe structure about half the length and height of a modern railroad shipping container. It was divided into bins that once held many bushels of dried corn and beans, and it took nearly two weeks to define its extent, expose the walls, and clear the interior. Then, in true archaeological fashion, I cut a small trench directly through one of the walls and the floor to see how the granary was constructed. Archaeology destroys to learn, and archaeologists understand the implications of a science that cannibalizes its own data. The little trench revealed that the puddled white adobe floors in each bin were underlain by layers of carefully sized gravels, and the exterior walls of the granary were set into deep foundations. No rodent could penetrate the barriers. The structure was built all at once and represented a substantial amount of labor. The roof had collapsed, but a large stone that had once sealed one of the hatches located over each bin lay slumped in the rubble. The other hatch stones were missing, probably reused for later granaries at this village, which was occupied in pulsations of intensity for three centuries. Nearly four decades later, after many sites and bouts of lost innocence, I do realize that archaeologists dig things, not lives. But archaeologists also see people differently than most—if not in a strictly sober way, then in one not marred by much romanticism. Our images, too, reveal "traces of Fremont."

Photographers often leave it to their images to tell a story. If any words are offered, they are typically ones of mystery and awe. Synthesis and meaning are left to the beholder to develop and to personalize. In contrast, archaeology prefers empiricism, and archaeologists usually don't stray too far from a story anchored to material things. Synthesis taken too far is damned as speculation.

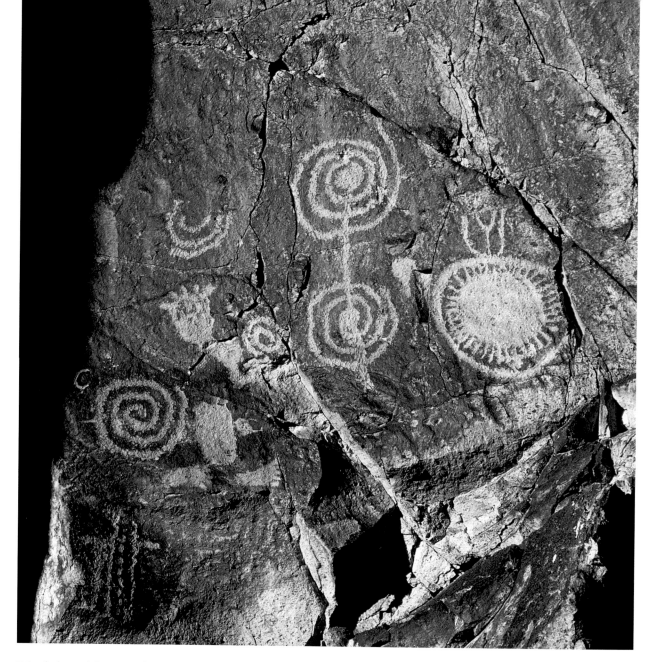

Petroglyph panel, Fremont Indian State Park, Sevier, Utah. Footprints, spirals, and other symbols appear on this panel.

In our case, serendipity entwined the paths of both photographer and archaeologist. François' photography became a vehicle to explore something archaeologists who work with the Fremont are beginning to return to: the nature of Fremont society, religion, and worldview. We aspire here to more than a book about rock art, artifacts, and a recitation of Fremont culture history. The archaeology of the Fremont has come a long way in the last few decades, even if the region still escapes notice in the shadows of the famous archaeological treasures of the Four Corners Southwest. We want to be a part of changing that, of drawing attention to that vanished culture, and *Traces of Fremont* is our collaboration.

—Steven Simms

ACKNOWLEDGMENTS

The author wishes to thank the following:

Thanks to Reba Rauch of the University of Utah Press for the opportunity to join François Gohier in his quest to portray the Fremont as people. Only a year earlier, I had engaged rock art studies more than I had in many years during an archaeological project near Moab. My colleague on that project, Leticia Neal, made rock art the heart of her master's thesis at the University of Nevada, Reno. Shortly after this project I discovered François' art of photography and recognized the possibility that rock art could be a vehicle to explore Fremont social organization and worldview. Serendipity indeed.

Several people reviewed an exploratory version of the manuscript. I appreciate the criticism and encouragement of Jason Bright, Alan Gold, Nancy Kay Harrison, and Leticia Neal. An anonymous reviewer read a revised, but still unconsummated, version and signaled the dangers of my foray into Fremont society. This was useful. Joel Janetski offered critical, detailed, constructive, and encouraging comments that were of immense help. Thank you, Joel, for your obvious time investment. After a rewrite in summer 2009, Stephen Lekson shared superb advice that helped with a particularly thorny section of the manuscript. Thank you, Steve.

François and I went on field trips to photograph rock art near Great Salt Lake, and I would like to thank Mark Stuart for organizing these trips. We appreciate the courtesy of ATK Space Systems and employees Holly Lamb, Kelly Hill, and Trevor Brasfield for the opportunity to visit the restricted access rock art at Connor Springs.

Nancy Kay Harrison crafted the map and the chronological chart, but her contributions run through the entire project. Thank you for being such a big part of this, Nancy Kay.

The photographer wishes to thank the following:

I would not have been able to take the photographs for this book without the assistance of archaeologists, managers and employees of federal and state agencies, and the directors and curators of collections at universities and local and private museums. To all I would like to express my deep thanks for helping me find rock art panels I would have otherwise missed, and giving me access to unique artifacts placed under your care:

- U.S. Bureau of Land Management: Harley J. Armstrong (Grand Junction, Colorado), Leigh Grench, Archaeologist (Moab, Utah), and Michael J. Herder (Ely, Nevada)

- College of Eastern Utah Prehistoric Museum, Price, Utah: Don Burge, founder and director emeritus, generously shared his knowledge of the Fremont, and supported this project from the beginning. I gratefully acknowledge the help and friendship of the museum staff, curators, and associates: Chanel Atwood, Reese Barrick, Renee Barlow, Jeff Bartlett, John Bird, Karen Green, Connie Leighton, Pamela Miller, Allison Sundhal, and Christine Trease

x

- Fremont Indian State Park, Sevier, Utah: Kari Carlisle, Bob Hanover, and Shirley Merrill

- Museum of Peoples and Cultures, Brigham Young University, Provo, Utah: Marti Lu Allen, Shane Baker, and Joel Janetski

- Museum of the San Rafael, Castle Dale, Utah: Margaret Keller and Janet Petersen

- U.S. Forest Service, Ely, Nevada: Nathan Thomas

- National Park Service: Lee Kreutzer (Capitol Reef National Park, Utah), Wayne Prokopetz (Dinosaur National Monument, Utah)

- Pectol Collection: Neal P. Busk, Chairman, E. P. and Dorothy Hickman Pectol Family Organization

- University of Colorado Museum of Natural History, Boulder, Colorado: Christina M. Cain, Deborah Confer, Sheila Goff, and Steve Lekson

- Utah Division of Wildlife Resources: Lt. Alan Green

- Utah Museum of Natural History, Salt Lake City: Duncan Metcalfe, Glenna Nielsen-Grimm, and Kara Hurst

I am indebted to the following people who over the years helped in many different ways: Carolyn Annerud, Pam Baker, Quentin Baker, Claudia Berner, Sue Ann Bilbey, Helen Cameron, Mercedes Cameron, Reid Cameron, Dell Crandall, Sandy Early, Dawn Folks, Warren D. Gore, Evan Hall, Doug Murphy, Roberta Nieslanik, Troy Scotter, Mark Stuart, Darlene Sweeney, Tim Sweeney, and Morris Wolf.

At the University of Utah Press, I wish to thank former director Jeff Grathwohl, who several years ago looked favorably on my project of a book on the Fremont; Peter DeLafosse, who kept the idea alive; and Reba Rauch and Glenda Cotter, who made it happen. I also thank Jessica Booth for a wonderful layout.

Special thanks to the McConkie-McKenzie family for allowing the public to visit the Fremont petroglyph panels located on their ranch in Dry Fork near Vernal, Utah.

I am especially grateful to J. Lynett Gillette for assistance during numerous trips in the field.

Two good friends have passed away since I began this project. Dee Hardy was Curator and Archaeologist at Fremont Indian State Park, Utah. His assistance was especially valuable in photographing the delicate Fremont artifacts shown in this book. At the CEU Prehistoric Museum in Price, Utah, Duane Taylor was Director of Collections. He placed in front of my camera the Pilling figurines and other treasures. Dee and Duane are dearly missed.

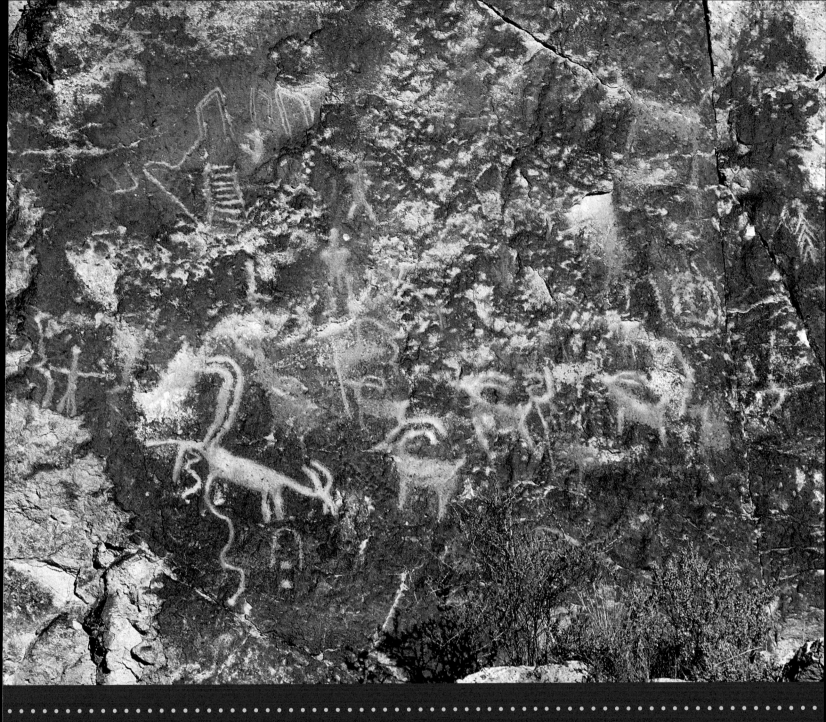

TRACES OF FREMONT: INTRODUCTION

Petroglyph panel at Fremont Indian State Park, Sevier, Utah. Located just behind the museum, this panel glows in the morning sun.

Fremont Indian State Park, Sevier, Utah. The soft volcanic tuff of Clear Creek Canyon, home to the large village at Five Finger Ridge, is the canvas for hundreds of petroglyphs arranged in distinct panels. Motifs range from elaborate anthropomorphs to simple and complex geometric symbols. Representations of bighorn sheep are particularly abundant.

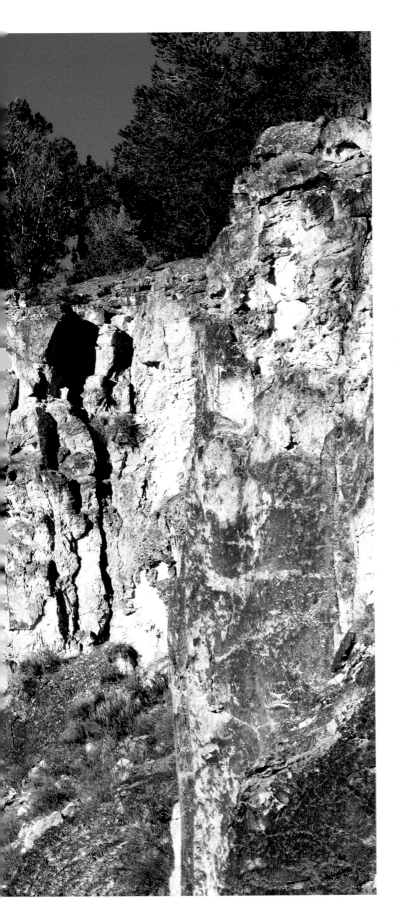

I am an archaeologist so I visit a lot of rock art. But
I have a confession to make. Most rock art is, considered
alone, inscrutable. It is susceptible to ad hoc interpreta-
tion because it is disconnected from... well, from people,
their behaviors, and the cultures in which they live. It is
the same with fancy artifacts such as baskets, arrow-
heads, or pots. Sure, I get excited with the occasional
spectacular find, such as the ancient unstrung bow I found
tucked into a ledge in Nevada years ago. And sure, upon
close examination, a fine basket or the motifs on a rock
art panel can be awe inspiring unto themselves. For the
most part though, the art is empty unless I know some-
thing about the people who created it. Call me a mod-
ernist, but unless I have access, not so much to the artist,
but to the cultural context of the artist, I have no way of
knowing the work. This surely reveals my shortcomings
as a fancier of art, but I want to suggest that the exqui-
site photographs of artifacts and rock art offered here
as *Traces of Fremont* is in fact a time machine of sorts.
It can take us into a Fremont world inhabited by real
people with real lives more than a thousand years ago.
The knowledge of anthropology can make these traces
come alive.

This book employs photography of Fremont rock art and
artifacts to investigate the Fremont world. The goal, how-
ever, is not a general treatise on all things Fremont. That
is available elsewhere.[1] Our focus here is on realms of
the Fremont examined by archaeologists only fleetingly
and sporadically.[2] I refer to the society and ideology of
Fremont people as they developed before the sixth cen-
tury A.D. and continued to evolve into at least the four-
teenth century. Society and ideology include the topics
of Fremont social and political organization and religion.

4

Also important is sense of place: how people perceive their landscape and how this arises from and informs their behavioral interactions with the natural world. All of these topics together comprise the Fremont worldview.

Admittedly, archaeologists shy away from topics of society and ideology because these require speculation, even for the restrained goal of tilting our inquiry in a different direction. It is difficult to know prehistoric society and ideology because hypothesis testing is elusive, and interpretations must rely on analogy.

On the other hand, we thirst to know what Fremont society was like, how people perceived their world, and what the rock art "means." Book after book tempts us with interpretations of rock art, and archaeology has a long history of living with an alternative literature wandering the trails that archaeologists refuse to tread. Even though I am an archaeologist with an established investment in deductive, hypothesis-testing science, I believe archaeologists do have some basis for informed conjecture that can better describe past worldviews. It is difficult, however, to present these matters in our technical reports and journal articles.

My desire to know the Fremont past reveals a passion—a childlike desire for a time machine. I don't want to know the Fremont through my own times: I want to be part of theirs. François Gohier's photographic images of rock art and artifacts are passageways to the Fremont, and his photo essay has urged me to explore some new ways of thinking about Fremont society and ideology.

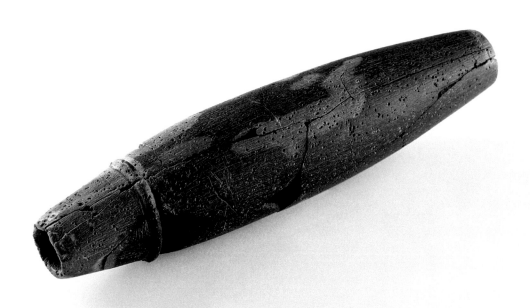

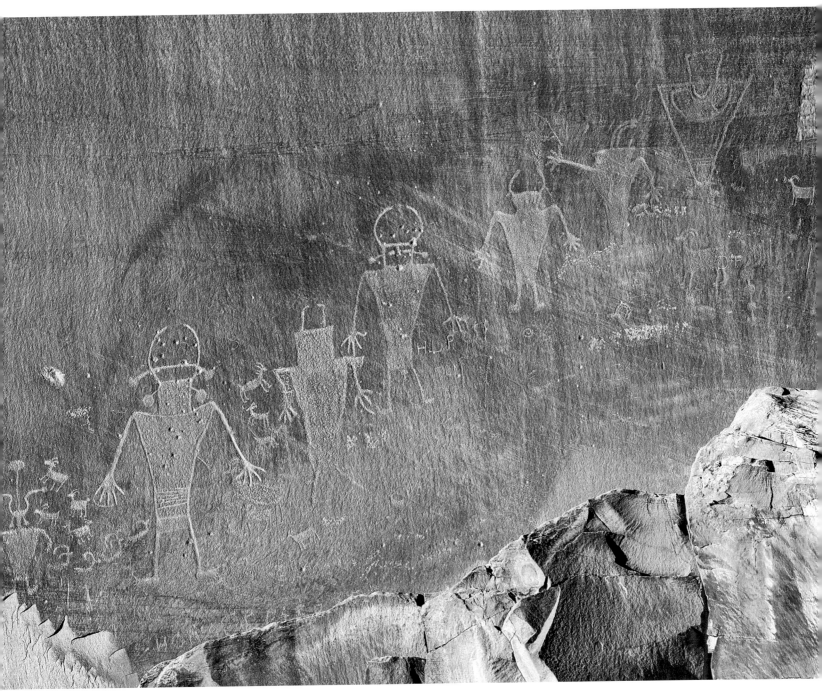

Southern San Rafael style panel at Capitol Reef National Park, Utah. This smooth wall in the Fremont River gorge projects a glorious orange color from the setting sun. This panel includes the large, heroic anthropomorphs reminiscent of the Classic Vernal style of northeastern Utah. Here the large figures are accompanied by smaller elements, including several bighorn sheep and other animal representations. There are many more petroglyphs on this cliff.

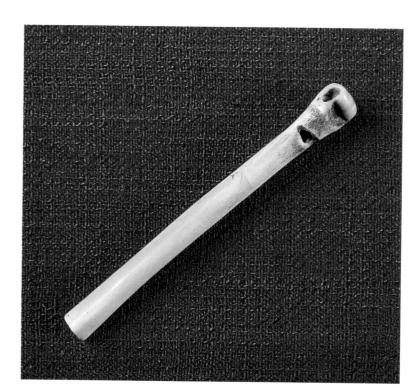

Bird bone whistles are widely found. This one is from Dinosaur National Monument, Utah.

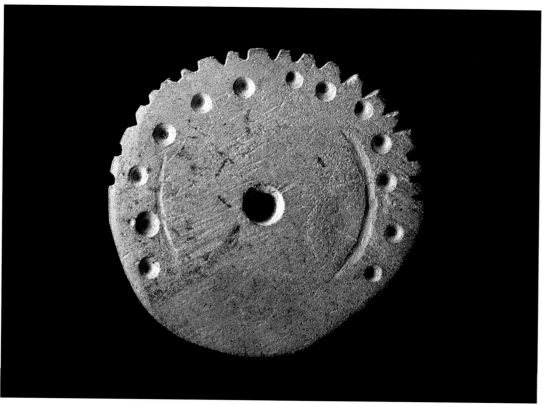

Small crafted objects evoke the fullness of Fremont life. Above, a notched disk with thirteen perimeter holes (of possible lunar significance) from Fremont Indian State Park, Utah.

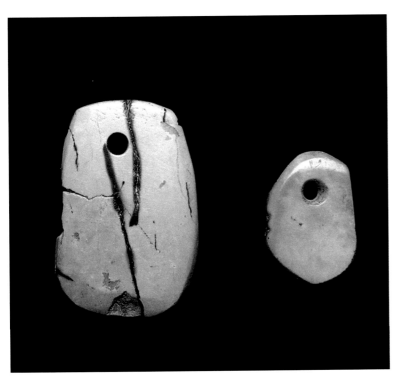

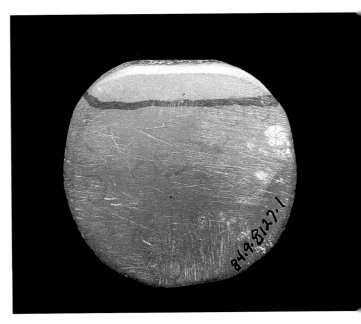

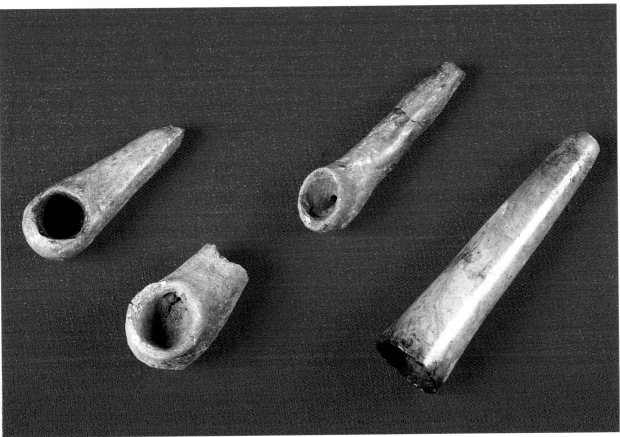

Turquoise pendants (upper left), a banded claystone disk (upper right), and smoking pipes (bottom) are a few of the artifacts from Fremont Indian State Park, Utah.

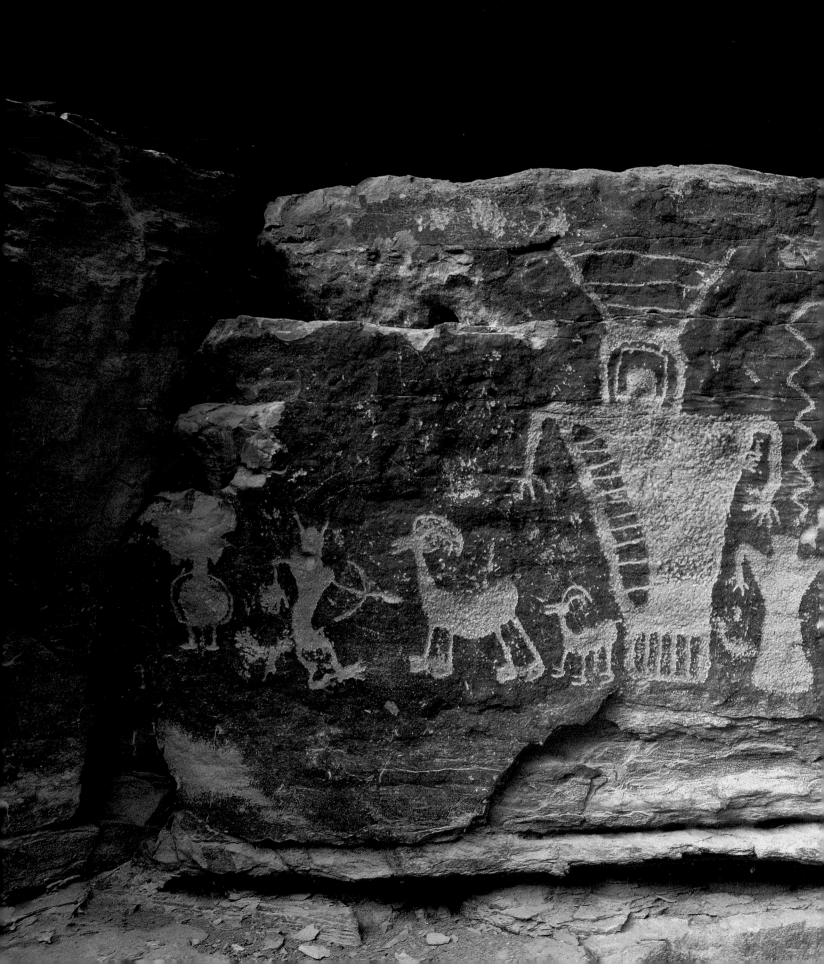

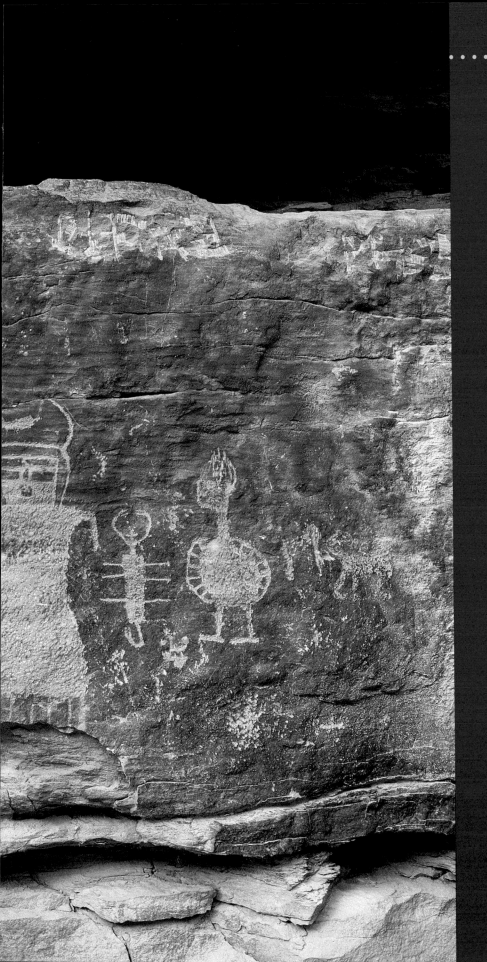

MY MESSAGES

Happy Family panel, Nine Mile Canyon, Utah. This panel's
seductive name signals the tendency to interpret rock art
through our own eyes, even as it offers a glimpse of the
Fremont world. The dominant anthropomorphs are in cos-
tume. To the right is a scorpion. Next to it is a figure that
some identify as a turkey, while others declare it a shield
figure. A snake slips between the large human figures.
On the left a hunter stands ready to dispatch a
bighorn ewe, followed by her lamb.

Long-Necked Quadrupeds panel, Nine Mile Canyon, Utah. This Northern San Rafael style panel is busy with anthropomorphs, animals, and abstract elements. The "long-necked quadrupeds" resemble Fremont bighorn sheep but have necks elongated to fantastic lengths. Nine Mile Canyon exhibits a succession of artists from the Archaic period to the historic Ute, and not all of the figures on this panel were made at the same time.

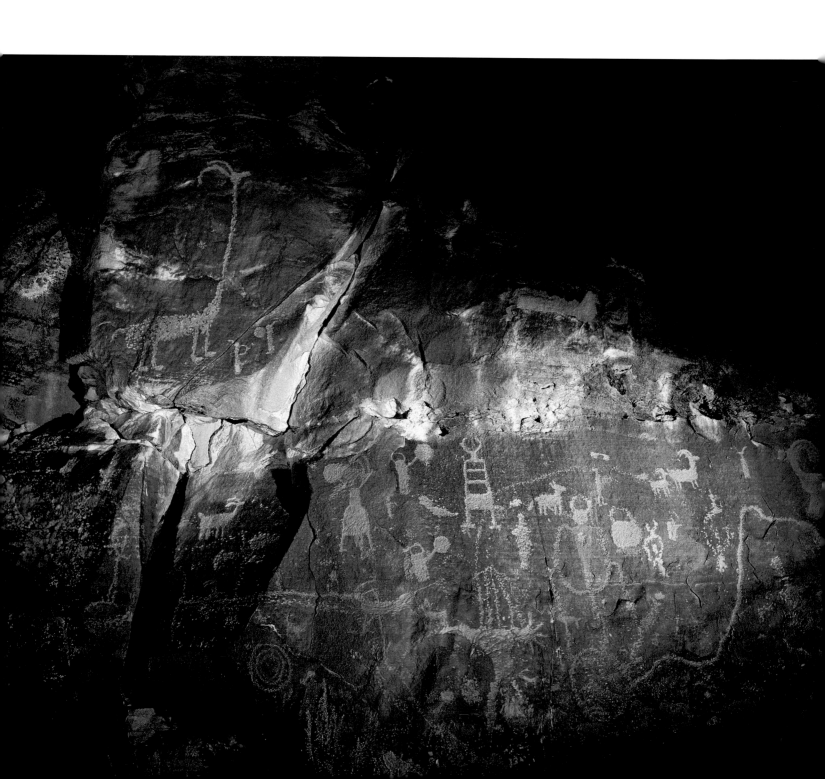

Ivie Creek Black-on-white bowl. The Southwest influence on the Fremont is clearly evident in the manufacturing technique and design elements of this bowl. Collections of Fremont Indian State Park, Sevier, Utah.

This essay is organized around tasks. First, I intro-duce Fremont archaeology and take fictional excursions to different kinds of Fremont places, including a farming hamlet, agricultural fields, and places of food storage. I then make a case for the existence of larger villages, the importance of community ties among Fremont villages and farmsteads, and the possibility that leadership was more authority-based than generally allowed for the Fremont.

This does not mean that Fremont society was one of kings and stratified social classes. Rather, Fremont leadership and authority were likely dynamic and situational. Anthropologists label such things as social complexity, and recognize that cultures take multiple pathways to authority, leadership, power, and inequality.[3]

The characteristics of Fremont society were inspired by the style of farming they practiced. This at once made them individual and communal. Fremont farmers were self-sufficient until the inevitable vagaries of farming in the high desert entwined them with other farms and villages into communities. Consequently, leadership ranged from the local to the communal, with individual spiritual assistants and healers called shamans, and political leaders representing communities. These things are part of Fremont archaeology and part of a multifaceted Fremont rock art tradition.

It is not possible to understand the Fremont without considering heritage, so I summarize current thinking on Fremont origins. Archaeologists agree that Fremont heritage is rooted well over two thousand years ago in the Archaic period, and in the Basketmaker II period of the Southwest.

Finally I turn to rock art both as a creation of Fremont society and ideology, and as a misty and incomplete representation of it. Running through these discussions are three theses.

My first thesis is that in order to know Fremont rock art, one must know something about Fremont, yet this is a name, not a self-evident thing. Rock art is not a distinct phenomenon that can be studied in isolation, even though it often is. Nor are rock art images unique to the individual artists who created them. The symbols and figures in Fremont rock art are part of an ideological fabric stretched across a sacred landscape, and the images are presented in a style that is unique to the Fremont region and period. Rock art is given form and meaning by a Fremont society and worldview that were more multifaceted than can be portrayed by monikers such as "the Fremont culture" or "the Fremont people."

My second thesis is that Fremont social organization was more layered, more communal, and more authority-based—hence more complex—than it has typically been portrayed over the past forty years. General practice has been to look to Great Basin hunter-gatherers for clues about Fremont society and ideology, especially the stereotype of Great Basin social organization as exclusively egalitarian and organized only at the level of the family—a stereotype that is wrong. Great Basin hunter-gatherers did exhibit variation in equality and leadership authority depending on the circumstances.[4] Indeed, anthropology now routinely recognizes situations that can lead to the trappings of social complexity among hunter-gatherers around the world, things such as unequal access to resources (and hence power), conflicts of interest among

leaders and people seeking gain, and social networks that cross-cut family and kin, leading to corporate groups with common concerns.[5]

The first archaeologists to define the Fremont recognized its connections with the ancient cultures of the Southwest. Despite that obvious heritage, most such comparisons in the past forty years have emphasized the distinctiveness of the Fremont—an almost nationalistic exercise. This common assertion arises from two biases. First, it results from a narrow view of social and religious organization in the Puebloan Southwest, largely known through Historic period ethnographies. Historic Puebloan social organization is more diverse than once thought, and there are striking differences between the societies of historic Puebloan peoples and the ancient social forms of the Anasazi. Second, the view that the Fremont were different from the cultures of the Southwest results from the stereotype that the Fremont were merely hunters and gatherers who did some farming on the side, and that they lived in small places, in small numbers, and the most a leader could do was command his family. This perspective was part of a movement beginning in the late 1960s to show that Fremont was a distinctive Utah culture. Ironically, it only furthered the very interpretation that it was intended to counter—that Fremont Utah was merely the "northern periphery" of the Southwest.[6]

There is evidence, however, for greater complexity of Fremont village size, economics, and, consequently, social organization than the discourse of the last forty years has portrayed. I join others who argue for a network of Fremont hamlets and farmsteads in collaboration with larger villages. I argue that individuals, families,

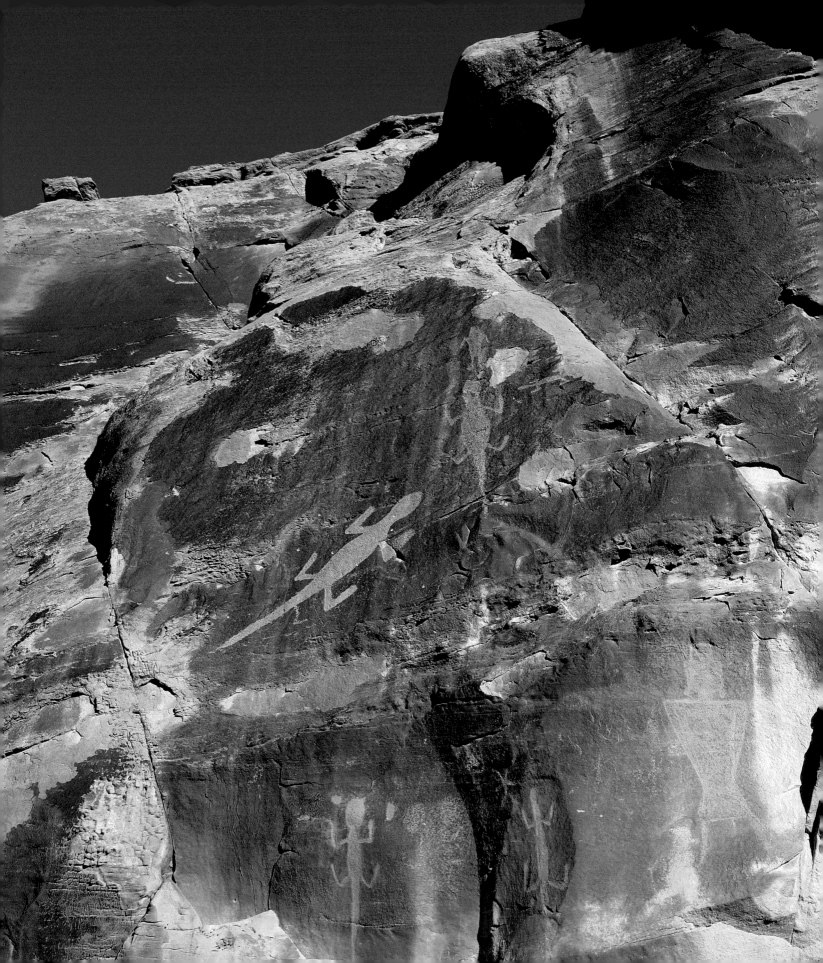

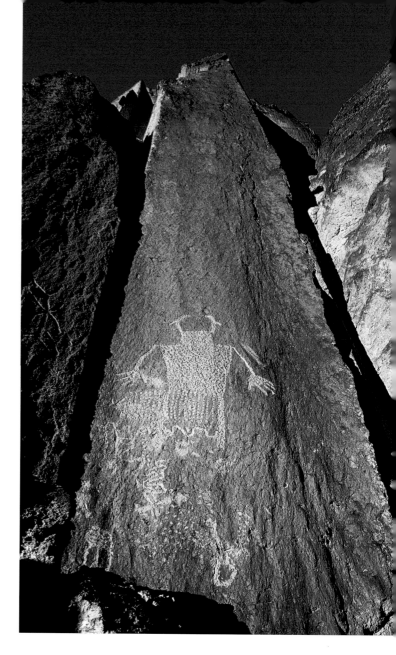

Anthropomorph, Fremont Indian State Park, Sevier, Utah. This figure, one of the park's few large anthropomorphs (1.4 meters high), is sometimes interpreted as the image of a shaman or a shaman's vision.

14

and groups moved over the course of their lives among places to form networks that could be called "dispersed communities."

This movement was not incessant or aimless, but created a residential cycling of related people across dispersed communities. Fremont residential cycling was episodic because the vagaries of farming the high desert ensured times of plenty and times of want, creating transience among both haves and have-nots. Fremont sense of place united life, landscape, time, and the mythical into a singular worldview.

I argue for inequality, and a fluid and situational group structure that vacillated between the interests of individuals and the demands of group life beyond the household.

I am not suggesting hierarchy, kings, and inherited leadership. Instead I employ the concept known to social scientists as "heterarchy," or "sequential hierarchy." Leaders could not simply command people to do things for them, but with charisma, powers of persuasion, cunning gift giving, and the networks created by marriage among lineages, leaders could amass power and influence—the kinds of leaders referred to by anthropologists as "Big Men." This would have made Fremont leadership situational and tenuous.

A leader may control productive agricultural fields or stored supplies. A charismatic leader able to orchestrate intricate obligations among kin may persuade enough people to construct an irrigation system to ensure more frequent and productive harvests. A revered ceramicist may influence the decisions of women across a

dispersed community simply because their craft brought them into routine association and gave rise to common interests. A talented hunter may lead the bighorn sheep drive, enabling him to bring meat and hides to many. A recluse may have spiritual qualities that lead them to periodically engage the social realm to lead community ceremonies. Instead of social classes and the strong hierarchies of authority that we are familiar with in our modern lives, Fremont leadership appears to have been fragmented and organized into corporate groups concerned with both alliances and conflicts of interest. Membership among such corporate groups can shift

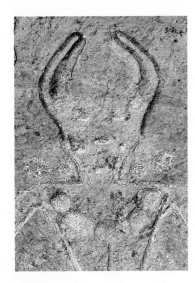

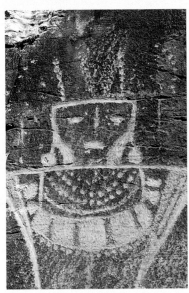
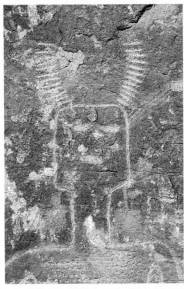
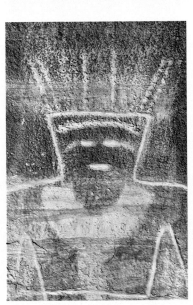

Fremont anthropomorphs, McConkie Ranch, Dry Fork, near Vernal, Utah. The stylistically regimented costume of these anthropomorphs evokes a tension between representation and individuality, yet the figures are distinct in the particulars of adornment, especially their headdresses, necklaces/breastplates, and ear ornaments.

because the interests and allegiances of individuals can vacillate among leaders. This would have made Fremont leadership and authority dynamic, but it also means that people's lives often would have been shaped by authoritative leadership and social expectations at a level beyond the family.

In the following pages I explore the implications of a southwestern affinity with the Fremont in terms of heritage, economics, and lifeway, while remaining attentive to the differences as well as the diversity we now recognize for societies of the Southwest. I do argue for a different model of Fremont society than we think we know, while admitting that Fremont society is difficult to describe because it is so unlike any social organization encountered by people of the industrialized world. Nevertheless, I urge an exploration of something that could not be explored in the absence of such a model.

My third thesis moves to a different topic: shamanism. Shamanism is now commonly invoked to explain rock art, sometimes without adequate anthropological context. Although often confused with religion, "shamanism" refers only to the interaction of particular religious specialists with spirits and deities on behalf of themselves, other individuals, and their communities. It is often conflated with a drug-induced trance, but it need not be.

Shamanism is not synonymous with political leadership, and shamans do not necessarily have followers, nor are they always healers. A good case has been made for shamanism being represented in some rock art, including some Fremont rock art, as well as the rock art of the preceding and probably ancestral Basketmaker II period. However, shamanism should not be a catch-all explanation for rock art, Fremont or otherwise.

I argue that the role that shamanism plays in a hunter-gatherer society is different than the one it played for the Fremont. Shamanism is just one level of Fremont ideological expression, and at times the individuality of shamanism was superseded by authoritative leadership, alliances, and conflicts of interest at the community level.

Once we understand that Fremont archaeology depicts a society that ate more maize than we thought, had larger populations than we thought, and lived in small places and big places that were socially and residentially networked, then the role of shamanism changes. Shamans did not disappear as the Fremont developed after A.D. 0 from Archaic and Basketmaker II roots. Fremont rock art shows that; however, the rock art is an incomplete representation of Fremont social, political, and ideological organization.

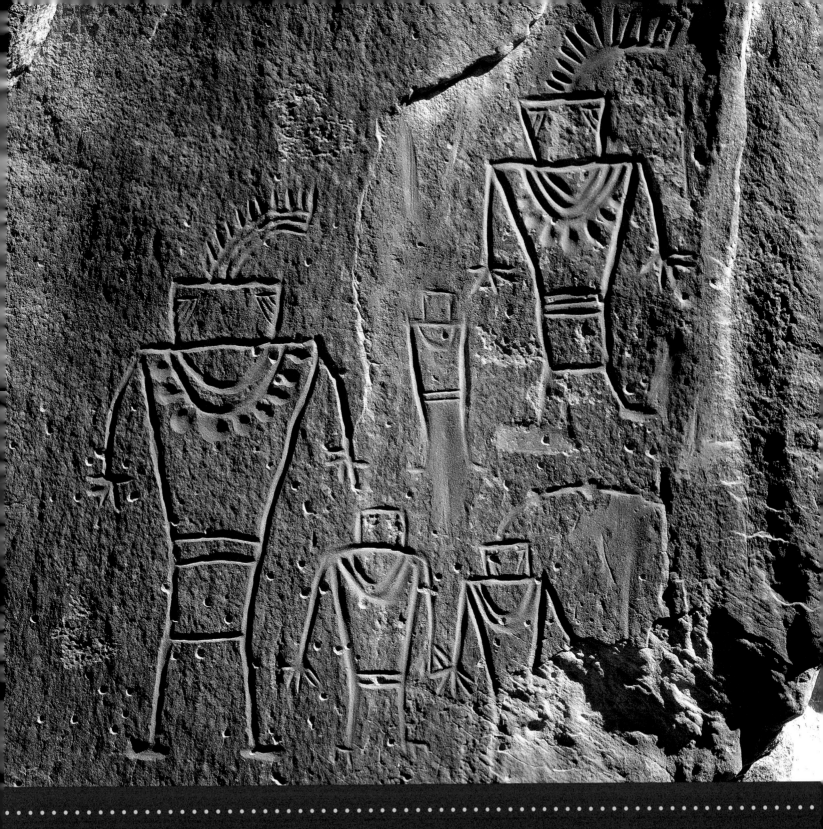

HOW CAN WE KNOW?

These anthropomorphs in Capitol Reef National Park, Utah, wear costumes with headdresses, necklaces, and pendants. Uniform in theme, each nevertheless shows individual differences. The figure outlines are deep, polished grooves, a technique seen elsewhere in Capitol Reef.

Flicker-feather headdress from Mantle's Cave, Dinosaur National Monument, Colorado, Collections of the University of Colorado Museum of Natural History, Boulder. In 1939 Charlie Mantle recognized the significance of Mantle's Cave, and he was the property owner when it was excavated in 1940. The cave was not used as a residential site, but rather for the storage of maize and items of special significance, including bags made of hide and netting, coiled basketry, snares, cordage, matting, moccasins, and this flicker-feather headdress, which was perhaps worn as a visor. Sixty centimeters long, it was found carefully folded inside a buckskin pouch cached in a pit in the floor of the cave. The crest is composed of 370 central tail feathers from at least 61 woodpeckers. Most of the feathers are from the red-shafted flicker, whose historic range is west of the Rockies; however, six feathers at the center of the crest are from the yellow-shafted flicker, which historically lives east of the Rockies. The feathers are carefully trimmed, and the quills are sewn together with sinew. Weasel fur lines the base of the feathers, which are backed with a strip of buckskin. Long wing feathers embellish the ends, and rawhide thongs at the ends held the garment in place. A tiny sample was analyzed through AMS radiocarbon dating, revealing that the headdress was made during Fremont times, between A.D. 996 and 1190.

How can I pursue a desire to know something about Fremont society and ideology? What are the bases of my theses? Of course, without time travel, and without being Fremont, we can never really know them. But we can construct an image of their society, their ideology, and their relationship to landscapes by using the tools of analogy and the rich world of anthropological context. This context takes several forms.

First, there is the context provided by archaeology, which documents the beginnings of Fremont in the first few centuries A.D., its growth to large populations in the tenth and eleventh centuries, and its lingering presence here and there in the fourteenth century as behavior and society transformed into something no longer recognizable as Fremont. Archaeology tells us a lot more than a sequence of Fremont culture history and the names of artifacts, regional variants, and lists of rock art styles. Archaeology sheds light on ancient understandings of landscape, and ancient senses of place. It glimpses the weaves of kinship, leadership, conflict, and cooperation that comprise the Fremont social fabric. Archaeology also glimpses ancient religion and the manner in which ritual, symbolism, and landscape become part of this same fabric.

Archaeology cannot achieve an adequate sense of these things merely by digging up Fremont houses, fire hearths, trash middens, and artifacts. To achieve its aim of knowing the past, archaeology, too, relies on context. The second level of context is found in the cultures of the historical Native American groups, especially the descendant cultures of the American Southwest and the Great Basin. Anthropologists call this form of context

"the direct historical approach," and it provides a useful, but dangerously seductive, analogy for ancient social organization, ritual, and symbolism.

Fremont is distant in time, and as such, the people of those times are not mere fossils of the historic Native Americans. If we restrict ourselves to the voices of the descendant peoples of history, then we know the past only as an extension of history. The Indian peoples are part of the post-Columbian transformation of America. Native Americans often say that it is strangely ethnocentric to see Indians as timeless, changeless ghosts of the past. Knowledge of the historical tribes and the perspectives of Native peoples can surely take us well into ancient worlds such as the Fremont, but the comparison of ancient and modern Native American worlds also draws distinctions between ancestors and descendants.

To rise above the contentions of the modern world, we need yet another, more general form of context: anthropology. I refer to the rich apparatus of anthropological knowledge about the patterns of culture found widely in non-Western societies. Fremont culture appears to have been similar to cultures elsewhere who exhibit forms of leadership and community that supersede the individual, the family, and the household.

Fremont populations were far larger than those of the hunter-gatherers who preceded and followed them. Their food production altered the land, and they used resources such as water and arable land in ways that require organized leadership and the management of conflicts of interest among people and places. They produced a food surplus that was at once the basis of

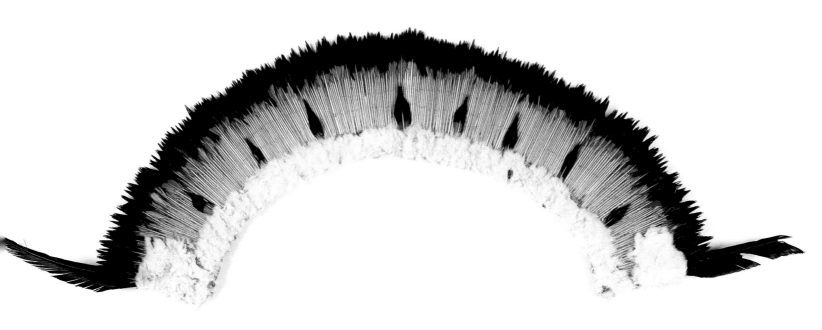

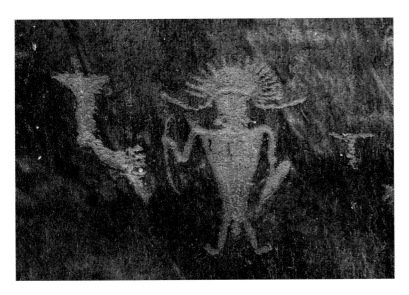

Rock art images and historic photographs offer analogies to the flicker-feather head-dress found in Mantle's Cave. The anthropomorph depicted in this petroglyph from the Moab area wears a strikingly similar headdress. The petroglyph may be Anasazi or Fremont.

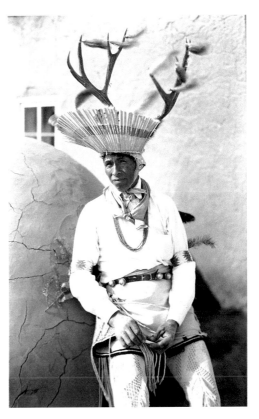

This Deer Dancer, photographed in San Juan Pueblo, New Mexico, ca. 1935, also wears a headdress/visor. Photo by T. Harmon Parkhurst, courtesy of the Palace of the Governors Photo Archives (NMHM/DCA), negative number 3860.

Snake Valley corrugated pitcher from Clear Creek Canyon, Utah, Collections of Fremont Indian State Park. The corrugations were made by pinching with the fingertips to create a surface allowing more efficient heating, while maintaining a cooler surface to pick up when the pitcher contained hot liquids. A red wash was often applied to such pieces and continues to enhance the beauty of this one. More than 80 percent of Snake Valley style pottery found at some Clear Creek Canyon sites was manufactured more than 40 miles away at pottery-making centers in the Parowan Valley.

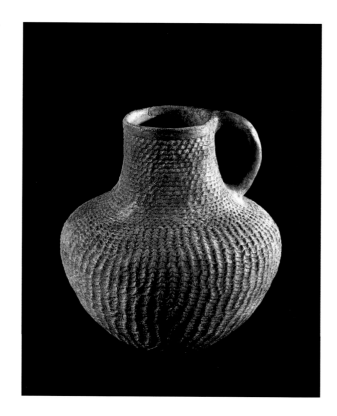

influence and wealth, and a source of tension. Economic volatility ensured the presence of a dynamic inequality that created opportunities for aggrandizing individuals and promoted alliances among communities and groups. As in most ancient societies, history was transmitted through stories, ritual, and symbolism in attire, artifacts, and rock art. Thus ritual and myth were entwined with the practical realities of economy and politics. This holistic worldview provided Fremont society with historical persistence even as it changed from a sprinkling of communities around A.D. 300 to a fully occupied landscape in the A.D. 1000s.

It is necessary to step outside of our own familiar analogies if we want to gain even slight purchase on Fremont society and ideology. Something anthropologists have recognized for more than a century is that in small scale, what were once called "primitive" societies, everything is at once practical and symbolic. Anthropologists refer to these non-Western, often ancient societies as "undifferentiated." Realms of life that modern people have no trouble separating—such as economics, kinship, politics, trade, and beliefs—were not so much combined in ancient non-Western societies as they were never separated in the first place. It was not possible to label those things because they did not exist as distinct entities.

The strength of pattern in the structure and organization of small-scale societies such as the Fremont has been well established through the study of hundreds of similar, historically known cases—Native American and many others around the world. Our appeal to this form of context helps us to better know the Fremont people on their own terms: as ancient Native Americans, and as ancestral to perhaps various living Native American groups.[7]

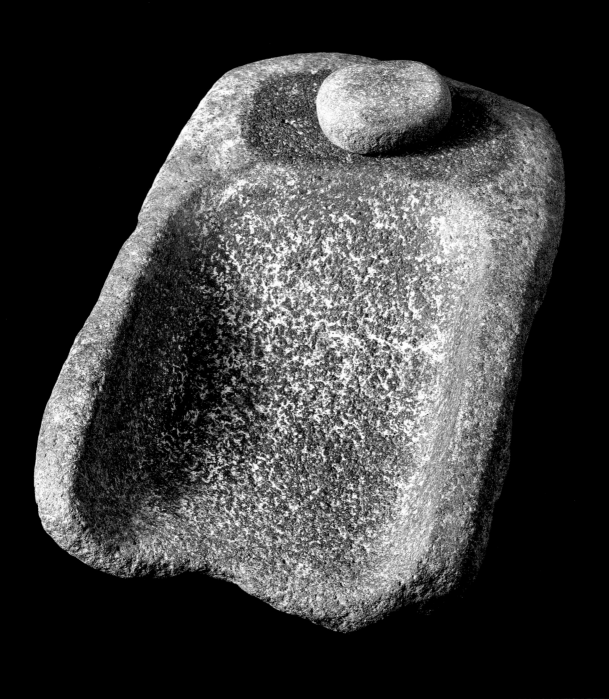

FREMONT ARCHAEOLOGY

Utah style metate, Fremont Indian State Park, Utah.

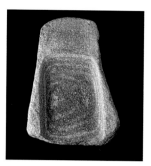

The shelf of the Utah style metate makes it the most distinctive of the wide array of grinding stones used to process maize and seeds into flour using the smaller stone mano resting on the shelf. Grinding stones were also used to hull nuts and crush bone, and small versions could be used for crushing medicinal herbs or minerals for paints, to name a few uses. Collections of Fremont Indian State Park.

Fremont moccasins from the collections of the Utah Museum of Natural History, Salt Lake City.

The Fremont were ancient farmers of maize, beans, and squash. They began to transform in the first few centuries A.D. from a society that collected food by foraging to one that produced food by investing labor into the land. Fremont culture crystallized by the sixth or seventh century, and populations peaked in the tenth to twelfth centuries. By the fourteenth century, and perhaps later in a few places, historical changes transformed the Fremont into something culturally different.

The Fremont culture is named after the Fremont River, which passes by the modern central Utah towns of Loa and Torrey on its way through Capitol Reef National Park. Noel Morss and others of the Claflin-Emerson Expedition visited the Fremont River country and other points of archaeological interest across eastern Utah from 1927 to 1930. Morss recognized the southwestern connections of the Fremont, but he also thought it was a distinct culture. He saw ancient irrigation ditches, granaries in cliffs, and remnants of houses—all reminiscent of the Anasazi of the Southwest. Morss also documented petroglyphs and pictographs, and these—like the arrowheads, baskets, and moccasins—looked "southwestern." At the same time, Morss recognized that the rock art looked distinctly local, implying indigenous roots. James Gunnerson later helped to report the findings of the Claflin-Emerson Expedition, and he extended the comparison to the Southwest by recognizing that the Fremont use of irrigation demanded authority, political dealings, and manpower beyond the family; they could not have been egalitarian.

The Fremont culture was born in the definitions of Noel Morss, James Gunnerson, and perhaps a dozen archeologists who followed.[8] Then and now we entertain a certain schizophrenia about the Fremont. It is its own culture with a deep indigenous heritage, but it is also Puebloan.

Unfortunately, our modern obsession to know the world through labels has turned a name into a thing: the Fremont culture. We will find that while the name has a certain utility, it is also a liability if we want to more fully know a Fremont world that was comprised of real people living real lives over a vast landscape of the Intermountain West—for centuries and centuries.

Our knowledge of people's ways of life during Fremont times is relatively abundant. Thousands of sites are documented, and more than a hundred are reported through excavation. We know the characteristics of Fremont houses and granaries. We know about their pottery and how it was made. We know about the tools that people used for everyday tasks and where the raw materials came from. We know the patterns of Fremont settlements on the landscape, and which areas were settled more heavily or with a lighter hand. We know about their economic systems and trade. We know which regions shared commonalities and exhibited differences. We also know something about Fremont history—the chronology and events of Fremont origins, spread, and change.

The Fremont is surely a culture in some sense, but it was likely comprised of local enclaves, peoples reflecting diversity in heritage, and perhaps significant linguistic diversity too.[9]

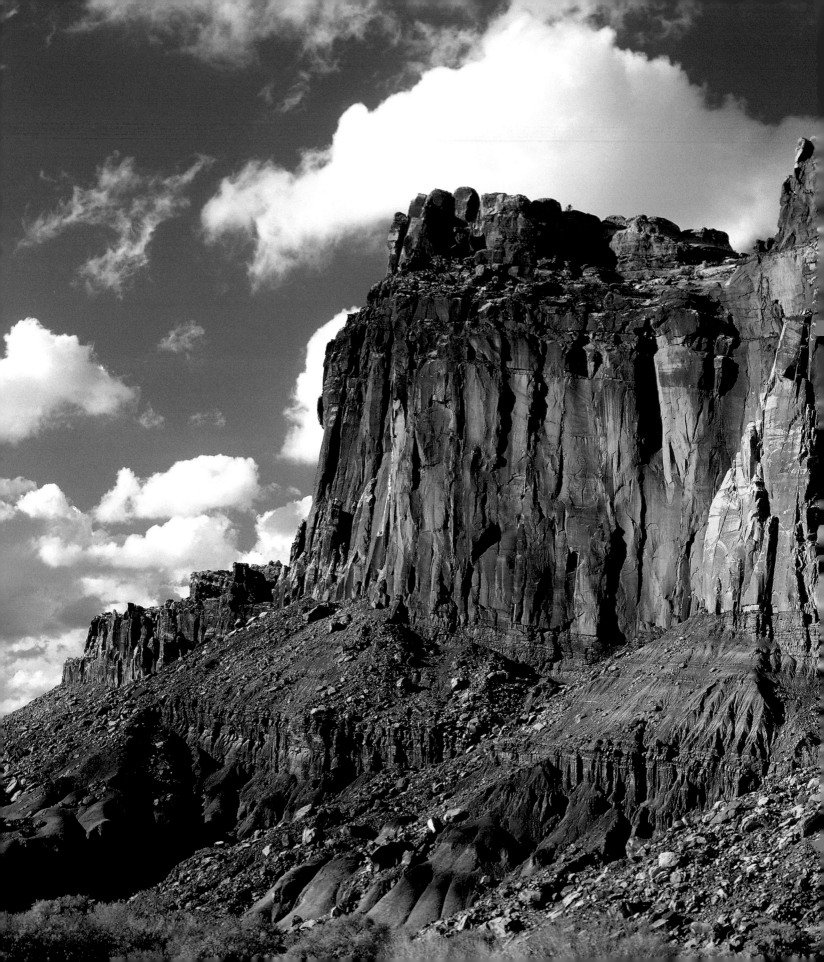

LIFE AT A FREMONT HAMLET

Cliffs above Fruita Historic District, Capitol Reef National Park, Utah.

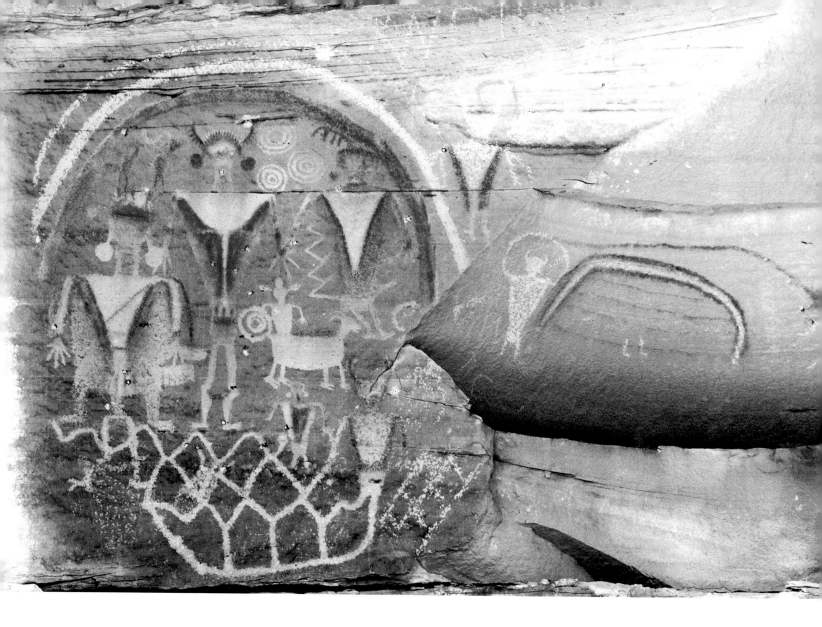

Our view is unobstructed as we approach the toe of a flattened ridge where the people live. The ridge fingers onto a floodplain hemmed among the sandstone walls of a canyon as unique as it is common in Utah. The trees and brush for some distance around have been cleared over the years by people living in this spot. A panel of rock art on a sunny sandstone wall at the edge of the canyon catches our eyes as if intended to do just that. The images are rows of bighorn sheep, arrangements of geometrics, and the triangular anthropomorphs typical of the Fremont. Some images are superimposed on others, but the panel mostly strings along as if constructed sequentially over time. It is a reminder that the past is very much part of the present in the Fremont world, and that this world is in constant renewal.

Our destination is just ahead, and in this case the rock art we just passed is clearly within view of the settlement. This is a small place, one that archaeologists often call a Fremont rancheria, farmstead, or hamlet. It is the most typical form of Fremont settlement. We will soon find, however, that Fremont hamlets were dynamic segments of larger networks of settlements—some much larger. The network linking these places encompassed kinship, language, symbolism, and place. These connections stretched across geography and across time, and were

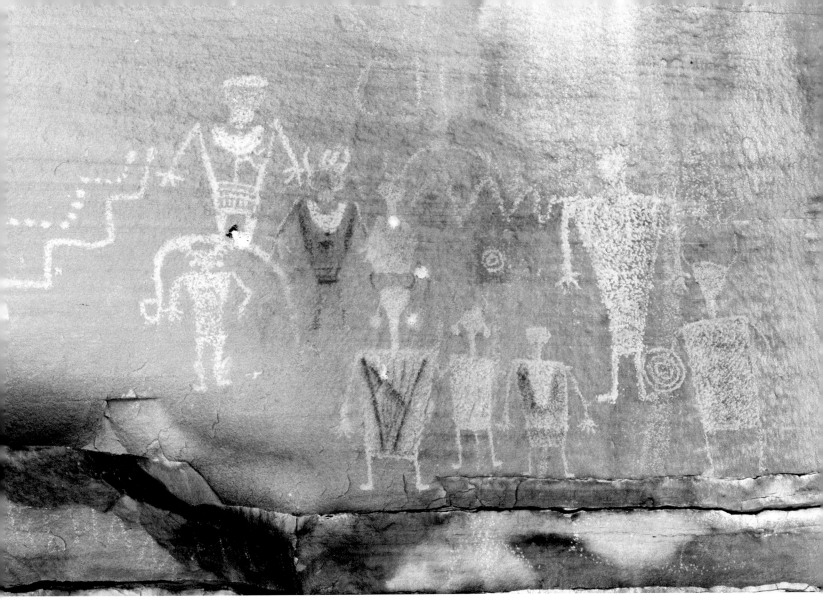

Rock art panel in Ferron Box, San Rafael Swell, Utah. A panoramic example of pictographs and petroglyphs in a mysterious and stunning composition. The panel extends to the left, but another part of it was destroyed by a vandal who left plaster on it after a failed attempt to make a copy.

made organic by cycles of human mobility and migration ingrained in a living landscape that was at once past and present.

Two rather unnatural domes of earth standing higher than the average human mark the locations of pithouses, semisubterranean residential structures with a floor space about the size of a modern kitchen or bedroom. A whiff of smoke drifts from an opening at the top of each dome that does double duty as an entryway. A woman entering the house steadies herself on the smooth knob topping the juniper entry ladder and lowers a burden basket into the hatch. The basket is full of shucked maize kernels to be ground on a large metate for the evening meal. The distinctive Fremont, "Utah style" metate has a shelf on one end—a reminder to rest the mano, or handstone, so it will be available for next time. Supper will be a porridge strewn with bits of rabbit meat, spiced with wild seeds such as tansy mustard, and perhaps laced with fresh greens. Or tonight it might just be a tortilla-like corn cake, beans, and a slice of boiled squash.

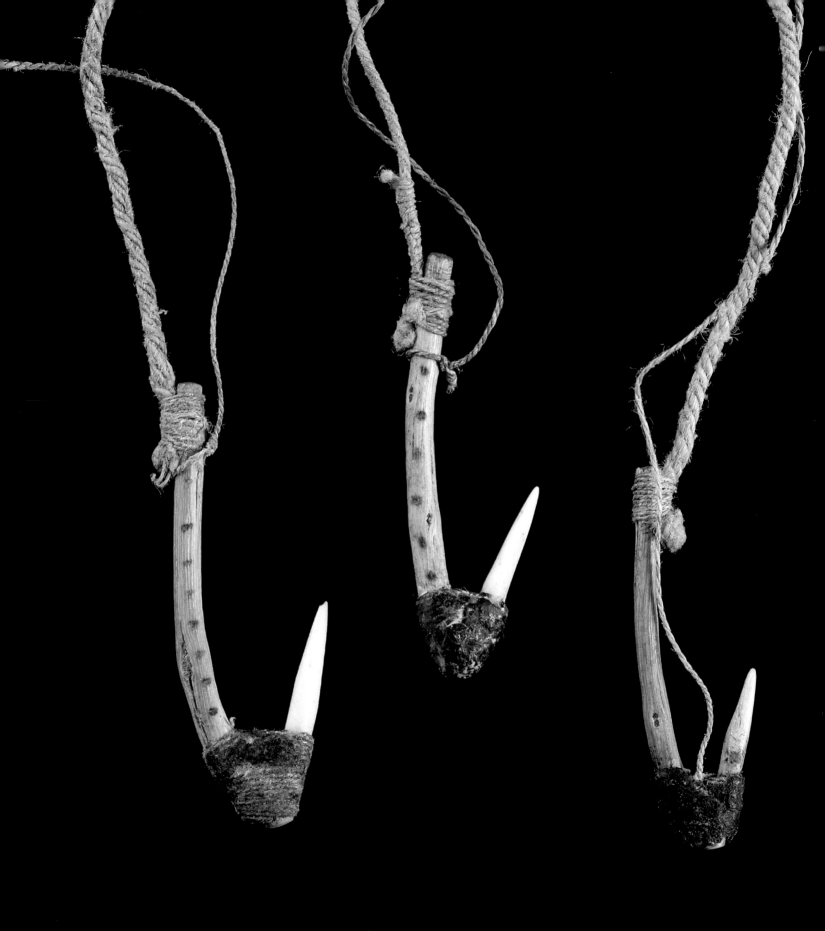

Fishing hooks from Mantle's Cave, Dinosaur National Monument, Colorado, Collections of the University of Colorado Museum of Natural History, Boulder. These delicate fishing hooks were stored in a basket along with a bundle of rabbit snares and other objects. Each hook is four to five centimeters long and made of bone and wood bound together by soft string and cemented with pine pitch. One hook was attached to a cord three meters long; the two others were attached at opposite ends of a cord three and a half meters long.

Two digging sticks (top) and the blade of a composite shovel (bottom) from the Pectol Collection. In the early twentieth century, the Pectol family of Torrey, Utah, collected "relics" from the vicinity of Capitol Reef National Park. The collection created a sensation among archaeologists of the time.

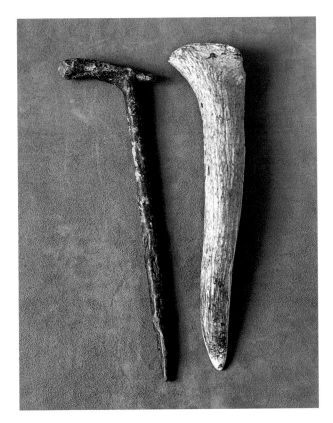

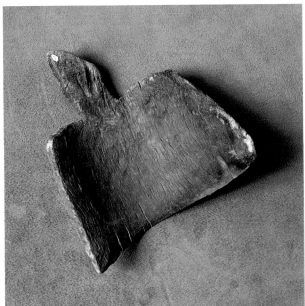

The houses are airy because they were constructed with vent tunnels dug laterally and upward, drawing in air that is directed around the perimeter of the house by a stone or adobe deflector. The constant fire in the central hearth rouses a draft that swirls the air around the perimeter of the floor, upward, and out the smoke hole. In the balmy autumn weather, only a month or so after the maize, bean, and squash harvest, the ventilator keeps the air fresh. In the winter the vent will be dampened to provide just enough flow to discharge the smoke from the hearth. Cool in summer and warm in winter, the pithouses are what archaeologists typically excavate, but the open plaza outside of the structures was the real center of household activity.

Most life goes on outside under ramadas and in the open yard between pithouses. Here is where people usually sleep, as well as eat, chat, and watch. A closer inspection shows just how much it takes to support this Fremont hamlet. There are racks for drying maize ears and for jerking strips of meat from bighorn sheep and cottontail rabbits. A ramada partially enclosed by a thin wall of sticks and adobe, called "jacal," offers a token of shade and wind protection. Mostly the ramada is a convenient place to hang just about anything that can be slung from its rafters, including tongs, rock lifters, nets, winnowing trays, mats, and an array of shaped sticks surely good for something.

Under the ramada, and sprinkled across the yard, are small hearths. They warm to use intermittently, but at least one is lit and working pretty much all the time. Surely reflecting some sort of organization are piles of stones for cooking rocks, and bundles or bags of sinew,

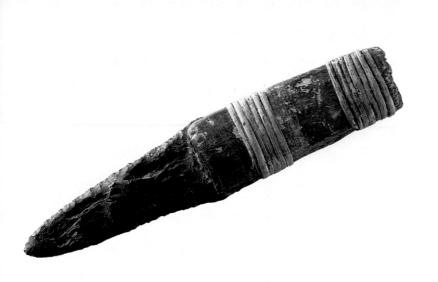
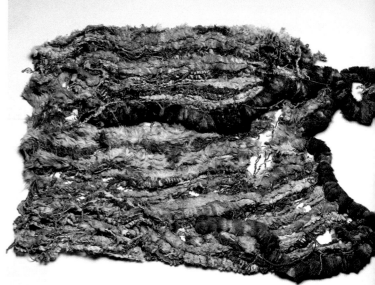

Hafted knife from Mantle's Cave, Dinosaur National Monument, Colorado, Collections of the University of Colorado Museum of Natural History, Boulder. Large stone blades were often used as knives, not projectile points. This knife is 20 centimeters long and has a handle of cottonwood with willow splints and pine pitch glue binding the blade.

Rabbit fur blanket, Collections of the Museum of the San Rafael, Castle Dale, Utah. Blankets and robes made of rabbit fur were used across the Desert West. Rabbit pelts were cut into strips that were wrapped around fiber string to make a thick yarn. The string-fur yarn was then stitched together to make a thick garment. Experiments have shown that the insulation of a rabbit fur blanket approaches that of modern out-door jackets.

fiber, leather, and special woods. Also in the plaza are baskets full of everything from wild roots and seeds to special clays collected from a distant canyon to be used to make the distinctive Fremont figurines.

Tucked up against one of the houses we find a small assortment of stone flakes. Most are nondescript, but they have working edges. Others are recognizable as blades and scrapers, and one big, leaf-shaped blade is ready to be hafted to a handle to become a knife.

Inside one of the houses, tucked away in a wall niche, is a small, finely woven basket with three rocks of different types. Each rock can be grasped in the fingertips, and each has a flaked graving tip. These belong to a shaman, who uses them to peck and engrave rock art. One is a piece of quartz, another is blue feldspar, and a third is a large topaz crystal bleached by the sun. We know little about the tools used to create Fremont rock art, but quartz fragments have been found embedded in

petroglyphs of the Coso Range in the Mojave Desert of California.[10]

One large basket is full of beeplant harvested from the edge of the maize field. Beeplant is boiled to make a thick, black syrup used as an alternative to the more common mineral paint, both used to create the characteristic geometric designs that decorate some ceramic vessels. There are pottery jars, too, but perhaps not as many as one might expect. A couple of large jars store water, and cooking pots smudged black await their next job.

Voices at this hamlet carry on the wind. We see no movement and can pick out no one. We know they are there, but they are encoded in our recitations of the names of their pottery, their baskets, their arrowheads, and their rock art. Our view of them is veiled. Finding the real lives of real people is always the most difficult task in archaeology.

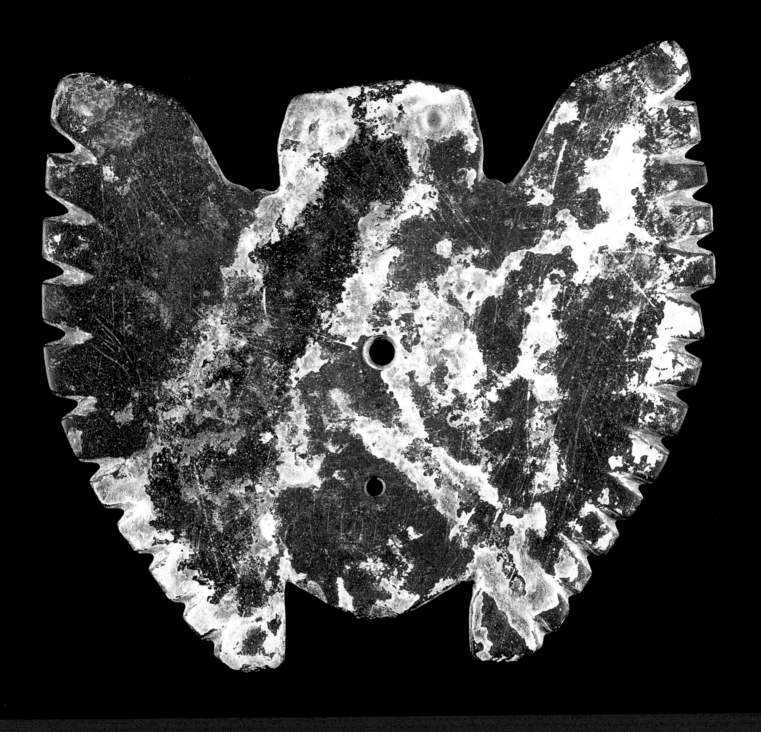

TEMPOS OF LIFE AND LANDSCAPE

Owl pendant (front) from Baker Village site, Nevada.

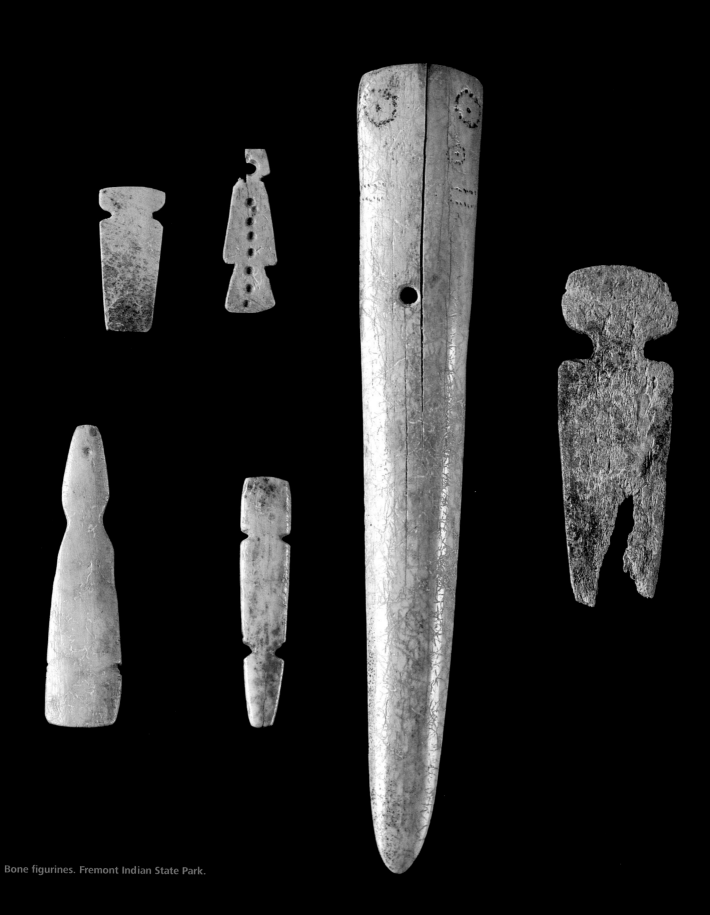

Bone figurines. Fremont Indian State Park.

This is a small community, but it is not static.
People come and go. This fact of life shapes the pace of ceramic manufacture and the intentions of potters. The pottery signifies that Fremont sense of place is at once settled, yet ebbs and flows across the landscape in relentless cycles of movement, return, and abandonment.

When people leave this place, perhaps only a few years after founding it, some useful items might be taken. If the typical expectation to return holds force, they might leave much of the place intact. If the movement is an intentional migration, they might clean the inside of the pithouses and ritually burn one of them, especially if one was the place of a recent death. After decades—in some cases, even centuries—the residents will leave for the last time.

Later peoples of the canyon will take away what is useful from this place, and time will eventually sweep away the ramada, the racks, and other perishables. Some of the houses will burn in natural wildfires, while others will just collapse. The holes will gradually be filled with sediment, or the trash of later residents, eventually becoming only subtle circular depressions. But what went on here will be recognizable to the archaeologists who excavate places like this. We can still identify this hamlet by the packed earth, the cold hearths, and the post holes that once held structural timbers. We will find the smears and humps of ashy sand mixed with everything discarded or broken— the trash middens.

Archaeologists resist writing too directly about the people because they are less tangible than the artifacts, the discarded food bones, and the dizzying array of samples taken by excavators. But at one time or another, all archaeologists put people back into the picture, even if only in our mind's eye.

33

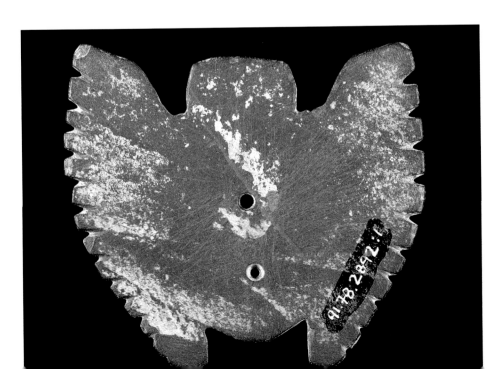

Owl pendant (back) from Baker Village site, Nevada. This pendant was carved from a thin sheet of slate and measures 7.8 centimeters wide by 7.1 centimeters in height. The white calcium carbonate covering part of it was probably deposited by water percolating through the soil in which it was buried. The Baker site was a planned Fremont village located at the foot of the mountains on the Utah-Nevada border, east of Great Basin National Park.

THE KINSHIP OF FARMING

View of Range Creek Canyon, Utah, looking north
from the upper ledge of Locomotive Rock.
The road is visible several hundred feet below.

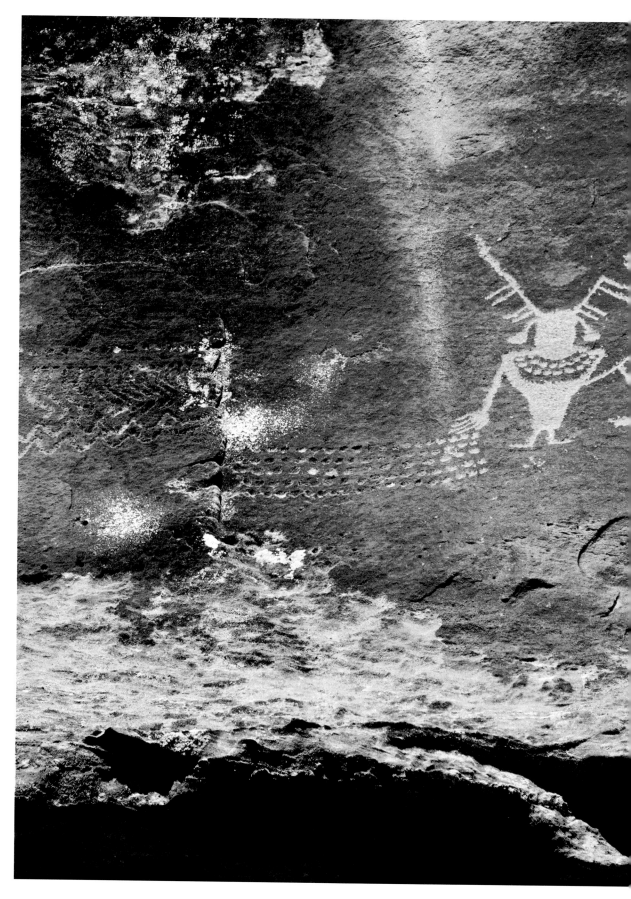

Petroglyph panel, Range Creek, Utah. The intrigue of this panel is its location high on Locomotive Rock on an exposed cliff of difficult access just below the summit. The cliffs on the south face of Locomotive Rock alternate with ledges, each of which contains a pithouse, thus creating a residential staircase of sorts with this petroglyph panel overlooking it. One interpretation has suggested that the central figure is sowing seeds in a field.

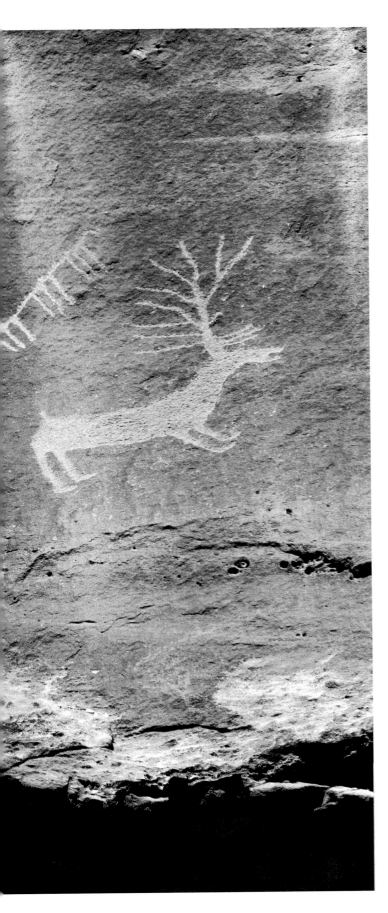

Everyone at this settlement is related in some sense of traced kinship, but the fabric of kin stretches well beyond modern perceptions of family to encompass lineage, perhaps groups that knit lineages together, as well as ancestors who are still considered very much alive. In Fremont society, kinship is also government, economy, and religion. It is past and present as one.

We see two young women and some girls working silently in the yard. An elderly woman sits in the shade of the ramada and sings to herself as she weaves a mat of rushes harvested from a marshy area about a mile down the canyon. On the floodplain below the hamlet is a party of girls prodding the ground with their digging sticks and hoes. A matronly woman wags her digging stick as if to supervise. Two men are clearing brush on a low terrace upstream. We realize there are people here and there in every direction working with carefully paced deliberation on what appears to our untrained eyes to be a mishmash of farm plots. The fields are not laid out in neat squares, but instead follow the terrain. And they are oddly scattered. One plot is along the base of a slope of exposed slickrock. The bare rock salvages water and sheds it into the sands below. The sand dune at the base of the cliff will harbor the moisture long after the rains stop, making it possible for the maize and beans to survive until the next storm.

The maize plants are set far apart so as to not rob water from their neighbors. Squash plants sprout from piles of stones arranged to hold moisture for the water-hungry fruits. Beans, too, are scattered here and there. They are spaced widely, in the way that the modern pinto bean farmers near Dove Creek, Colorado, plant them in fields farmed without sprinklers or irrigation.

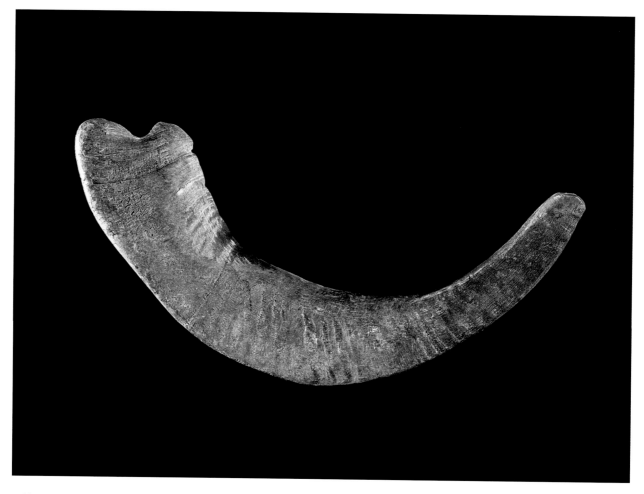

Sickle made from the horn of a bighorn sheep. Fremont Indian State Park.

Another field across the canyon is above the floodplain, but in an area protected from the searing sun and especially the wind. A single storm can level a field of maize before it can fruit. A big plot on the floodplain itself is on a low terrace where stream water naturally seeps into the sand. The maize and beans are planted more closely together here, but the fortunes found in this location are rare and can be swept away by a single flash flood.

Yet another farm plot is well away from the stream in an ancient, now dry stream channel. The plants there benefit from water that occasionally jumps the banks of the main stream to find its way to this little depression. If the flood is too big, this plot may also be swept away, but it is safer than the other one, even though it won't produce

as much. Upstream is a party of men wielding wooden-bladed shovels. They are diverting water out of the stream to reach fields less well watered. The men would rather not do this, but when the rains do not come, they are forced to invest their labor on behalf of an uncertain future.

These are just the fields within easy view. Others are much higher on the mesa above. Some are on north slopes, while others face the morning sun. Together the dozen or so fields that support this hamlet round out a portfolio of arable plots knitted together by kin, cooperation, alliance, conflict, and mobility across the landscape. The kinship of farming hedges the insecurities of the high desert—in most years.

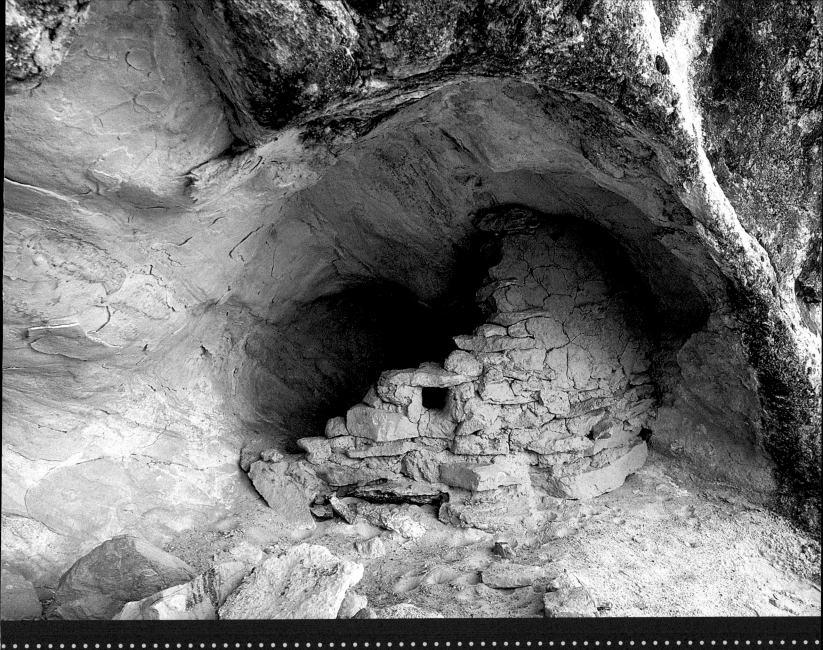

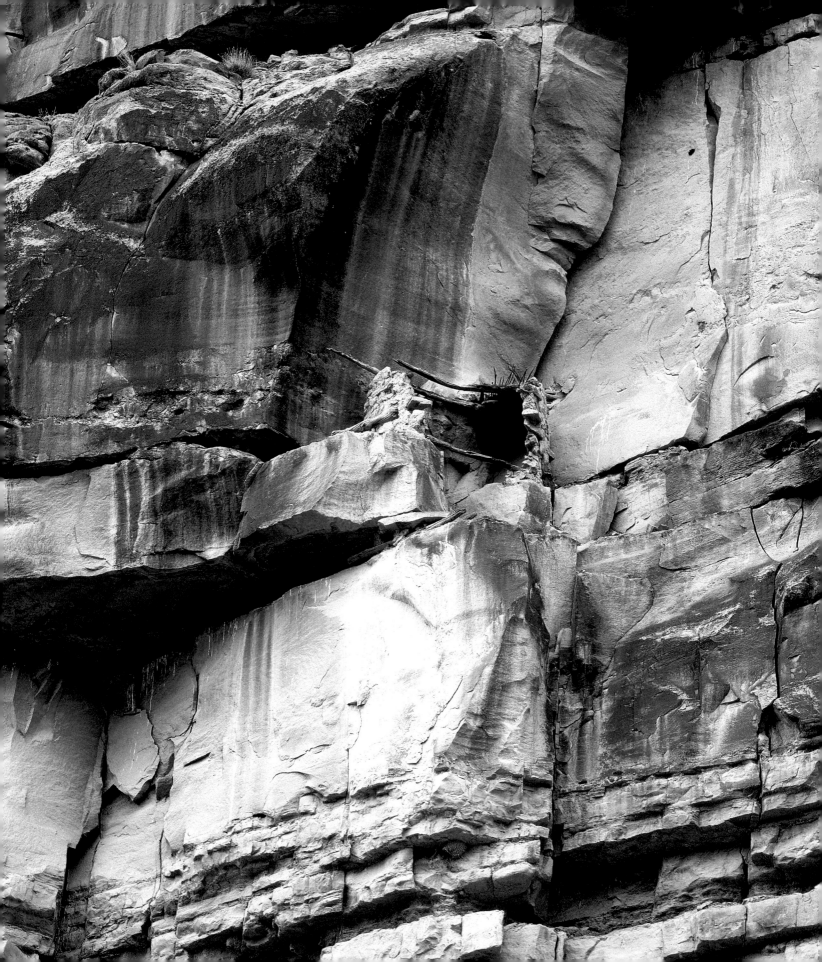

Storage, too, is part of the commitment to living here. Farming alone does not tether people. Fields can be planted and loosely managed from then on. Storage of the saved surplus from farming is the real tether because this landscape is full of people. It is people who place constraints on life, not the mere act of farming, producing, and saving. Once a landscape is inhabited, it is inevitable that freedoms will be defined and constrained by society. This social fact was just as real in Fremont times as it is today.

Some of the surplus food is stored inside the home and in granaries built of coursed adobe located near the pithouses. These impenetrable adobe boxes are filled through roof hatches that are then covered with a slab of stone and sealed with mud. When these free-standing

storage structures are found at Fremont hamlets, they are usually small—about the volume of a large automobile trunk. Others at larger villages can be as long as a modern shipping container and divided into bins, each holding nearly a small pickup truck load.

Relatively tiny granaries are slab-lined cists dug into the ground that hold half a bushel or less, or small masonry cribs located near the fields. That way the maize and beans do not have to be carried far for storage.

High on the canyon wall above this village we see two places where storage bins of stacked stone masonry are perched on seemingly unreachable cliffs. We wonder why someone would go to such effort to carry the stones, the clay and water for mortar, and the food up a cliff that

41

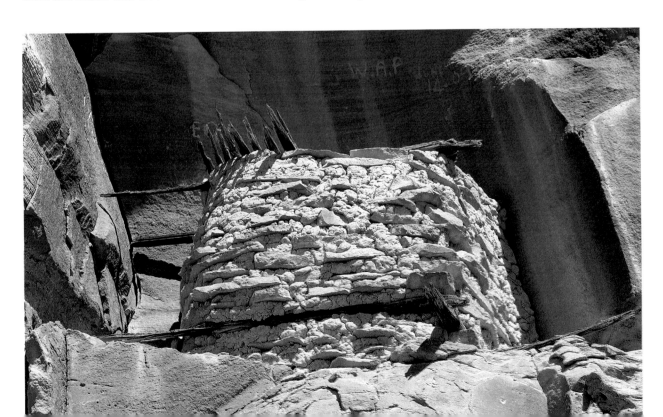

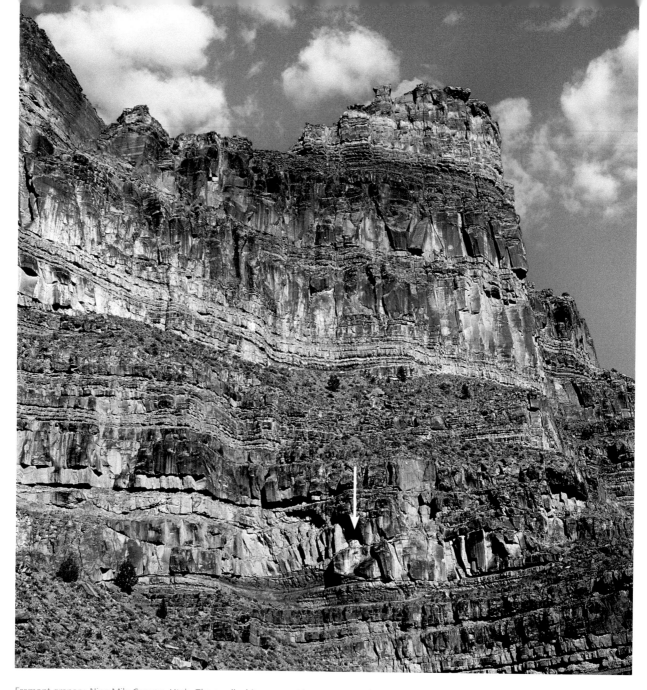

Fremont granary, Nine Mile Canyon, Utah. The small white arrow at lower center points to a remote granary built on a ledge under an overhang.

would easily dissuade access by most modern people. We imagine all kinds of answers, but most of them tell us more about ourselves than the Fremont.

The cliff granaries are often easy to see even though they appear inaccessible. Each one stores only a small amount of food, perhaps enough for four people for a month, sometimes less. Like the fields, the houses, and the adobe granaries, these remote structures are part of the landscape. They are not just about hoarded food, a rainy day fund. Nor are the cliff granaries likely to signify the heroic acts of defense of family and home that are the stuff of romanticized accounts of primitive peoples.

The granaries, like the array of fields in different locations, are part of the social fabric. These granaries are in

Fremont granary, Range Creek
Canyon, Utah.

full view of anyone who even attempts to gain access. They are impossible to reach without someone, maybe almost everyone, knowing about it—even at night. Everyone in the community knows who controls each one. They know when they are full, and when they lie empty.

The ostentatious inaccessibility of these strange cliff granaries symbolizes power. They reflect authority, alliances, and obligations that extend to matters well beyond their meager contents. Whoever controls the two cliff granaries visible from this hamlet likely also controls most of the decisions about the fields and the other hoards of farmed foods.

This control is not strictly in the hands of individuals. The authority of individuals comes from their place in the lineage, their skills, and their charisma, and may be validated by ritual and belief. The spectacular cliff granaries are symbolically charged and woven into the social fabric of kinship that is one with economics, politics, worldview, and perceptions of place.[11]

It is a fact that the Fremont built granaries, sometimes in remote places, to save food for bad times. It is also a fact that stored food must sometimes be defended

This corncob on a stick, from the Pectol Collection, was found in the vicinity of Capitol Reef National Park.

from enemies. Beyond the pragmatics, however, is the seemingly inscrutable remoteness of some Fremont storage structures. Why would the same people who store in easily accessible granaries near their homes also risk their lives to construct cliff granaries that are so difficult to access yet on public display? We will find that all this means a great deal when it comes to knowing the Fremont. This form of storage is a signal that Fremont social organization was more than that of individual heads of family.

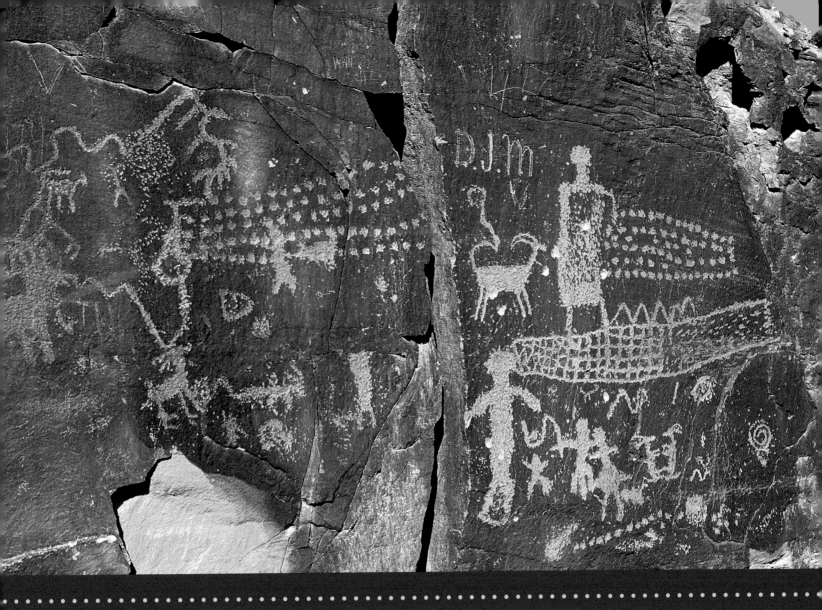

A POPULATION DYNAMIC

Anthropomorphs, sheep, "dancers," "sitting sheep," and grids (sometimes interpreted as hunting nets), Nine Mile Canyon, Utah.

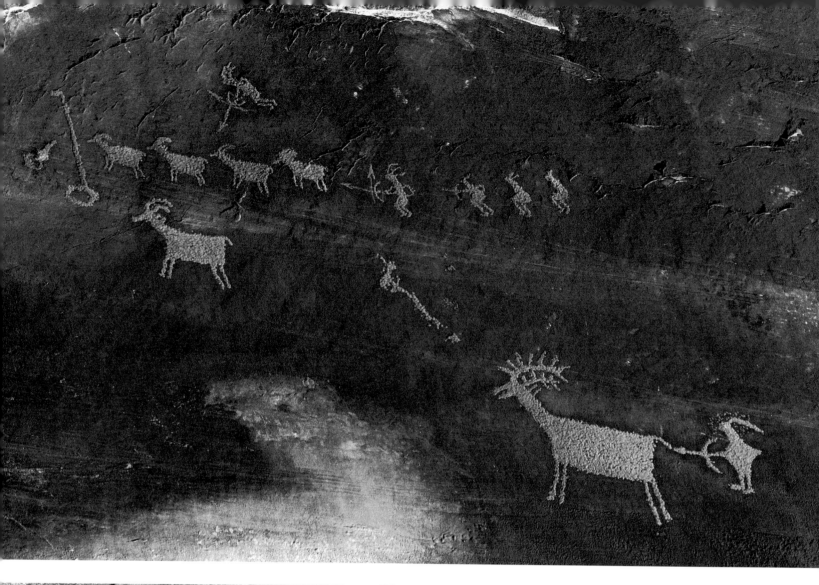

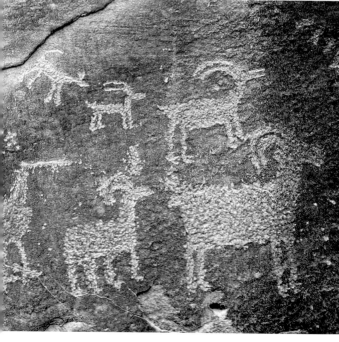

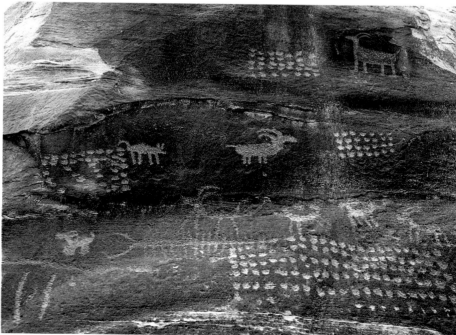

How many people might live in a place like this?
Probably no more than two dozen, but such a pat answer is misleading because the population fluctuates constantly. Most of the work that sustains a community like this is done away from home. There are the trips to quarry useful stone, and trips to collect medicinal herbs, minerals, special fibers, and wood. Trips may take an individual or small group away for days or weeks. Hunting of small animals using snares in trap lines might be done within a few miles of home, but it can take many hours to work a trapline.

Large game is likely scarce in the canyon because the mule deer and bighorn sheep have given way to the people. Big game hunting might take groups of adult men, young men, and yes, women into the backcountry for weeks at a time. Groups of mixed age and gender might also take trips to favorite locations to dig roots or collect seeds, and these might last days or weeks. When a hunting party leaves, an elder might go along as a source of knowledge and spiritual guidance. Physically active grandmothers may accompany the expedition and manage the base camp. The elderly who stay at the hamlet do much of the work there, and together with the young mothers with infants and the less mobile children, they constitute the most visible presence in the community much of the time.

There is another dimension to the matter of population size, one that is sometimes difficult for modern people to understand. Fremont groups were not stable and fixed, which is not to say that they had an unstable family life. But the notion of a family unit spending their lives in a single house, or even the same hamlet, to raise their

47

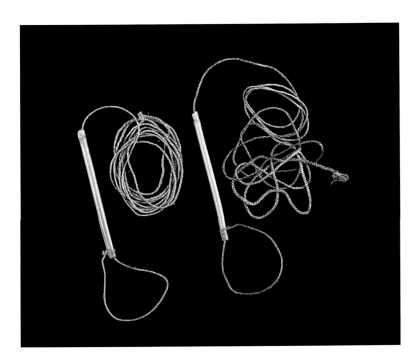

Scissors snares from the collections of the Prehistoric Museum of the College of Eastern Utah, Price.

Petroglyph panel, McKee Springs Wash, Dinosaur National Monument, Colorado. This panel is located on a natural trail leading from the Fremont sites along Dry Fork into McKee Springs Wash. A large anthropomorph in the center bears a knife and shield, and wears a headdress. Anthropomorphs on either side wear masks with bearlike ears. The bison were added later. Other panels located down the trail display a succession of costumed figures, some bearing shields and displaying trophy heads.

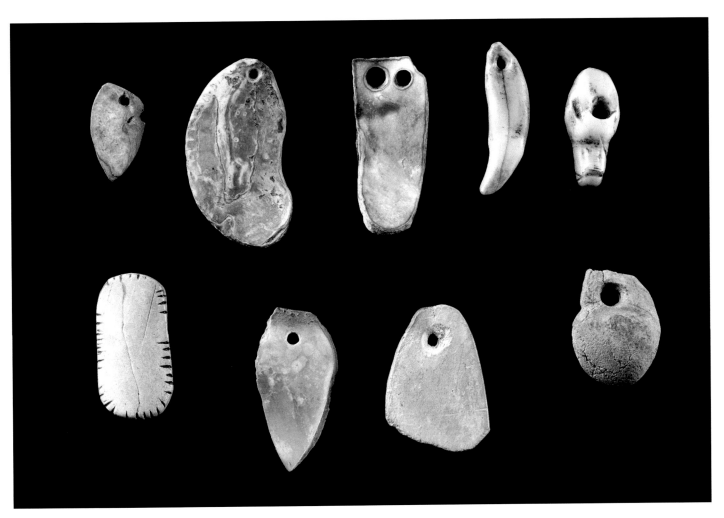

Jewelry from Fremont sites in the Great Salt Lake wetlands, Weber County, Utah. The pendants were made from bone, shell, and a dog tooth. The abalone shell that was used to make the pendant on the upper left (top row, second from left) originated in the waters off the California coast. Collection of Mark Stuart.

children, grow old, and die is probably far from the truth. People moved around. Parts of families left to live in other places—sometimes for months, and sometimes for many years. There were marriages of individuals from distant lineages, and divorce. There may have been movement of families and individuals back and forth among familiar places many times—and sometimes longer migrations to less familiar places. This movement was neither aimless nor nomadic.

To be sure, Fremont farms were tethers, and the demands of farming in the high desert made settlements clearly defined places. The movement of the Fremont was, like that of the Anasazi of the Southwest, a ritual of abandonment, migration, reclamation, and renewal. This movement was made real to the people through a connection between the ancestors of the past and the living. The movements were based on memory and structured by the stories told over generations about mythical migrations. Fremont movement was a ritual cycle of residence and a successful way of life for a people who sustained themselves by farming in the fickle climate of the high desert.

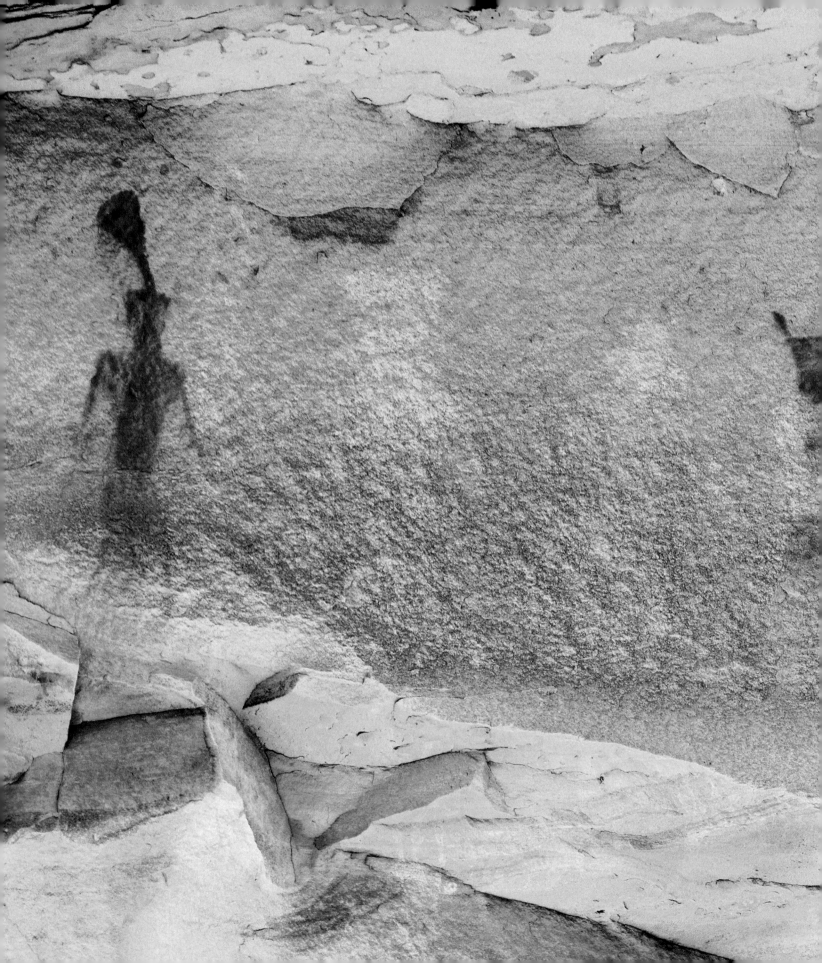

FREMONT BIG VILLAGES

Fremont pictographs, Range Creek, Utah.
Anthropomorphs in red, white, and green paint,
each with a distinctive headdress.

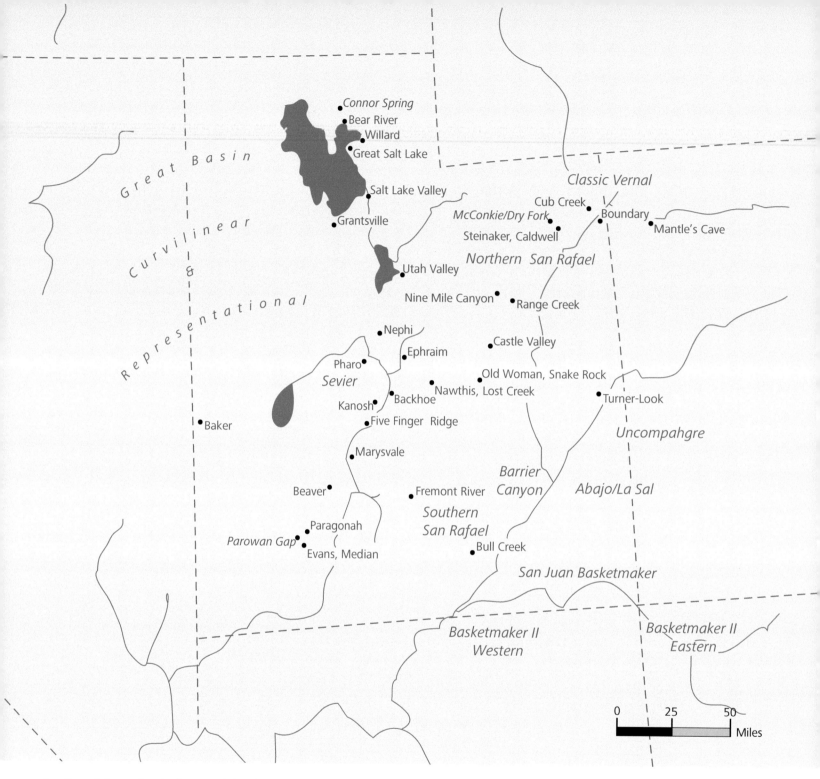

Great Basin

Curvilinear

&

Representational

Connor Spring
Bear River
Willard
Great Salt Lake
Salt Lake Valley
Grantsville

Classic Vernal

Cub Creek
McConkie/Dry Fork
Boundary
Mantle's Cave
Steinaker, Caldwell

Northern San Rafael

Utah Valley

Nine Mile Canyon
Range Creek

Nephi
Ephraim
Castle Valley

Pharo
Sevier
Old Woman, Snake Rock
Nawthis, Lost Creek
Turner-Look

Baker
Kanosh
Backhoe
Five Finger Ridge

Uncompahgre

Marysvale

Barrier
Canyon
Abajo/La Sal

Beaver
Fremont River
Southern
San Rafael

Paragonah
Parowan Gap
Evans, Median
Bull Creek

San Juan Basketmaker

Basketmaker II
Western
Basketmaker II
Eastern

0 25 50
Miles

Locations of places referred to in text, including locations of Fremont villages (blue), rock art concentrations (blue italics), rock art styles (orange italics), and the locations of the Basketmaker II cultures of the Southwest. Map by Nancy Kay Harrison.

By the height of the Fremont period, in the A.D. 1000s, hamlets were sprinkled across the landscape in virtually every farmable place. Small Fremont sites far outnumber what may have been larger villages. Sites with dozens, and even hundreds, of pithouses were typically seen by archaeologists as the product of accumulation, not villages. To this day, most archaeologists habitually recite the lore that the Fremont lived only in small groups. Of course, in such a situation there can be no social complexity.

Let's examine this lore. In the 1960s and 70s, the practice was to estimate settlement size by using the most conservative reading of the stratigraphy to provide a minimum count of how many pithouses could be directly shown to be occupied at any one time. The number was usually about three. Radiocarbon and tree-ring dating were either not done at all, or so few samples were dated that they gave only a general impression of the time of occupation. In retrospect, we turned what was intended to be a demonstrable minimum count into the *actual* count of contemporaneously occupied pithouses. This logic is akin to finding a thousand human bones, but only one left clavicle, and concluding that only one person is present, when the mere existence of a thousand bones allows for at least four people. This amounts to the use of negative evidence to make a positive declaration, which upon recitation creates the doctrine that there are no Fremont villages.[12]

I think some misinterpretation can be attributed to the zeal to distinguish the Fremont from the Anasazi, and to abolish the denigrating term "northern periphery." To be sure, some of the caution was the result of bringing much-needed empiricism to archaeology, even if we tended to create a conclusion on the basis of what was, in fact, little information. Finally, the mistaken belief that Fremont culture was organized only at the household level arose from a poor understanding of Fremont subsistence and the dogma that Fremont people were engaged in only casual farming. We now know from stable carbon isotopes housed in human bone that Fremont people ate as much maize as the Anasazi, and that there was variability in both groups.[13]

Once the dogma began to be challenged, we started to see evidence for Fremont villages—some of them quite large. A site near Willard, in northern Utah, even had a low wall surrounding an area encompassing twenty-five acres, prompting us to conceptualize the village as extensive rather than compact. A wall that took hundreds, if not thousands, of man-hours to construct would certainly not enclose a hamlet of three pithouses. The twenty-five acres of the Big Village at Willard may contain clusters of settlement whose total population may at times have been in the hundreds.

Another possible big village is Five Finger Ridge in Clear Creek Canyon, near Fremont Indian State Park. It covered an entire ridgetop and overlooked farmland and Fremont hamlets below. There are differences in the sizes of the houses and a possible plaza. There are exotics. Scattered human bones that were burned, cut, and boiled offer a chilling reminder that when times are hard, humans resort to terrifying violence and intimidation. Five Finger Ridge and the Big Village at Willard symbolize the case for Fremont villages.[14]

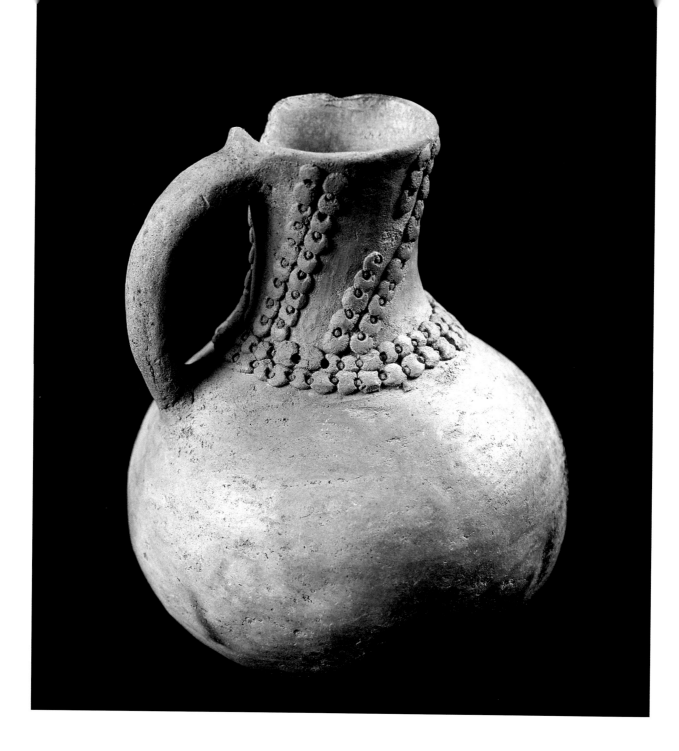

Big villages are probably best thought of as collections of settlement in some proximity, but not necessarily tightly compact units. Big villages are comprised of the mounds that archaeologists see, which are accumulations of pit-houses and other structures; however, the concept of "village" is not necessarily restricted to a single mound. In some cases, large mounds may indeed comprise a village,

but in others, such as Nawthis Village or nearby in Lost Creek, mounds are strung along watercourses as tightly together as beads and clearly comprise social collections.

One of the arguments behind the village concept is the implied social organization and authoritative leadership that accompanies it. Consider the hypothetical of twenty

mounds, each with several houses, all located along a quarter mile of a single stream. If everyone was trying to farm the land adjacent to the stream, some degree of organization for allocating the limited water to the fields and the labor to construct and maintain a ditch system would have been essential. It takes a village.

Examples of likely Fremont villages are found from Cedar City, Utah, to Preston, Idaho. They often lie under modern cities and towns, including Richfield, Beaver, Salt Lake City, Ogden, Provo, and many others. The criteria used by the Fremont for selecting farmland and places to live were similar to those used by the first Mormon settlers: terrain suitable for digging irrigation ditches, or places where water flowed near the ground surface so fields could be dry farmed. These places tend to be alluvial fans and floodplains.

Before most of the Fremont villages were stripped away to level the land for modern farming, there were more than four hundred "Indian mounds" in the Parowan Valley, and probably similar numbers in the Sevier, San Pete, and Utah valleys and along the Wasatch Front. Villages likely existed along the foot of the Book Cliffs, in Range Creek Canyon, and in Castle Valley south of Price. They occupied floodplains and the terraces above them in the Uinta Basin near Vernal.

Most big villages met their demise before archaeologists could excavate them. A man in nineteenth-century Utah Valley had a business using a horse-drawn scraper to remove "Indian mounds." The mounds that remain lie under Utah towns and, increasingly, under urban sprawl. They are mostly known anecdotally through amateur

archaeologists, and suspected through cultural resource management study when places are slated for construction. Unfortunately, the regulatory environment tends to restrict excavation to small areas, ensuring that even if we suspect something big, we can only nibble at these potentially huge sites. We end up with an atomized understanding of the Fremont, much like excavating a single lot in an effort to know New York City.

At the Paragonah site in the Parowan Valley, homes are clustered around open plazas surrounded by very public granaries. Early Fremont archaeologists referred to open spaces among pithouses as "possible plazas" because they recognized the southwestern, Anasazi affinities of the Fremont. Median Village and the Evans Mound north of Cedar City both had large granaries, and at Evans different parts of the mound were occupied at the same time. Baker Village, on the Utah-Nevada border, appears to have been a planned settlement with aligned houses.[15]

Places that became big villages were often used for a century or two, but like all large congregations of people, each had its peak. Willard, Median, Evans, and Nawthis finished their runs in the mid-twelfth century. The population peak at Five Finger Ridge occurred nearly a century later, signifying that the presence of large villages and attendant social complexity were pulsations within an enduring Fremont settlement pattern of farmsteads and hamlets.

Big villages usually have more of the exotic trade goods from far away, such as marine shell from California. In some cases craft groups may have formed. At the big village in Clear Creek Canyon, nearly 80 percent of the

pottery had been imported from manufacturing villages in the Parowan Valley more than forty miles away.[16] The Parowan Valley seems to have been a pottery center because vessels manufactured from materials found there show up widely across the west deserts of Utah and eastern Nevada.

The presence of Fremont big villages during the tenth through thirteenth centuries implies that no Fremont hamlet was independent. The pattern of abandonment and the consequent residential cycling connected large and small, weaving a social and kinship tapestry that ensured an organic whole. Villages anchored the backdrop of more remote farmsteads and hamlets. In this way, the Fremont pattern holds strong similarities to that of the Anasazi of the Southwest, where larger and smaller sites comprised a social fabric that resulted from the cycle of abandonment and reclamation spurred by the farming life.

I do not wish to join the debate as to whether the Fremont were centralized or dispersed. They were clearly both. Instead, the nature of Fremont social fabrics is found in the *connections* between the centralized and the dispersed. These connections were temporally dynamic between larger and smaller segments of the system, and this dynamic holds implications for understanding Fremont society and ideology.

Archaeologists have long dubbed the Fremont the backwater, country cousins of the Southwest. The Fremont had no Chaco Canyon, and no huge pueblos such as Salmon and Aztec in New Mexico, or Sand Canyon and Cliff Palace in Colorado.

Those who study rock art took the archaeologists at their word and drew their inferences from the stereotype of the Fremont as mixed foragers and farmers, with little social organization beyond the pithouse. Religion was seen as purely individualistic, with expression at no more abstract a sociopolitical level.

The basis for change was laid in the 1990s when archaeologists once again broached the subject of Fremont social organization and the possibility of complexity. By the early 2000s there was hard data for it from the Clear Creek Canyon studies. For the first time in decades it was acceptable to discuss larger village sizes and the social complexity that may have arisen from linkages among Fremont communities.[17] We are now poised to model the form of Fremont society and, by extension, the organization of their religion as having communal elements, and the iconography and cosmological perceptions as having great regional time depth. Once we leave behind the stereotype of Fremont society as atomistic and isolated, affected only by the agency of individuals, we are poised to understand the contexts of their rock art production in new ways.

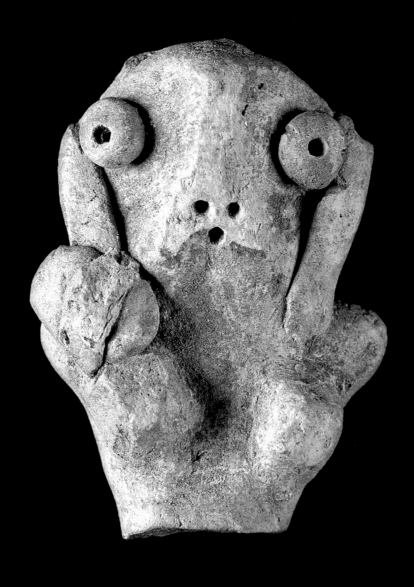

FREMONT DISPERSED COMMUNITIES

This clay figurine fragment was recovered during the archaeological excavations at Fremont Indian State Park, Utah. It measures almost five centimeters in height.

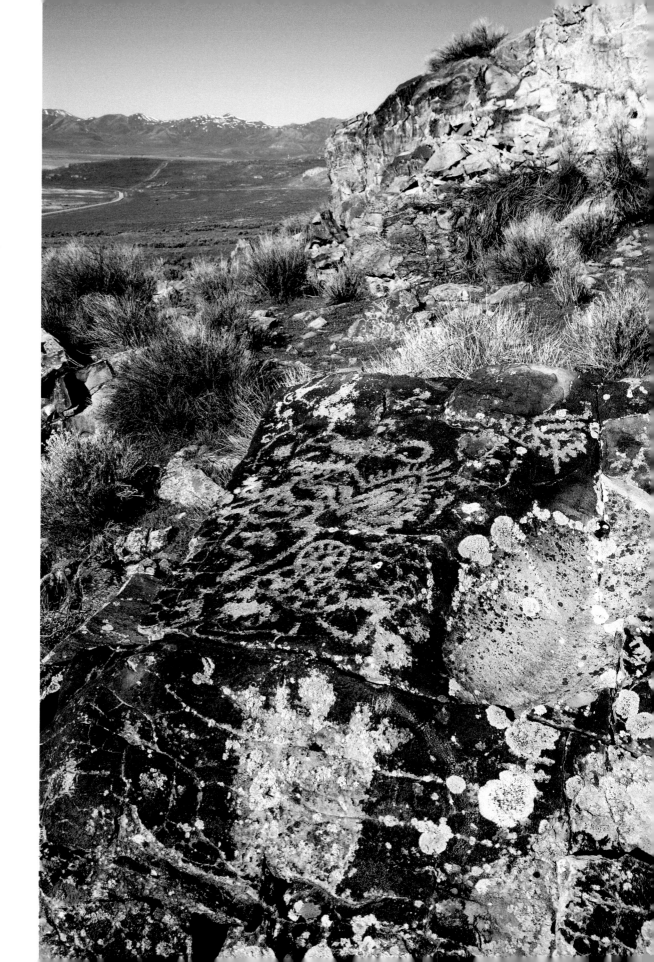

Connor Spring rock art site, near Corinne, Utah.

Residential cycling among farmsteads, hamlets, and big villages formed a social landscape of dispersed communities composed of kin, bands, and neighbors, and some groups may have been ethnically diverse.[18] Fremont villages grew larger where there was abundant farmland, which explains why our knowledge of them is obstructed by urban sprawl. Fremont sites in open farmland were long ago destroyed because they were in the way.

One force that can create dispersed communities and a diversity of kin lineages, and even account for people from other places, is labor. The ethnography of hunter-gatherer societies shows that in places and times of abundance, labor is a valuable commodity and is recruited through marriage, obligation, and coersion.[19] Recruitment intensifies as social complexity increases, and would have been spurred further during climatic regimes favorable to agriculture because labor would have been in short supply. It is thus no coincidence that the Fremont population and big villages trend upward at times during the eleventh century and again in the late thirteenth century when summer rains and annual temperature patterns were more frequently favorable to Fremont agriculture.[20]

The common heritage of the Fremont and Anasazi enables us to draw judiciously upon analogy to glimpse the social form of Fremont dispersed communities. During periods of labor shortage, the Anasazi were attracted to, and recruited to, pueblos. This led to immigration, resulting in marriage as well as the possibility of entry into the community under conditions of reduced status. As local landscapes filled up, established lineages and corporate groups would have had little to gain from recruiting new members and became more closed. During

times of larger settlements, there was greater production and population growth, but also greater inequality.

I do not argue that the Fremont were the same as the Anasazi or were uniformly complex. The associations, alliances, and corporate groups that I propose can come and go, rising in influence under some circumstances. Rather than being a hierarchy, this kind of system is a heterarchy: a network in which the elements of the organization share the same horizontal position in a decision-making system.

Decisions in this kind of society are made consensually among segments, making them different from vertical hierarchies, where decisions are made by small numbers of elites. Some lineages and communities would have held more sway than others, and shifting alliances would have caused the fortunes of Fremont individuals, kin lineages, hamlets, and villages to fluctuate—just as the fortunes of agricultural production fluctuate in the erratic high desert environment.

Ritual would have been important because participation in ritual fosters conformity and favors those who would build consensus and seek to lead. Visual arts are often important because they connect the identity of potential leaders to the larger social context. The rituals usually demand special objects and costumes.

All of these likely existed among the Fremont, and rock art provides some support for this in the frequency of formally decorated anthropomorphs displaying ritual costume and yet conveying individuality. Rituals would have represented the power held by individuals and,

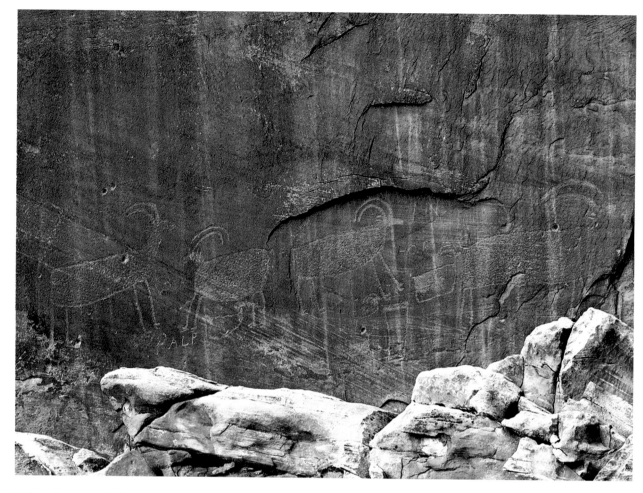

Bighorn sheep petroglyphs, Capitol Reef National Park, Utah.

more importantly, would have symbolized the membership of powerful, charismatic individuals in lineages and, at times, larger organizations. Rock art depicting rows of individuals holding hands, perhaps participating in ritual, suggests communalism.[21]

A different response would have occurred during times of drought, which peppered the entire span of the Fremont but were especially harsh in the mid-twelfth century and again in the thirteenth century. Perhaps during these times the more powerful alliances would have appropriated stored food and the best farm plots, while others dispersed, relegated to farming in remote or marginal places.[22]

Over time the forces of community, competition, movement, and isolation created the Fremont archaeology we see today. It grew out of the cumulative experiences of Fremont kinship, politics, and economics over spans of time difficult for us to comprehend. Trying to find the "real" Fremont social organization is truly chasing a will o' the wisp. The cycles of wet times and dry times, and the cycles of mobility and migration ensured that the Fremont social tapestry was changing all the time, even as an underlying heritage and worldview endured for centuries.

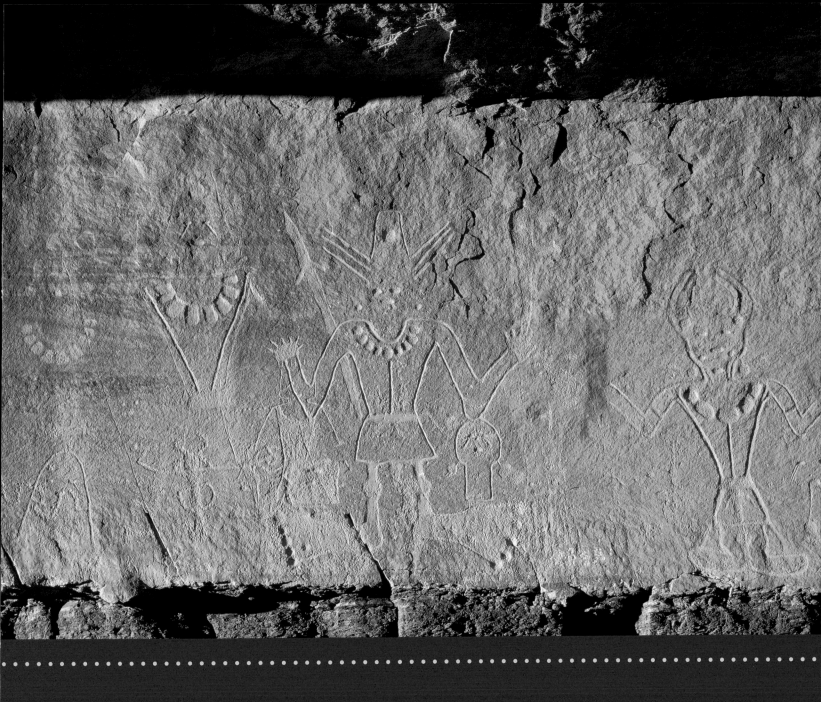

A 28-foot-long necklace made of juniper berries and bird bones from Mantle's Cave, Castle Park, Dinosaur National Monument, Colorado. Collections of the University of Colorado Museum of Natural History.

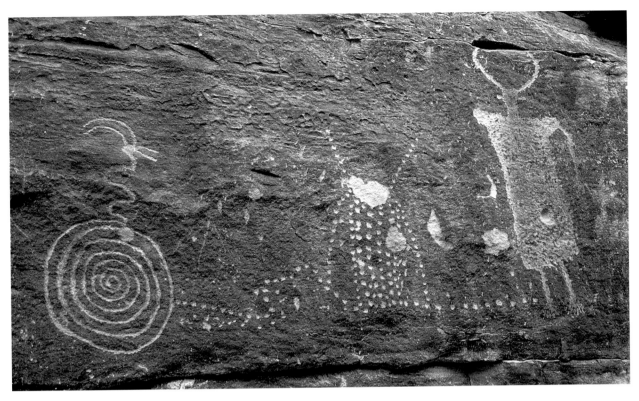

Petroglyph panel, Nine Mile Canyon, Utah. A plumed serpent with tail coiled in a spiral and an anthropomorph dominate this scene.

The tensions of self-reliance, surplus, shortage, and inequality in Fremont dispersed communities invited the formation of corporate groups of common concerns through all forms of recruitment: marriage, fictive kinship, slavery, and immigration. For example, in some societies in other parts of the world whose scale and circumstance are similar to those of the Fremont, the institution of cross-cousin marriage weaves lineages of extended families into corporate groups. This practice of marrying first cousins of the opposite sex tends to occur under circumstances where kin lineages are closely knit by labor, such as the kind of farming system found among the Fremont and elsewhere in the American Southwest.[23] It also tends to occur where lineages have ties to landscape and may be in competition, as were the Fremont.

The Fremont necessarily had strong ties to place because they were farmers. But they also had ties that could extend widely across landscapes because residential cycling was demanded by the vagaries of farming the high mesas and canyons.

The formation of corporate groups among the Fremont need not imply that these groups were monolithic and inflexible. Nor does it imply huge population centers, public architecture, ranked burial grounds, and large meeting areas. The path to complexity among the Fremont was more fluid, but corporate groups provided a way to knit lineages together through alliance and define boundaries.

The notion that the Fremont were moving toward some corporate structure as populations peaked between A.D. 900 and 1300 would be expected in a system where the instability of farm production was the sole constant. It would have been the only way for them to manage a steadily increasing population that was practicing an intensifying economy in a place where agricultural fortunes varied in expression among years, and especially among places.

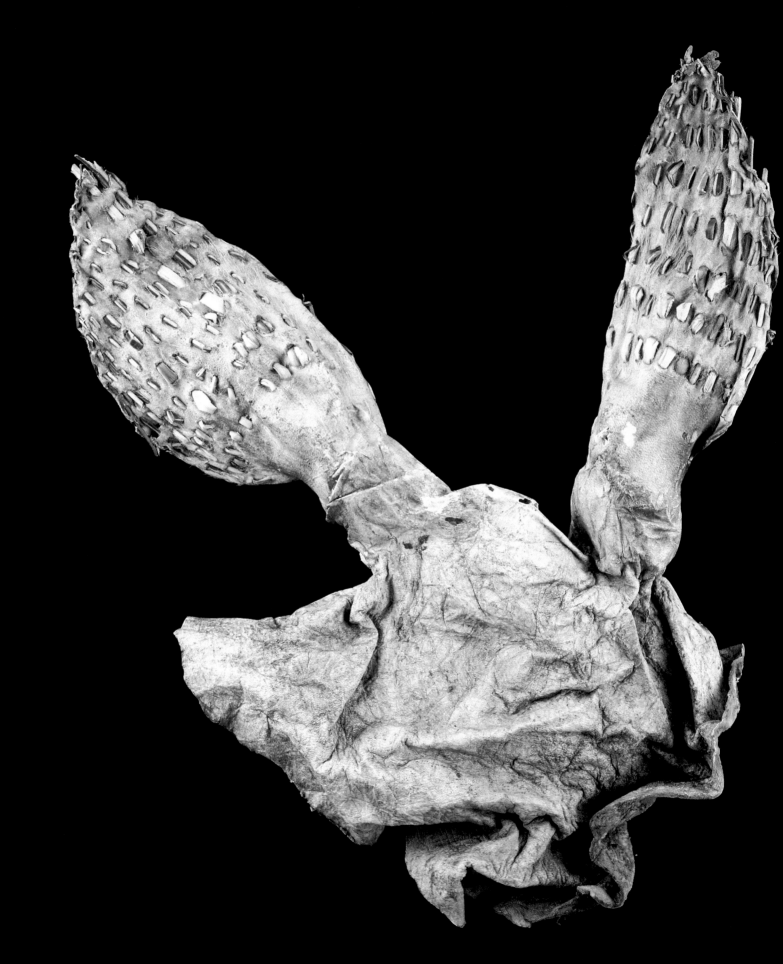

POWER AND LEADERSHIP

Deer-scalp headdress from Mantle's Cave, Dinosaur National Monument, Colorado, Collections of the University of Colorado Museum of Natural History, Boulder. This headdress was found buried in the floor of the cave in a shallow pit lined with bark and sticks. Made from the crown of a doe, the hide was tanned after the hair was removed. Feather quills were woven through the ears and, along with cedar bark, kept the ears erect. This scalp dates to 3000–500 B.C., well before the Fremont period; however, similar specimens dating to later periods, including Fremont times, are found elsewhere in the West. Ethnographic documentation shows that they were often used as disguises for hunting and as spirit helpers by leaders and shamans. Headdresses are commonly depicted in Fremont rock art.

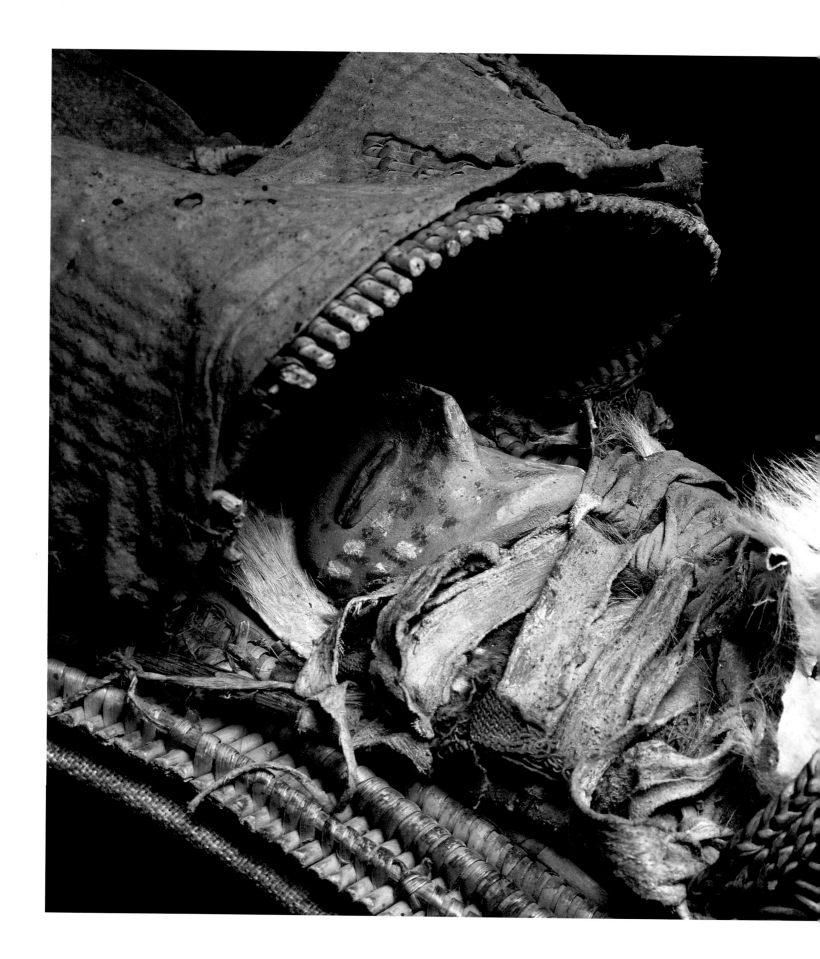

Detail of figurine in cradle board from the Pectol Collection. See page 101 for the complete artifact.

The power of leaders in Fremont society was likely 67 fed by a combination of personal charisma, the fortunes of resource production and control, and networks linking leaders at home and in the dispersed community.

The authority of a would-be leader was dependent on the individual's station within the dispersed community and in a corporate group. The influence of a leader from a Fremont hamlet or one living in a big village would play out in the competition, alliances, inequalities, and kin networks among segments of the dispersed community. Such leaders might wield material power in terms of decision making about stored food, claims to the best farm plots, expertise in public speaking and negotiation, knowledge of medicine, or exceptional physical skills. It is unlikely that all of these skills were held by the same people, and thus the direct influence of any one leader would have been limited. Further, the success of leaders was circumstantial, having more to do with their collaborations at larger scales in the community than with the particular place they lived.

Ritual played a role by enhancing the influence of leaders while at the same time diminishing their individuality. The notion that some aspects of leadership are "faceless" means that personal influence is enhanced by the station one occupies in a ritualized and sacred reality.[24] Individual, aggrandizing leaders were important in the Fremont world, but social organization at the scale of the dispersed community ensured that these people were not independent. The religious system enabled claims of power by individuals to be ritually sanctioned, while at the same time making these leaders representative of the collective.

In these kinds of societies, status arises more from the movement of wealth and influence among segments of society than from the mere possession of wealth. This is one reason why burial goods may not be a useful measure of status and prestige.

One obvious source of status among the Fremont was influence over the disbursement of maize from a local granary, or perhaps even one beyond their direct control because they held a ritually sanctioned position in a corporate group that broadened their influence across the hamlet or village. This may be one reason for the ostentatious display of stored food, either in massive above-ground adobe granaries or a granary perched on a seemingly inaccessible cliff, yet in full view of everyone. Power depended not only on the size and importance of the place one lived or was from, but on the relationships a leader had with other leaders.

All of this made for a pliable social fabric that was sustained through ritual and myth for centuries. A connection to landscape is also implied by the residential cycling and dispersed communities central to the Fremont way of life. Ritual and politics likely played out in multiple tempos and modes—over seasons, over years, over the course of human lives, and over mythical migrations on a scale of centuries. These same things shaped the rock art.

LANDSCAPE AND
THE FREMONT
CULTURE

The Fremont River east of Capitol Reef
National Park, with the Henry Mountains
in the background.

Petroglyphs on Coulter Rock, overlooking Great Salt Lake, Willard, Utah. The numerous petroglyphs on top of this giant boulder cannot be seen unless one climbs the rock. The anthropomorphs shown here vary from 11 to 24 centimeters high, and the cupules vary from 3 to 6 centimeters in diameter.

The Fremont landscape was much more than a container. It was experienced, and imbued with memories and meanings. Important to the story here is the notion that landscape is the canvas upon which rock art is created. For the Fremont that canvas was a social landscape—a life of a sort of farming that produced the movement of people, often kin, sometimes not, among hamlets and villages. It was also a fully populated landscape: more people lived in the Southwest and in Fremont land during the tenth through the thirteenth centuries than in any other period. These facts are the foundation of Fremont perceptions of place. The concept of sacred landscapes and an acknowledgment of the Fremont social tapestry are essential for understanding the cultural context of Fremont rock art.

A landscape level of comprehension helps us to reconcile the stark contrasts in Fremont culture between its localness and its geographic expansiveness. These opposites are seen in the broad patterns in Fremont rock art, in the regional variations, and in the different contexts of Fremont rock art production. Fremont localness and expansiveness were also shaped by a Fremont heritage that was multicultural, including both the indigenous foragers of the preceding Archaic period and the southwestern farmers who immigrated into the Fremont area during the Basketmaker II period and perhaps continued to do so in some parts of Fremont country.

Archaeologists are becoming aware that we tend to think about cultures and societies on too large a scale—as whole entities—as in the case of "the" Fremont. In actual practice, social realities are small in scale and deal with the local concerns and conflicts of interest of everyday life. Neither are social realities static; rather, they are variable across space, and plastic over time—even in the face of underlying themes recognizable to us as Fremont and even larger, continental-scale forces that shape heritage. Each segment in the Fremont dispersed community experienced a tension between the small scale of daily life against the landscape scale of lifetimes, as well as a belief in ancestral migrations and a blurring of past and present.[25]

The concept of sacred landscapes links the contrasting scales of the Fremont world to the role of ritual and symbolism in Fremont life and rock art. These things are used by people to draw distinctions, to fragment, as well as to identify themselves. At the same time these things are used to entangle the histories and geography of all the small entities. The symbols seen in some Fremont artifacts, and especially in the rock art, arose from these conflicting practices. Local perceptions of identity were woven with the cyclical and, at times, migratory movement of people over centuries to create "braided histories."[26]

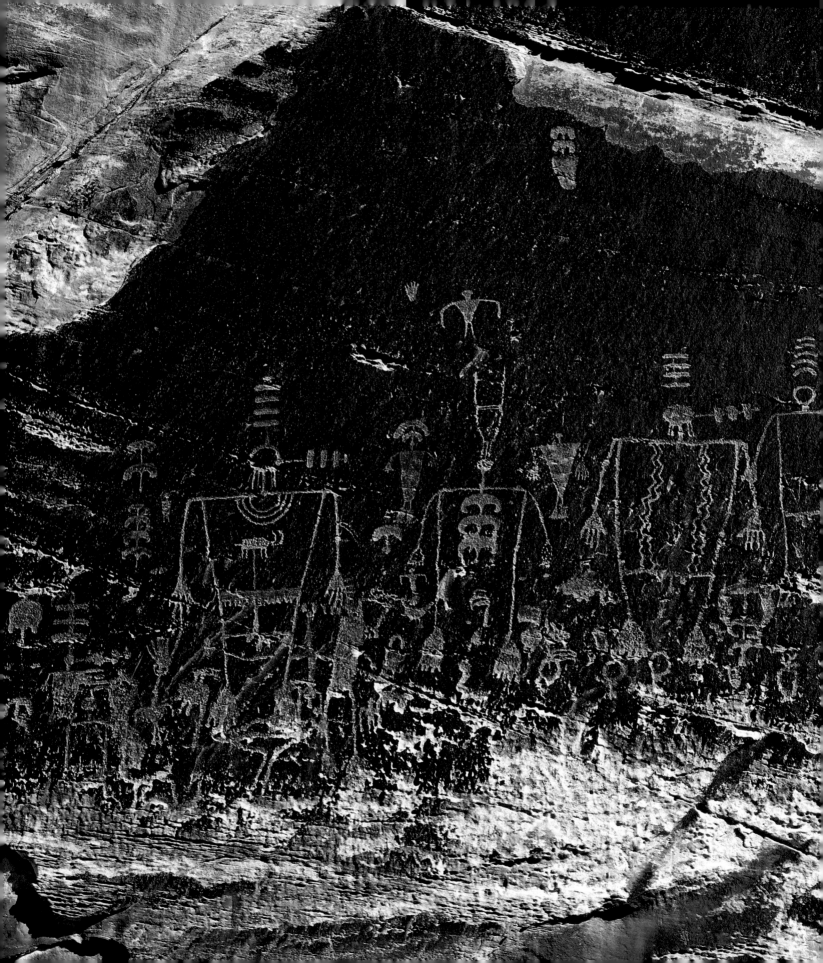

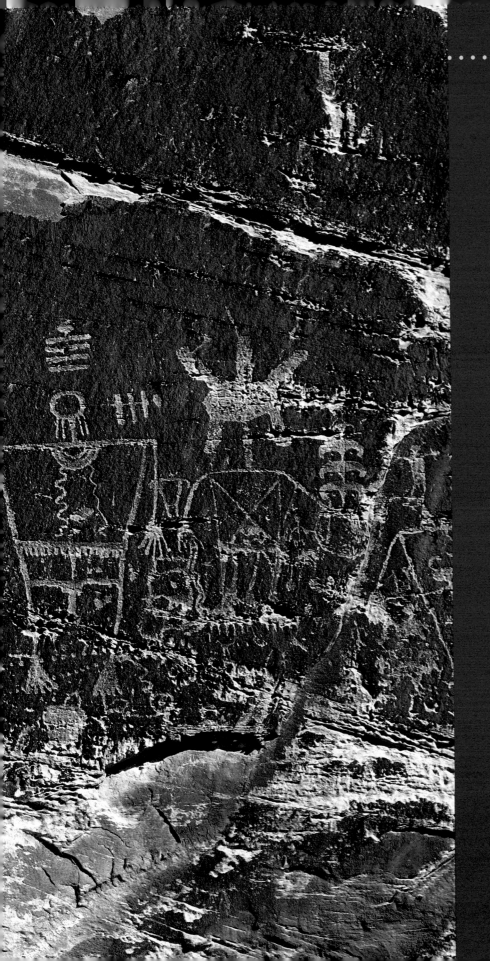

FREMONT ORIGINS

Basketmaker petroglyph panel, Butler Wash,
San Juan River, Utah.

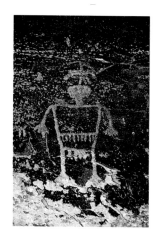

San Juan Basketmaker style anthropomorph near Bluff, Utah.

Fremont basket from Mantle's Cave, Castle Park, Dinosaur National Monument, Colorado. Collections of the University of Colorado Museum of Natural History, Boulder.

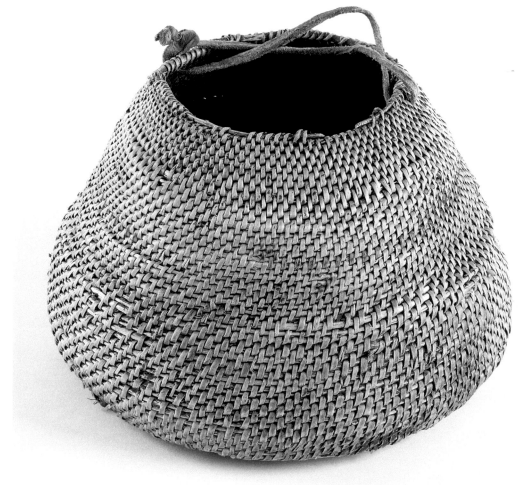

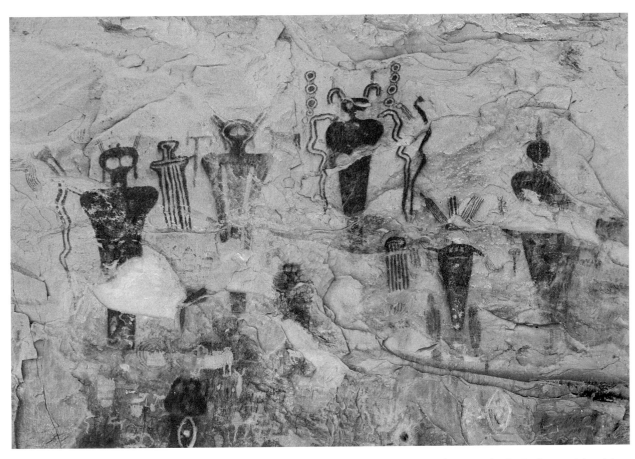

Barrier Canyon style rock art, Thompson Wash–Sego Canyon, Utah. This is just the central portion of an extensive Barrier Canyon style painting in Sego Canyon. The figures with bulging eyes are surrounded by snakes and flying entities. Other rock art panels nearby display Fremont anthropomorphs in red paint and petroglyphs of classic anthropomorphs in costume and a hunter wielding a bow and arrow in an encounter with bighorn sheep. The images are similar in concept and execution to Fremont rock art in Nine Mile Canyon and south onto the San Rafael Swell. On one Sego Canyon panel (see page 91), Fremont anthropomorphs were pecked just below a line of Barrier Canyon figures in red paint and show some superposition that was noted by Noel Morss (1931)—a case of Fremont rock art succeeding Barrier Canyon rock art.

Archaeologists have long debated whether the Fremont arose from an Archaic base with a few southwestern traits that diffused northward, or more directly from a northward migration of southwestern farmers. Both are true to some extent, but when the discussion is framed as alternatives, something is lost. There are several aspects of Fremont origins that will help us understand how their rock art conveys a sense of their cultural heritage.[27]

First, the origins of the Fremont cannot be understood as an event. It was a process that played out over centuries. The process began in a frontier setting around A.D. 0, perhaps before. A sprinkling of farming outposts

in the early centuries A.D. were inhabited by immigrant and indigenous peoples, and the Fremont culture became regionally apparent after about A.D. 500. The Fremont persisted as a recognizable unit for the next eight centuries before change again transformed Fremont culture into something new. The origins of the Fremont thus span at least five centuries—hardly an event—and the full span of Fremont history rivals that of Europe in temporal scale.

Second, the Fremont cannot be understood as a unitary phenomenon because it involves a diversity of indigenous Archaic foragers encountering immigrants. The Fremont culture was borne of encounters between culturally

diverse peoples—what anthropologists call "cultural Others." Indigenous Archaic foragers provided continuities evident in Fremont material culture, including rock art and basketry. But the lifestyles and the ethnic and linguistic groupings of these Archaic foragers likely varied considerably across the huge region that would eventually become Fremont. The Archaic foragers were not all of a cloth; thus local populations of foragers had their own encounters with the great changes that eventually led to the Fremont.

Third, a significant element of Fremont origins resulted from the explosion of farming populations in the Southwest over the past three thousand years or more. This was not necessarily a wave of advance of entire peoples spreading north from Arizona and New Mexico. It is more likely that individuals, probably mostly males, immigrated during the early frontier phase, followed centuries later by small bands of colonist farmers. Rather than replacing the indigenous foragers, the immigrants would have transformed them through cultural contact. The immigrants, too, would have been transformed and perhaps remained tied to their southwestern ancestors only mythically. The immigrants of the early centuries A.D. were few in number and far away from homelands that became dimmer in memory as the centuries passed.[28]

The Fremont is thus a novel culture borne of indigenous roots, of immigrant populations, and of change to all. The Fremont's Archaic root is a transformed heritage. The Fremont were not remnant Archaic. The southwestern root of the Fremont was also a transformed heritage. The Fremont did not descend from the Anasazi, nor from any of their historical descendants, such as the Hopi, Zuni, or Rio Grande Pueblos. The Fremont descended from the *ancestors* of the Anasazi, and the gulf between them may be as significant as are the complex connections among ancestral Native American heritages. To know the origins of the Fremont and the paths it took, we need to know the ancient Archaic of Utah and the Basketmaker II of the Southwest in the early centuries B.C.

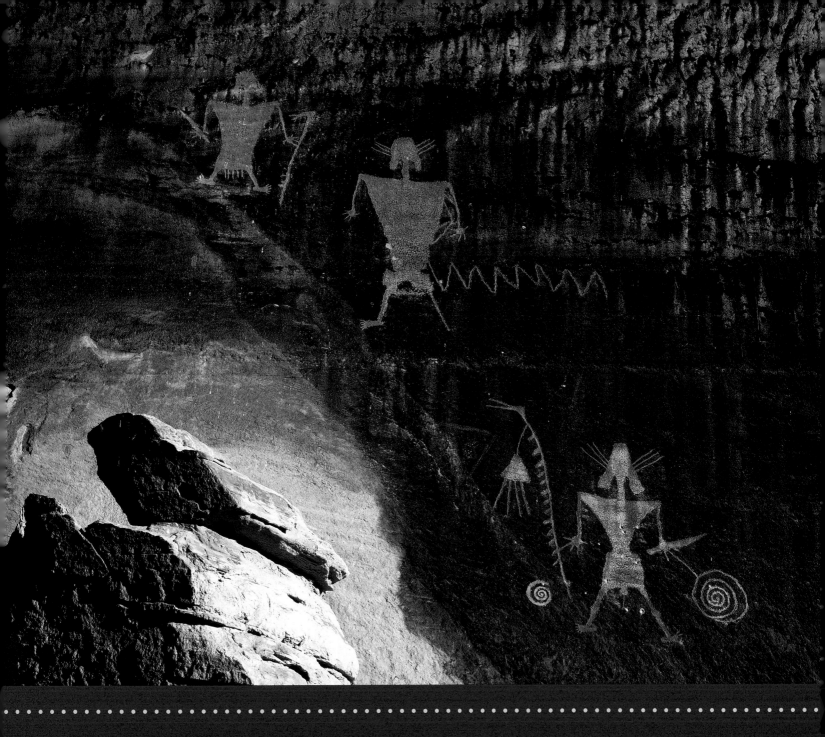

THE FREMONT FRONTIER

Anthropomorphs, Glade Park, Colorado. These nearly life-sized figures were pecked into the rock at one of the few Fremont sites
located southeast of the Colorado River. Two figures wield daggers and bird-headed staffs. The staff held by the lower figure is fringed,
and a bag dangles from the bird's neck. This staff is similar to one found at a Basketmaker II site in Arizona.

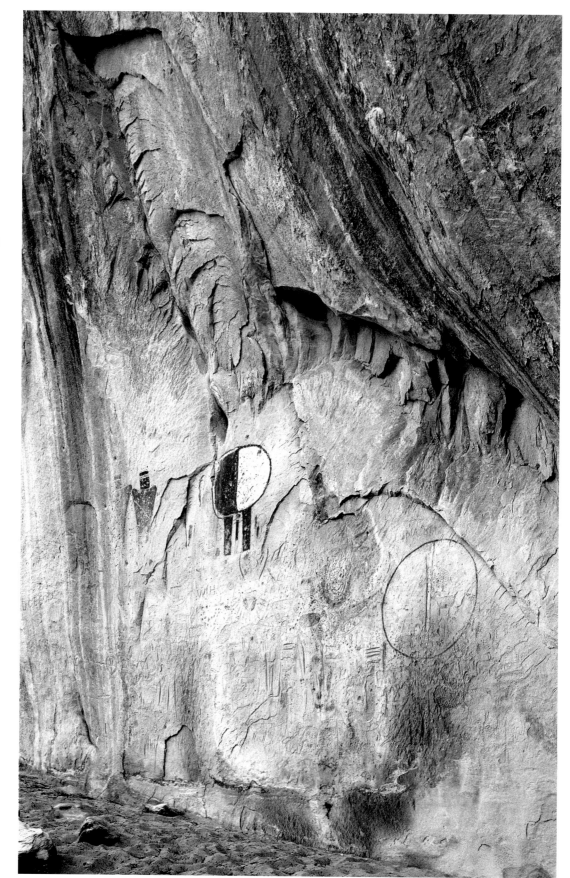

Rock art panel, Fish Creek Cove, near Torrey, Utah. Not far from Capitol Reef National Park and well within what most would consider Fremont country, this panel evokes strong southwestern elements and reminds us that both Fremont and Anasazi cultural waves shaped the area's archaeology.

People were farming in southern Arizona after 2000 B.C. Farming spread north into the Four Corners of the Southwest after pausing for centuries as maize adapted to the higher elevations and shorter growing season of the Colorado Plateau. The Basketmaker II cultures developed on the Colorado Plateau after about 1000 B.C. Once thought to be marginal farmers who mostly foraged for wild foods, it is now clear that Basketmaker populations grew increasingly reliant on maize after 500 B.C.[29]

There is evidence that Basketmakers were ethnically and linguistically diverse. The Eastern "Durango" Basketmakers may have been largely indigenous Archaic populations who adopted farming in northwestern New Mexico and southwestern Colorado as a result of contact with, and perhaps immigration of, farmers south of the Colorado Plateau. The Western "White Dog" Basketmakers may have been rooted even more in immigrant farmers moving up onto the Colorado Plateau from the well-established farming communities in central and southern Arizona.[30] Everyone was influenced by the long presence of farming in the American Southwest, and by the population growth and migrations it spawned.

The details of all this remain elusive, but it is clear that Basketmaker II people occupied the high mesas and canyons of the Four Corners region. The geographic limits of the Basketmaker II peoples were the slickrock canyons north of the Colorado River and the vast, uncharted northern Colorado Plateau of eastern Utah and western Colorado.

The Basketmakers were southwestern not only by virtue of their farming, but in their use of pottery and bell-shaped storage pits, their style of burials, their clothing and adornment, and their use of pithouses for residence. Their rock art was the symbolic foundation of the flourishing that would follow at different times among the Anasazi of Chaco, Mesa Verde, and Kayenta—and among the Fremont.

It is the diversity among the Basketmakers that is important to understanding their relationship to what would become Fremont. Along Glen Canyon of the Colorado River, the distinction between White Dog Basketmakers and the Archaic foragers to the north is relatively sharp. The projectile points differ, and a boundary is apparent in the differential adoption of the bow and arrow. There are also signs of conflict. Their use of defensive locations, the presence of scalp stretchers, and even a few cases of scalped skulls corroborate with rock art that occasionally depicts trophy skulls, scalping, and, according to some interpretations, masks made of human scalps, such as the case of a scalp mask found adorning a head in an actual Basketmaker II burial.[31]

Another significant contrast between Basketmaker II and the peoples north of the Colorado River is their basketry. The White Dog Basketmakers employed a southwestern approach to making a coiled basket using a two-rod foundation for each coil. The Archaic peoples to the north, who would become Fremont, used a single rod and had done so for thousands of years. The White Dog Basketmakers were not only newcomer explorers,

colonists, and farmers, they were an Other, different in both heritage and language.

The Durango Basketmakers, still poorly understood, were of indigenous roots. Northwestern New Mexico and southwestern Colorado may have been a region where maize farming was adopted by indigenous peoples. Perhaps the pause in the northward spread of farming caused by the higher elevations slowed the flow of immigrants enough to allow the indigenous populations to take on farming without completely losing their Archaic heritage. The Eastern Basketmaker II fiber technology was similar to that of the indigenes, and the yet-to-come Fremont, in using a single-rod and sometimes a half-rod foundation in their coiled baskets. Their projectile points showed more similarity too. Nevertheless, the Durango Basketmakers remained an Other, in contrast to the indigenous foragers to the north. Farming made them different.[32]

Farming populations eventually pressed northward because farming is a population centrifuge. The endless cycle of surplus production and inevitable shortages ensures two things. Population would have increased until times of shortage, causing people to invest more labor into the system or to colonize new places. Wherever farming is found in the world, it spreads to its limits.[33]

About two thousand years ago, or perhaps earlier, what would become Fremont country was a frontier of explorers and entrepreneurs. Typically these were largely individuals or small groups of males marginalized from their own societies. The frontier brought opportunities to the Archaic foragers to barter in everything from exotic stone to medicinal plants that were strange but attractive to the newcomers, and to meat from large game that the indigenes knew best where, when, and how to hunt. In turn, the Basketmaker frontiersmen brought connection to a larger world to the south; although they were intruders, they offered the seduction of a larger Native American world. They also brought change as immigrant men appropriated or married indigenous women and disrupted the indigenous cultures, even as the Basketmakers themselves became integrated into the frontier life.

Inevitably, the farming populations south of the Colorado River sent forth small groups of colonists. Families and groups of families would have sought the best places to establish outposts in what by the early centuries A.D. had already become the Fremont frontier. It was perhaps well-known enough that some colonists had heard of the best places to settle in the new country. Perhaps the Steinaker Gap site, near Vernal, occupied by A.D. 250, is one such case. Occasional Basketmaker-like burials found in such places as Nine Mile Canyon indicate the same, as do some sites along the base of the Book Cliffs near Thompson and in the San Rafael Swell.[34]

These outposts would have added pressure to the landscape, causing some indigenous foragers to turn to farming. These immigrants and indigenes shared the landscape, perhaps not always amicably, and together formed the Fremont. This is how the Fremont were borne of the deeply indigenous peoples of the Archaic period and yet at the same time were the "Fremont of the Southwest."[35]

FREMONT ROCK ART

McConkie Ranch, Dry Fork, near Vernal, Utah. The extensive Sun Carrier panel is prominently displayed
on a sandstone pillar about two-thirds the way up the cliffs from the canyon bottom.

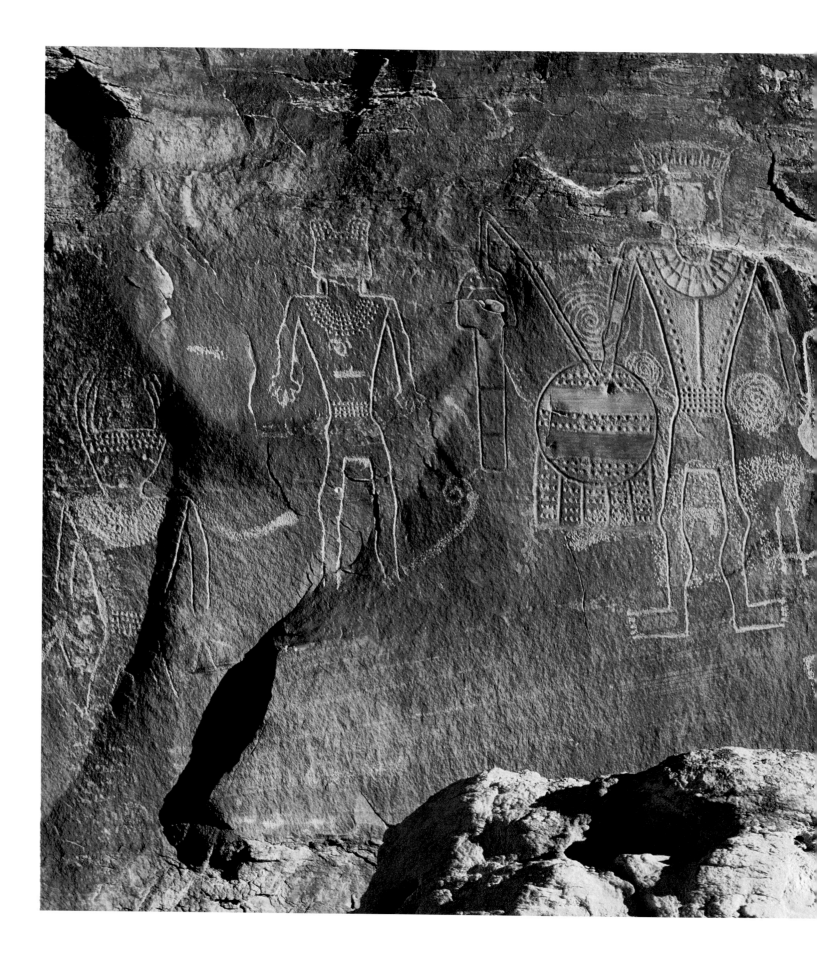

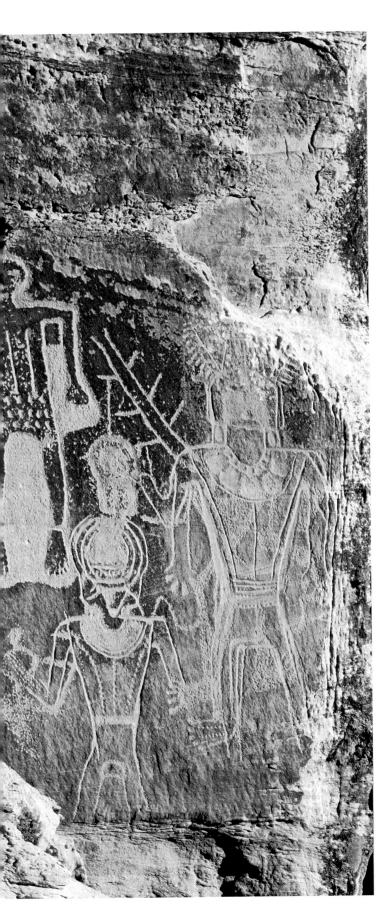

The Sun Carrier panel, McConkie Ranch, Dry Fork, near Vernal, Utah. This grouping of images is also referred to as the Three Kings panel.

Rock art is one element of a Fremont "social geography." It offers a glimpse of the agency of individuals who did not act alone but were instead part of a social fabric that for the Fremont included a worldview that extended beyond the household and the family. Nor is rock art just about the makers and the meaning it held for them. This is because rock art remains meaningful on time scales that transcend the lives of individuals. Indeed, the initial intent fades and the importance of the maker diminishes as future users and caretakers construct the meaning of rock art for their own times. Rock art does not passively reflect a meaning, but is a vehicle used to construct meaning as history proceeds.

Systematic study of the locations of southern Utah rock art suggests that staggering numbers of diverse glyphs on boulders may be landmarks containing spatial information. Rock art can be produced in the course of everyday activities, and the imagery can vary with the diversity and frequency of these activities. Images in rock shelters tend to be more redundant, if only because the activities that occurred in those places were less diverse than in all the other places where rock art was made.[36]

Some rock art is monumental and stunningly executed. One interpretation is that such rock art may in some instances reflect the social influence of individuals, either directly or through control of the labor of exceptional artists. This view of rock art as "prestige technology" suggests a possible role in the maintenance of status and power among leaders.[37]

In a broader sense, rock art represents more than individual artists and spiritual experiences. The very social

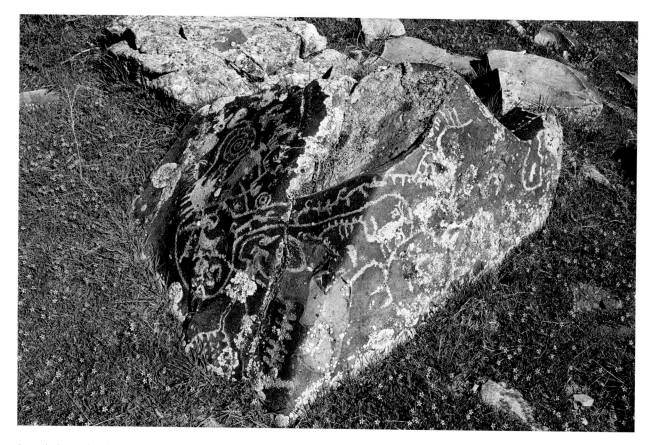

Petroglyph panel on boulder, Connor Spring rock art site, near Corinne, Utah.

contexts that shaped the perceptions of the individual artists were borne of the interaction of everyday circumstance and a worldview shaped by heritage. Thus, rock art is not reducible to the idiosyncrasy of individual artists, nor is it a distinct phenomenon that can be interpreted apart from culture, behavior, or time.

A variety of named styles organize the description of rock art themes and variations in terms of geography and culture history. Fremont rock art styles include the Classic Vernal style, the Northern and Southern San Rafael styles, the Sevier style, and the Great Basin Curvilinear style. Other styles relevant to comprehending Fremont heritage include Barrier Canyon, San Juan Basketmaker, Abajo–La Sal, and Uncompahgre.[38]

Rock art styles help us to see heritage and commonalities of perception. It perhaps stands with basketry as a relatively plentiful material referent of ethnicity—something otherwise difficult to perceive in archaeology. Nevertheless, style is not fixed into distinct groups with sharp boundaries. Style varies continuously and is best used as a guide to the threads of heritage in a pliable social fabric. Fremont rock art styles are not cultural badges of neatly demarcated ethnic and language groups. Indeed, in the Fremont social tapestry proposed here, such boundaries would have been so entwined, and the histories of peoples so variously woven, that it would be futile to seek such crisp categorizations in the archaeology. Nevertheless, rock art signals something about culture and heritage—a Fremont heritage that was diverse, temporally deep, and transformed.

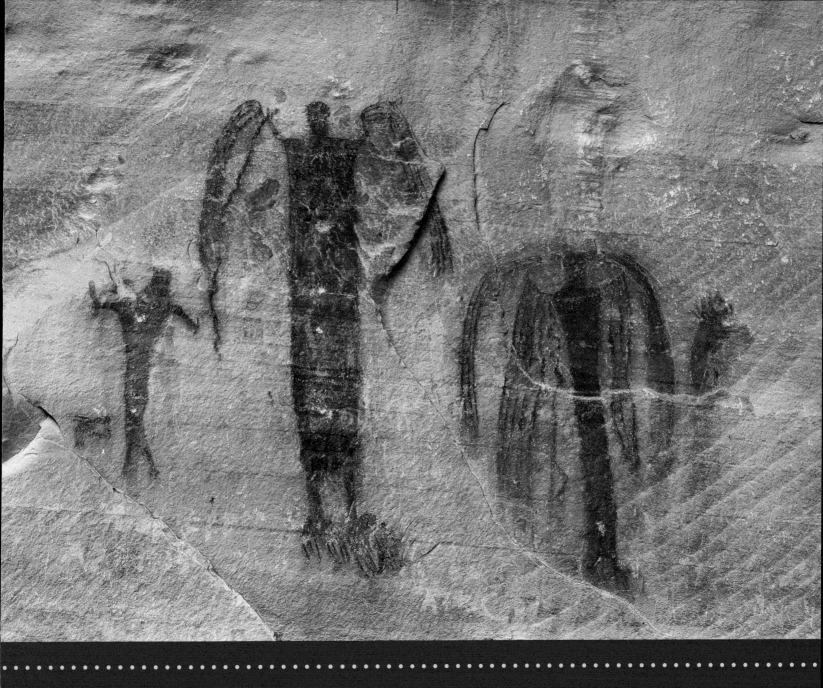

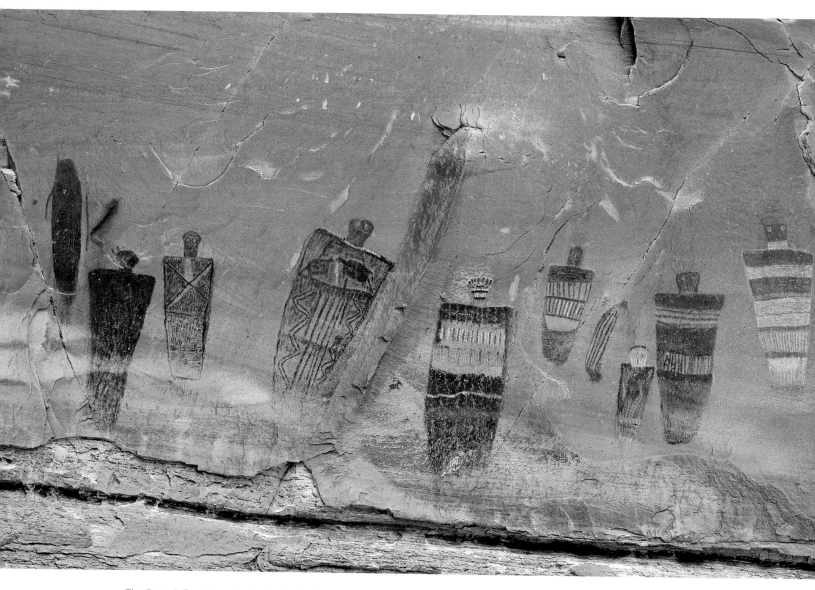

The Great Gallery, Canyonlands National Park, Utah. Barrier Canyon style figures, the largest of which are about life size.

The transformations of diverse heritages that be-came Fremont are apparent in the rock art. The mysterious Barrier Canyon style stretches along the tributaries of the Colorado River through the Canyonlands and San Rafael Swell of Utah, and south of the river into north-central Arizona. Barrier Canyon rock art is best known for the large ghost or mummy-like painted anthropomorphs with tapered bodies, although the style includes a variety of forms, and some are pecked. Barrier Canyon panels are often highly organized, and some were added to over time in formal ways, indicating a chain of heritage.

The Barrier Canyon style is just one of several representational styles across the Southwest and southern Plains that originated sometime during the Archaic. Just how old some Barrier Canyon images might be remains murky, but there is consensus that the style continued at least into the time of the Fremont frontier, between A.D. 0 and 500.

Some panels appear to be the work of a single artist, and the quality suggests that their production was in the hands of specialists who may have been influential individuals. In some instances, Barrier Canyon paintings were

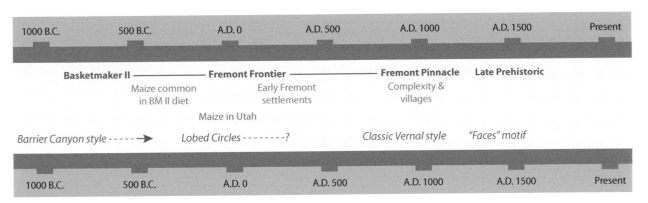

1000 B.C.	500 B.C.	A.D. 0	A.D. 500	A.D. 1000	A.D. 1500	Present

Basketmaker II ——————— **Fremont Frontier** ——————— **Fremont Pinnacle** **Late Prehistoric**

Maize common in BM II diet · Early Fremont settlements · Complexity & villages

Maize in Utah

Barrier Canyon style - - - - -→ · *Lobed Circles* - - - - - - - -? · *Classic Vernal style* · *"Faces" motif*

1000 B.C.	500 B.C.	A.D. 0	A.D. 500	A.D. 1000	A.D. 1500	Present

Chronological chart of archaeological periods, events, and selected rock art styles (blue italics). Courtesy of Nancy Kay Harrison.

intentionally obliterated and reproduced. In other cases, Barrier Canyon elements are superimposed by later, distinctive Fremont rock art.

The Barrier Canyon style is distinct from what would become Fremont rock art, but nevertheless signals the Archaic threads of the Fremont.[39] The motifs and execution of Barrier Canyon rock art also represent an important element of the supernatural world: shamanism. Although it is not a blanket explanation for Fremont rock art, shamanism was embedded in the complex Fremont social and ideological world.

Other Archaic rock art traditions found in the Great Basin include both representational and curvilinear styles. The abstract elements of these styles include wavy lines, spirals, circles, the maze, enclosed areas with lines, and geometrics. Representational elements include snakes, birds, and especially deer and bighorn sheep. The Great Basin Representational and Great Basin Curvilinear styles of rock art are deeply Archaic and span an enormous region, from the Mojave Desert of southern California across

Nevada to the western third of Utah. Although so generic and variable as to be expected everywhere in some form, these styles also reflect the persistence of Archaic heritage in the Fremont.

Like the Barrier Canyon style, the rock art styles of Great Basin Archaic period hunter-gatherers represent elements of a supernatural world that would carry forth into other, later styles. These elements are again shamanism, especially vision questing, hunting magic, and an animistic world in which spirits may harbor in plants, animals, objects, and places. These are not mutually exclusive, and they too are woven through the Fremont social and ideological world.

Perhaps the most directly influential rock art for considering Fremont origins is the San Juan Basketmaker style. The Basketmaker II period began as early as 1000 B.C. and was strongly present by 500 B.C., marked by the first agricultural populations of the Colorado Plateau. Basketmaker II rock art includes petroglyphs and pictographs, is decidedly representational, and shows

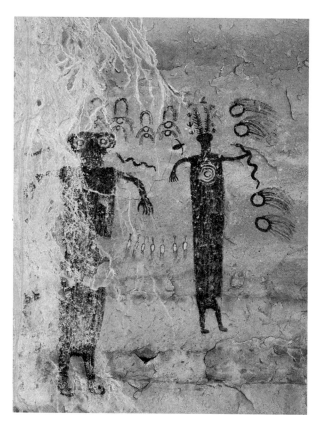

Head of Sinbad, San Rafael Swell, Utah. This panel shows characteristics of the Barrier Canyon style, featuring ghostly, elongated anthropomorphs with bulging eyes accompanied by snakes, birds, and other, unknown flying entities.

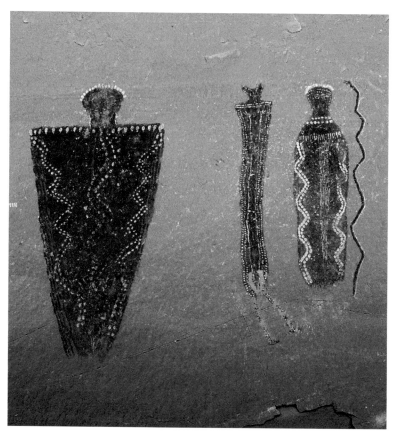

The Perfect panel, Glen Canyon National Recreation Area, Utah. This panel is an example of Barrier Canyon style. The figure on the left is 1.5 meters high.

consistency in attributes south of the Colorado River, across what would become the southern Fremont frontier.

The style features anthropomorphs with broad, square shoulders, tapered and rectangular bodies, often ornamented, and heads often depicted with headdresses and masks. The anthropomorphs are frequently arranged in rows. They are symbolic rather than naturalistic depictions, but some are so personalized as to imply realistic individuals.[40] Some Basketmaker rock art seems to depict scenes, implying an entwining of mythical stories, actual events, and social memory. The individualism implied by some of the anthropomorphs is enveloped in the mythical, the past, and the present.

The lobed circle/keyhole-shaped image is typically ascribed to Basketmaker times, although the dating of

this motif, like that of much rock art, is weak. The lobed circle is found well north of the Basketmaker cultures, extending across northeastern Utah and into northwestern Colorado—Fremont country. One interpretation is that the lobed circle refers to the uterus as a metaphor for fertility where it occurs in various contexts among early southwestern cultures.[41]

Although some Basketmaker representations, such as the lobed circle, diminished in presence, others persisted for centuries in Anasazi and Fremont societies. These include birds, snakes, bighorn sheep, stick figures, hand prints, fringed wands, and humpbacked flute players. Some imagery is the work of individual artists, but while some of the rock art may have been in the hands of ritual specialists, the variability in quality and forms suggests diversity in the contexts of its production. The argument for some degree of Fremont social complexity directs us

Pictographs, Range Creek, Utah. Barrier Canyon style figures overlook the canyon.

to forces beyond individual agents guiding the production of rock art, and proposes that the role of rock art among the Fremont changed from that of similar motifs in Basketmaker II.

An interesting facet of Basketmaker II rock art is the interpretation that some of it depicts masks. Masking is important to Pueblo societies of the Historic period and consistent with the nature of corporate groups. The donning of masks while performing rituals transforms the individuals into something societal, much in the same way that corporate group structure makes individual leaders faceless in contexts where they represent a collective. Masking may imply the process where the shift to farming, larger populations, and residential cycling

began to transform leadership and group organization in such a way that individuals remained agents, but increasingly lived in a complex and ritualized society requiring at least episodic leadership at higher levels. The process was just beginning in Basketmaker II times, and the contexts of rock art production changed in the more complex Fremont and Anasazi periods, maintaining but transforming the heritage.[42]

Basketmaker II rock art depicts scalplike subjects and related ornaments. Then there are the finds of circular wood and fiber frames known to be used for stretching scalps to prepare them for ritual use. Some rock art depicts figures holding scalps, or faces decorated to represent scalping.

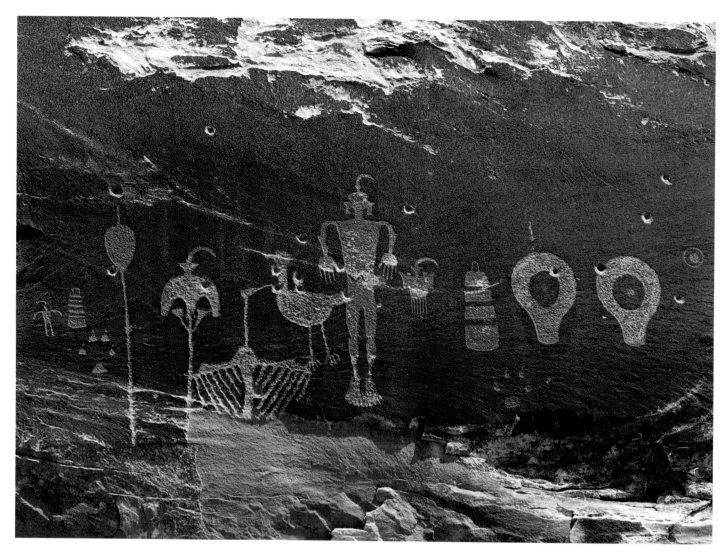

The Wolf Man panel, Butler Wash, near Bluff, Utah. This panel is an example of the San Juan Basketmaker style. Note the lobed circles at the right.

Anthropomorph, Sand Island Recreation Area, near Bluff, Utah. This image shows the foundational affinities of the San Juan Basketmaker style with Fremont anthropomorphs, as well as differences suggesting the distinctive heritage of Fremont.

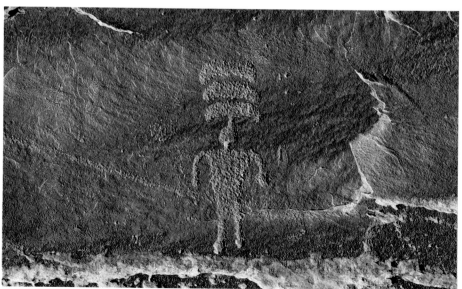

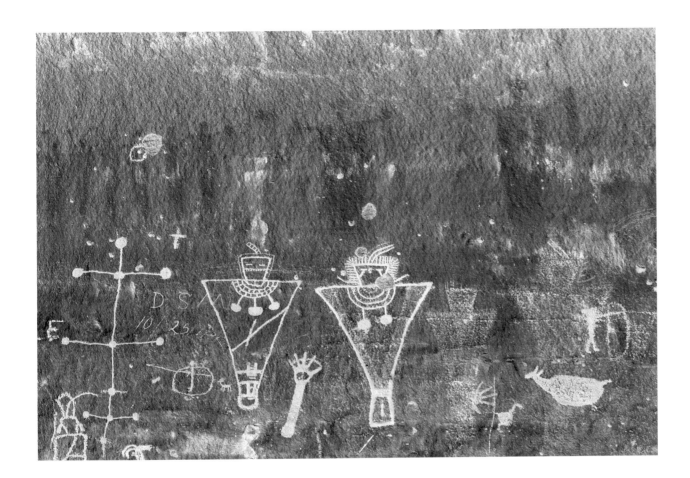

Basketmaker II farms were small and sprinkled along the Colorado River frontier. That frontier was populated by indigenes and immigrants, and would eventually transform into the Fremont. Like frontiers everywhere, conflicts of interest were inherent and at times led to violence. The bow and arrow—a technology that accompanied organized violence among groups of combatants, not just individual adversaries—spread into southern Utah in the first century A.D.

Frontiers produce social memories, and it is important to remember that in Native American religions, themes of warfare and violence, represented by trophies and scalps, are sometimes superimposed on broader spiritual issues. In the historical Southwest, scalps were tools to bring rain and promote abundance from agriculture and nature. Like the stories of the wild American frontier of the nineteenth century, experiences became myths, which in turn transformed those experiences into symbols.[43]

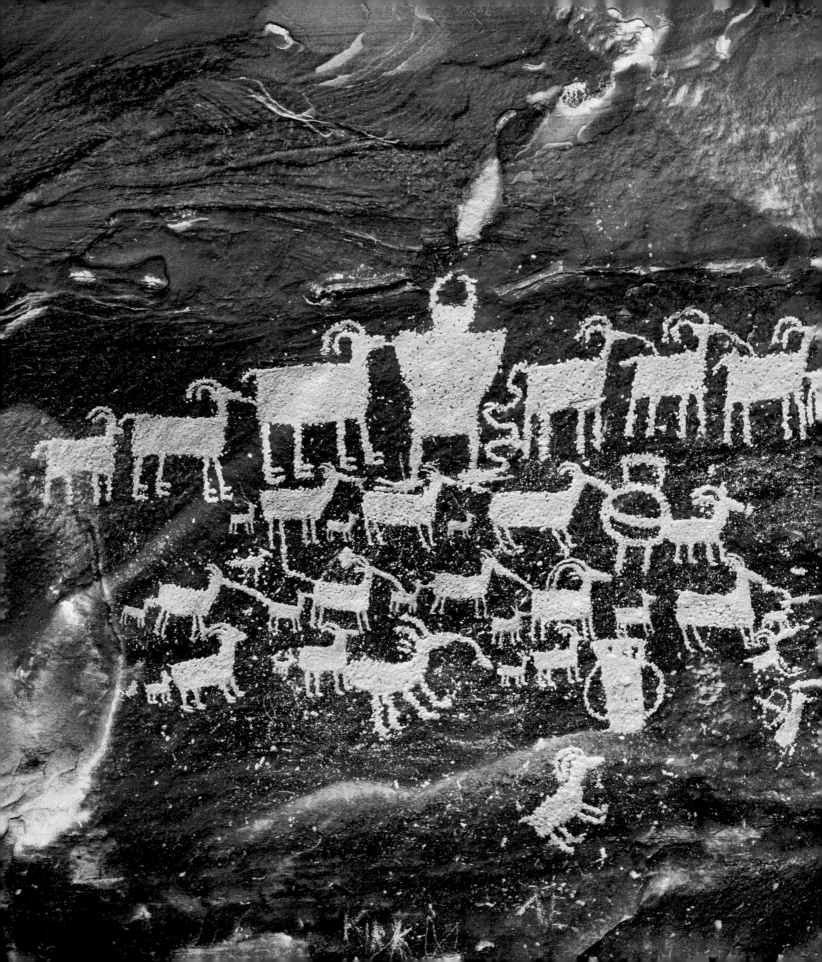

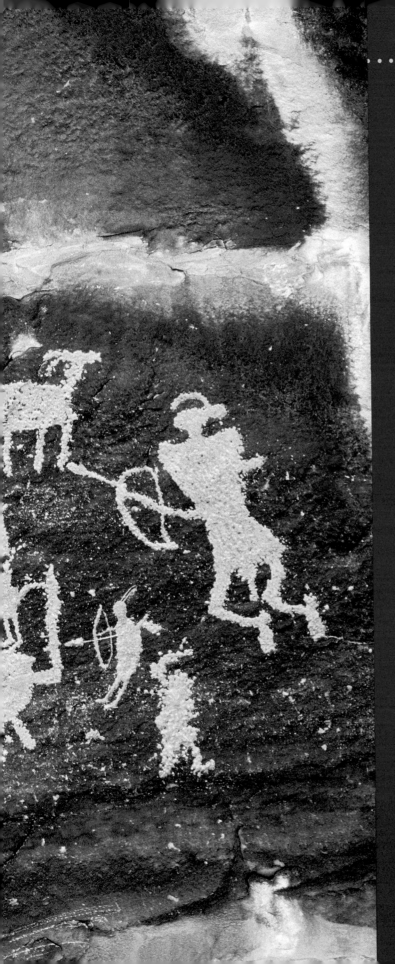

FREMONT ROCK ART:
THEMES, UNITY, AND VARIATION

Petroglyph panel in Cottonwood Canyon near the junction with Nine Mile
Canyon, Utah. This extraordinary panel depicts a herd of sheep during
the migration from the high country in the fall, the only season when rams join
the rest of the herd. Hunters, some wearing disguises, wait for the sheep.
The horned figure in the top row is often interpreted as a shaman.
Ethnographic sources indicate that such a person can bring spiritual
assistance to a hunt, be a hunt leader, or both.

Rock art panel, McKee Springs Wash, Dinosaur National Monument, Colorado. Two anthropomorphs are linked by a spiral or shieldlike object and hold trophy heads.

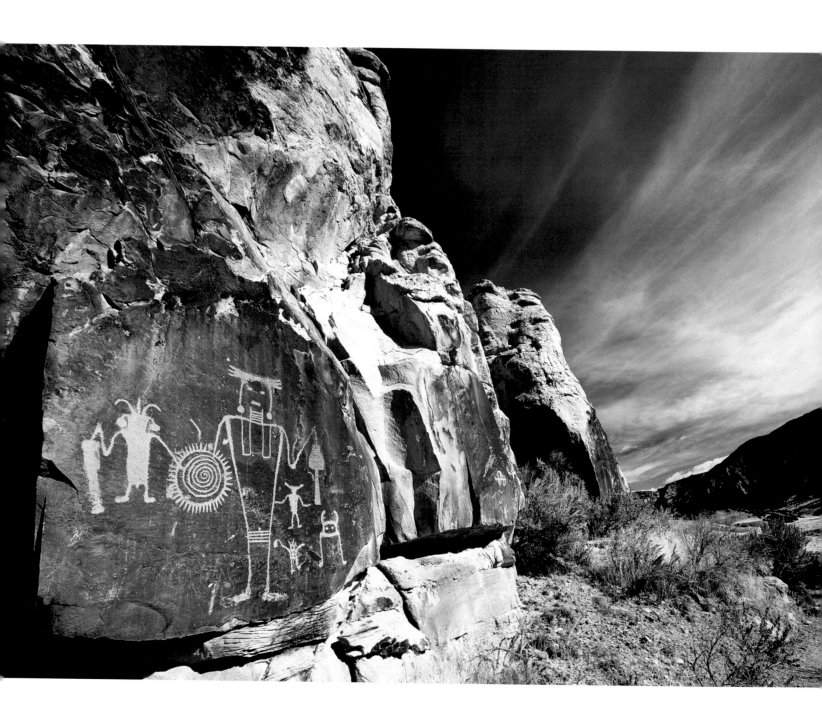

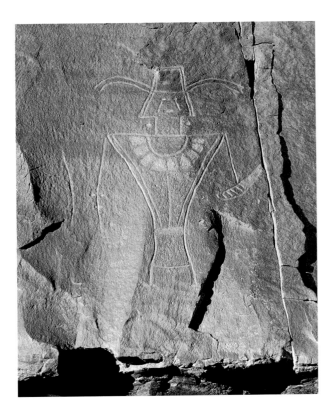

A detailed example of a Fremont anthropomorph of the Classic Vernal style, McConkie Ranch, Dry Fork, near Vernal, Utah. The triangular body is emphasized by its pose, facing the viewer. In similar images, the helmetlike headdress often features flares upward or to the side. Most figures depicted in this style wear a semicircular necklace of pendants that sometimes appears more like a breastplate. Ear ornaments are common. The figures often carry a weapon. This anthropomorph occurs alone, but on another part of the same cliff it is nearly replicated (from the chest up). There, however, it is portrayed among several other, less-decorated figures, along with a special figure known as "Bigfoot" because of its exaggerated feet (see page 61). The tension between standardized costume and individuality makes it difficult to know whether the image portrays a representative or a particular personage. This panel is particularly interesting in that regard because it is rare to see virtually the same highly decorated and individualized figure depicted on two different panels, but on the same cliff.

Northeastern Utah

Some interpret the San Juan Basketmaker style as foundational to the Fremont, and especially to the Uinta Basin Fremont. The Classic Vernal style is noted for its depictions of heroic figures in highly organized scenes that are clearly symbolic and strongly mythical. In a Fremont world, such depictions may have been connected to remembered events and revered ancestors, and thus seen as living history. The most famous examples of the Classic Vernal style employ themes of conflict and displays of bloodshed, trophy taking, and scalping. Actual scalps have been found in Nine Mile Canyon burials.

Painted shield images are also the most common in Uinta Basin Fremont rock art, as is the Weeping Eye motif. Shields and the Weeping Eye are widespread over the Plains and spill into the Basin-Plateau region. Many date after A.D. 1300, hence into Late Prehistoric and Protohistoric times. Shields are often thought to represent warfare. The Weeping Eye motif is an example of symbolism that stretches across diverse cultural boundaries, with variations found even in the Eastern Woodland cultures. These examples remind us that the symbolism found in rock art can reflect continental scales of Native American cosmology and consequent iconography.[44]

The warrior scenes of the Classic Vernal style are more than representations of battles and individual heroes, and more than narrative history. The context of Fremont socioreligious organization reminds us that debates over whether these individuals were real or not miss the point that living personages justified their influence through ritualized power, mediating communities variously in alliance and competition.

Shield figures, McConkie Ranch, Dry Fork, near Vernal, Utah. Two formal shield figures face each other on perpendicular panels, and other anthropomorphs were added later. The left wall is covered with petroglyphs to a height of over six meters. At the bottom is a Classic Vernal style figure with a necklace. Another one to the left is depicted as a tall silhouette of sweeping, curved lines. Near the top left are the "Conjoined Twins"; although joined at the shoulder and requiring only two legs, they remain individuals.

The Great Shield panel, Ashley Creek, near Vernal, Utah. This petroglyph contains one of the most elaborate shield images in the Uinta Basin area. It is held by an anthropomorph with distinctive body decoration.

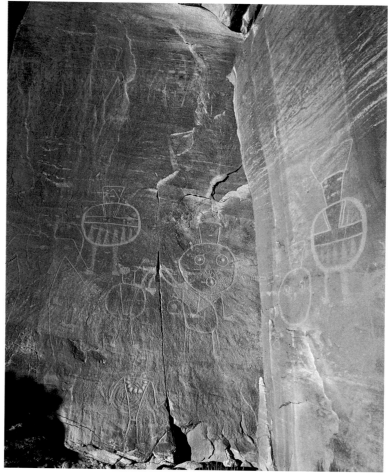

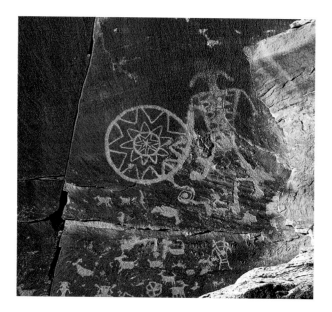

The much discussed phenomenon of shamanism is thought to underlie some rock art symbolism; however, the Classic Vernal style signals that Fremont rock art has layers of meaning beyond individual shamanism. Although shamanism exists among socially complex hunter-gatherer societies, and in the Historic period southwestern cultures, in those cases it is embedded under layers of organization that supersede the individual. To the extent that Fremont rock art is shamanistic, then it tells us about one facet of Fremont society—perhaps a role similar to Anasazi rock art, which does not fully represent Anasazi social and ideological organization.

The Fremont rock art of the Uinta Basin is significant in two ways. First, the best candidate for Basketmaker II immigration to the Fremont frontier by A.D. 300 is the region of eastern Utah and western Colorado. This immigration would have laid the foundation for the Fremont variant long recognized as strongly southwestern. Second, that legacy would reappear in the later, Classic Vernal rock art style, probably timed with Uinta Fremont population peaks between A.D. 650–800 and 950–1050. Burials from this period exhibit the most southwestern-looking cranial characteristics and stand apart as a group from other Fremont populations. Some Uinta Basin burials exhibit cranial deformation caused by binding infants to cradle boards. This trait is absent from the Archaic and from Basketmaker II, but is found in some Anasazi populations of the same period as Uinta Fremont. Cranial deformation is virtually absent in other Fremont populations, except for those in the Great Salt Lake region, where it occurs in low frequency.[45]

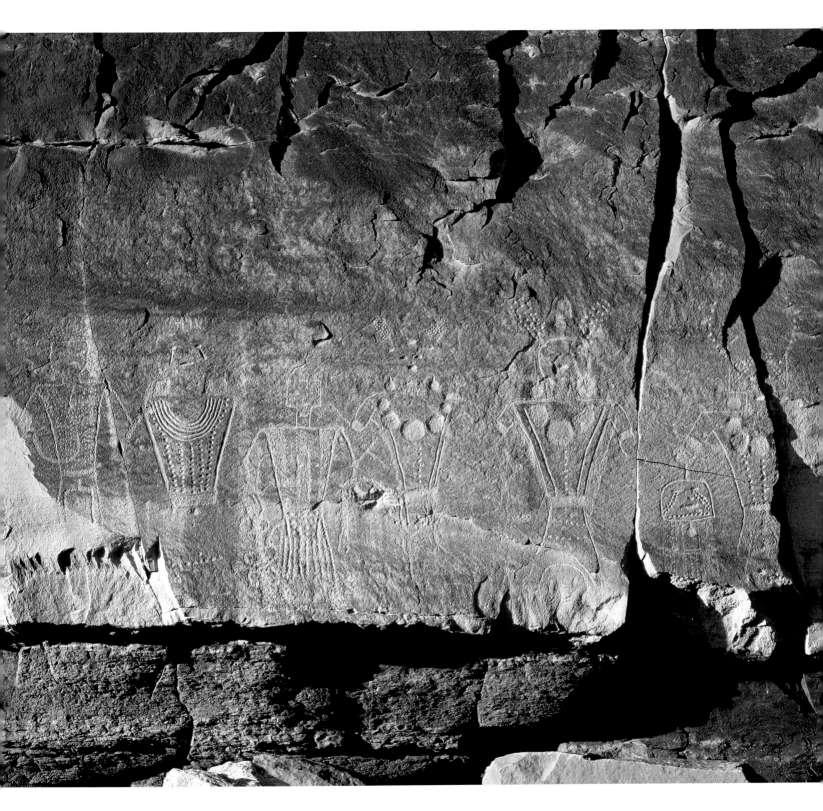

Classic Vernal style panel, McConkie Ranch, Dry Fork, Vernal, Utah. Another theme in the Classic Vernal style is the display of trophy heads. The figure on the right holds a trophy head that drips blood. Old photographs show that the scene once portrayed the dripping blood forming a pool in a depression on the ground. The scar in the rock is plainly visible where this part of the panel broke away sometime after 1928.

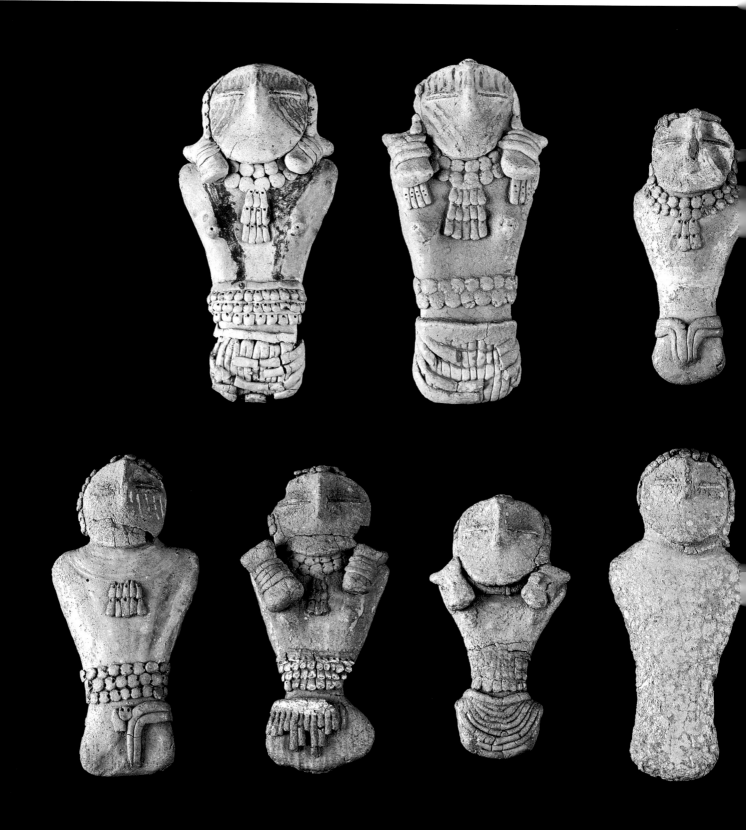

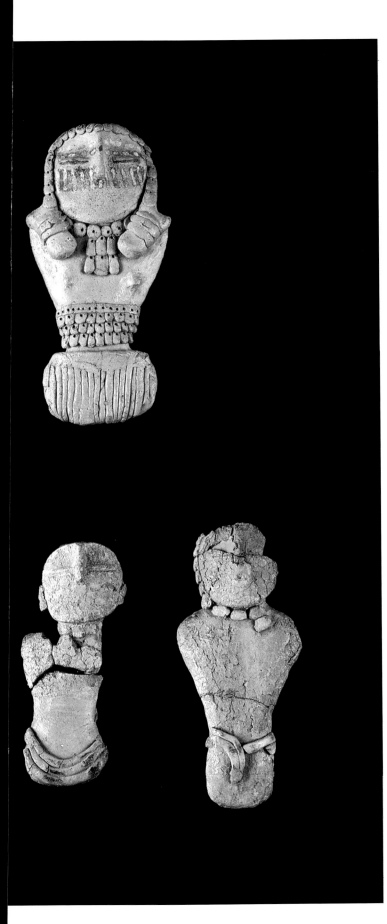

Fremont rock art in other parts of Utah reflects both the unity of the Fremont, based on a common origin centering on the transition to farming, and the variation that arose from the interaction of immigrants and indigenous peoples on local scales.

Rock art along the Fremont River in central Utah bears resemblance to the Classic Vernal style. Some anthropomorphs of the Southern San Rafael style also reflect the Faces motif. This style features painted anthropomorphs with the same details found on some Fremont figurines scattered across the region, but best represented by the Pilling collection, found on a tributary of Range Creek Canyon near Price. The unbaked clay figurines are detailed with appliqué and painted in red, buff, blue, and black paints. Together with the rock art, the Pilling figurines provide clues to ornamentation. Some figures wear necklaces of teardrop-shaped, polished stones, some of which are found in archaeological collections (sometimes mistakenly labeled as fishing net weights). Other pendants were possibly made of leather, bone, or wood. Elements of the Faces motif are also found in western Mesa Verde Anasazi architecture and ceramics of the A.D. 1100s and 1200s.

Figurines from the Pilling collection. In 1950, Clarence Pilling, a resident of Price, Utah, discovered eleven Fremont clay figurines on a rock ledge in a small cave in a side canyon of Range Creek, Utah. The figurines were taken for study by Noel Morss to the Peabody Museum of American Archaeology and Ethnology at Harvard University and were later exhibited in various places. When they were finally deposited in the Prehistoric Museum of the College of Eastern Utah in Price, one of them was missing. This photograph shows the surviving ten. The similarities between the figurines and the anthropomorphs depicted in much Fremont rock art are compelling.

Anthropomorphs, Range Creek Canyon, Utah. These figures are strikingly similar to the Pilling figurines, which were found two miles away in a tributary of Range Creek. They are a reminder that the individuality in Fremont anthropomorphs revolves around fundamental themes of cultural style, making the individuals representative of society.

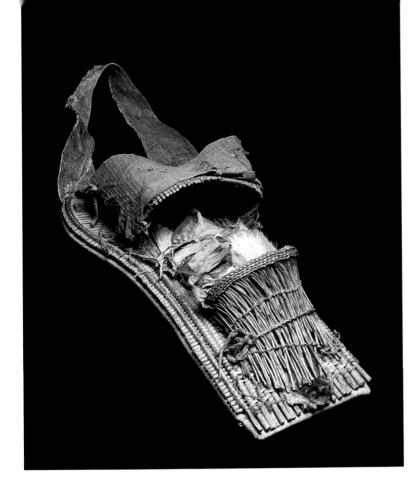

Figurine in cradle board from the Pectol Collection. Perhaps the most spectacular item in the collection is this one-of-a-kind cradle board nestling a Fremont figurine. It was made using willow, rabbitbrush, domesticated cotton, animal pelts, yucca fiber, and clay, and dates to about A.D. 1100. The items in the Pectol Collection came from various archaeological sites. Both the Fremont and the Anasazi occupied the Capitol Reef area. Some of the baskets in the Pectol Collection are distinctively Fremont or Anasazi, but others were made using techniques from both heritages. It is possible that the long apprenticeship of basket weavers exposed them to master weavers from various cultural and ethnic backgrounds.

Like the shield figures, the Faces motif may have persisted through time. An AMS radiocarbon sample from the horns and headdress band of a Faces anthropomorph at Ceremonial Cave in Glen Canyon dated between A.D. 1250 and 1400.[46] The affinity of this Fremont motif with themes from the height of Mesa Verde Anasazi, as well as the persistence of some traits to very late in Fremont times, shows that while the Fremont were distinct from the Anasazi, they were part of a larger southwestern world with elements of common perception and worldview.

A similar situation of affinity and contrast is found in comparisons between the Abajo–La Sal style of southeastern Utah and the Uncompahgre style of western Colorado. In this transitional zone between high desert foragers, the Fremont, and the Anasazi, the rock art sometimes clearly reflects one or another style. In some instances, however, rock art panels, and even individual elements on panels, appear to incorporate different styles.[47]

This transitional, interactive pattern tends to promote discussion of the concepts of "groups," "boundaries," "interaction," and the use of areas by one or another "people." However, bounded terminology and metaphors of interaction may not be the best way to represent the human dynamic represented in the rock art.

Various ethnic and linguistic groups surely occupied this and other regions, and there was likely an ebb and flow of peoples over time. One view is that some rock art signals places of transition, but this is not the same as making rock art a badge of membership in one or another group.

Fremont anthropomorphs, Nine Mile Canyon, Utah. The dominant figure wears a mask reminiscent of a deer-scalp headdress found in the excavation of Mantle's Cave in Dinosaur National Monument, Colorado, and another in the Pectol Collection from the area of Capitol Reef National Park, Utah. This is one of the best representations of such a disguise in all of Fremont rock art. In this depiction, the left hand of the masked individual seems to touch a bighorn sheep, and another bighorn sheep appears to touch its nose to his right shoulder. This photo also shows two of five more anthropomorphs, all in static poses. The small figures at the bottom of the panel are often interpreted as burden bearers, signifying the transport of meat after a hunt.

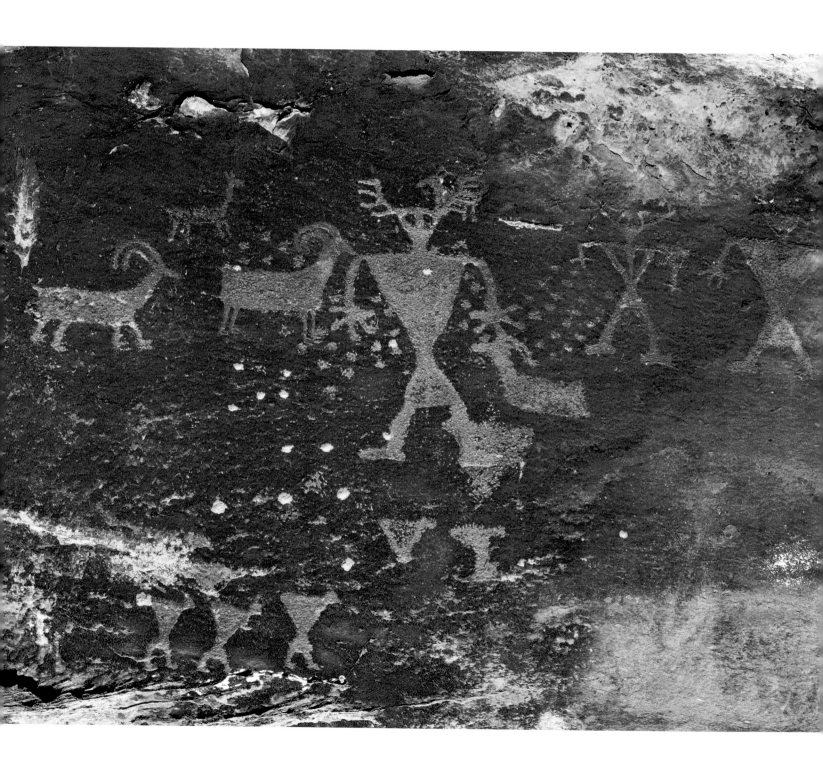

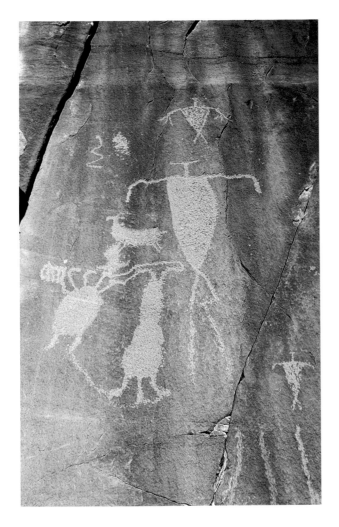

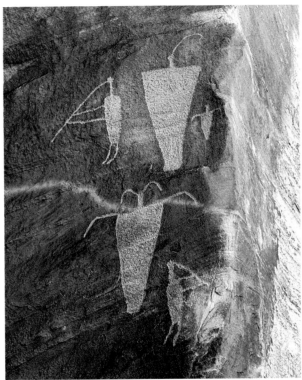

Petroglyph panels, Indian Creek area near Moab, Utah. These two panels represent the Abajo-La Sal style that blends Barrier Canyon style and San Juan Basketmaker style attributes.

It is important to remember that ethnicity and culture are not synonymous. Ethnicity is situational and constructed from elements of culture and cultures. Ethnicity is about identity, and people can move among ethnicities. Communities of economic interdependence and marriage may have been multiethnic and multilingual. The abandonments, migrations, and organized movements that are the stuff of Fremont and Anasazi life entwined and reconfigured heritage. Themes in worldview can traverse the particulars of ethnicity, and the spans of time we see in archaeology and rock art transcend the lives of individual people. My proposal for a greater degree of Fremont social complexity only heightens the expectation for these sorts of group dynamics.

A loose analogy may be the iconography of Christianity and Islam, which is strongly cross-cultural, temporally persistent, and used to mark ties to group and place as much as it is used to cross boundaries of place, language, and ethnicity. All of the borderlands of the Fremont in southern Utah seem to suggest a similar dynamic, as well as distinction from and unity with the spiritual heritage of the Southwest.

Sevier style snake on a basalt boulder along Interstate 70 near Fremont Junction. Noel Morss noted the association between snakes on black boulders and Fremont villages. The Fremont sites of Snake Rock, Old Woman, Poplar Knob, and others are located near this boulder.

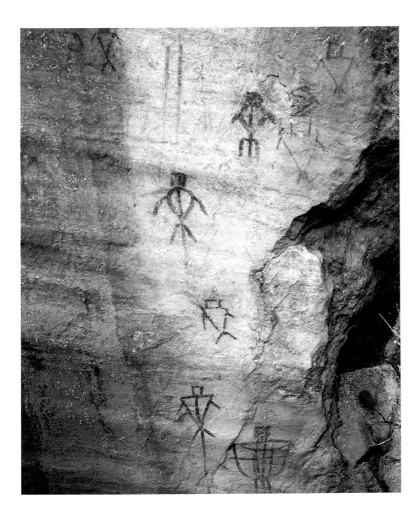

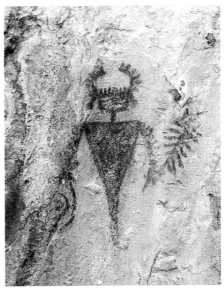

Rock art near Ely, Nevada. A giant boulder is the canvas for these highly stylized figures. These images are less meticulous than much of the rock art on the Colorado Plateau, but the squarish bucket heads and the occasional headdress evoke Fremont. They are small: the boxy figure with legs at lower right is only 28 centimeters high.

Kachina Rock Shelter, eastern Nevada. This elegant figure in red paint is only 32 centimeters high.

Moving to central Utah, the rock art of the West Tavaputs Plateau differs from that found in the Uinta Basin. Anthropomorphs are present but are not portrayed as so heroic and dominant. Much more of the rock art in Nine Mile and Range Creek canyons is abstract, but also includes an abundance of solidly carved representational elements.

One of the most famous rock art panels of Nine Mile Canyon is "the hunting scene"—a highly organized, realistic depiction of bighorn sheep surrounding an anthropomorph wearing a horned headdress disguise, and an attacking hunter wielding a bow and arrow. Other Nine Mile panels also show hunting disguises, such as the famous panel of bighorn sheep with a human figure clearly wearing a mask and headdress. These panels suggest the importance of the hunting "boss" so well documented in Great Basin ethnography. Hunts of different animals were often led by a specialist in that activity who may have had, in addition to charisma and personal skills, a shamanistic relationship with the animal sought. Perhaps the most famous examples in the Great Basin are the "rabbit boss" and "antelope charmer," but shamans also provided spiritual assistance with hunting other animals. Often juxtaposed as alternative explanations for rock art, shamanism, hunting, and sympathetic magic were probably entwined.[48] Not all rock art depicting animals indicates hunting, but neither is it restricted to a lone shaman seeking a relationship with his spirit helpers as an independent and unique spiritual activity. There is a strong social dimension in a collective farming society such as the Fremont, and leadership likely extended well beyond the acts of visionaries, medicine men, and other shamanistic individuals.[49]

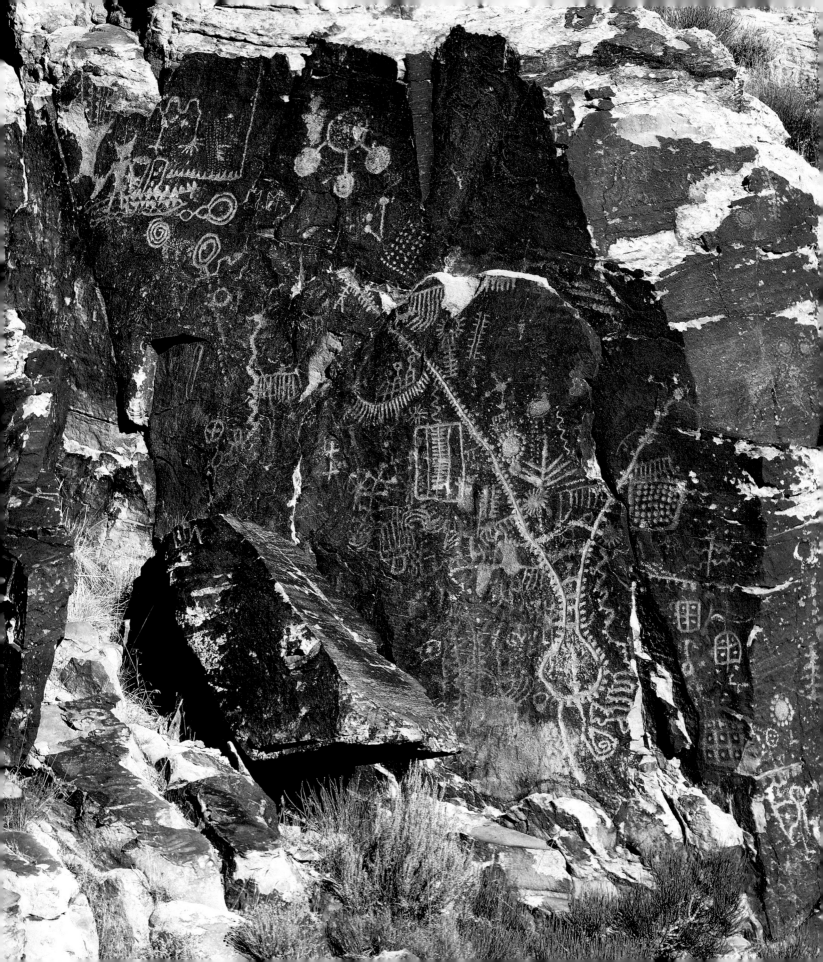

Anthropomorph in rock shelter overlooking Great Salt Lake, Willard, Utah. The figure was painted on limestone and is 30 centimeters high.

107

Western Utah

The strongest contrast in Fremont rock art is that between the art of the Colorado Plateau and the Great Basin. Rock art of the Great Basin Fremont, such as the Sevier style found in Clear Creek Canyon and surrounding areas, continued the traditions of Great Basin Archaic foragers even as it is unmistakably Fremont.[50] The trapezoidal anthropomorphs are much less frequent, but the horns, helmets, ear bobs, and other ornaments show the pervasiveness of human representation and the linkage with ritualized personages and events. Nevertheless, the rock art of western Utah suggests difference in heritage from the Colorado Plateau—a contrast so marked that archaeologists once referred to a Sevier culture, considered distinct from the Fremont.

There are local variations across western Utah as well. Rock art of the Great Salt Lake Fremont is strongly Great Basin but includes a painted style using red, white, and black paints to depict anthropomorphs, and abundant geometrics, including dots, ladders, and the step-fret designs sometimes seen on pottery. The Wasatch Front may have been home to some of the largest villages in Fremont times. In this region, rock art appears to have assumed a different role, akin perhaps to the changing and somewhat diminished role that rock art played at the height of the Anasazi.

Moving south toward the Parowan Valley there is great diversity in rock art. Some themes in the Sevier style are seen as derivative of the Kayenta and Virgin Anasazi, who

bordered central and western Utah during the peak of Fremont times.[51] Like the Faces motif of Canyonlands, these affinities indicate that while routine interaction with Anasazi populations was probably not the case in southwestern Utah, the Fremont were indeed part of the southwestern iconic world.[52]

Landscape, too, shaped Fremont rock art. Some places throughout the Fremont region were clearly favored for rock art over long time spans. Ethnography of the Zuni and others suggests that it is the power of place that inspires people to create rock art, setting off recurrent cycles of symbolic affirmation as rock art accumulates over the centuries. The Parowan Gap in southwestern Utah is a stark example of a place of power and significance. An inscrutable diversity of rock art was created there. Others—such as at McConkie/Dry Fork in the Uinta Basin and Nine Mile Canyon—represent just two of dozens of locales, suggesting that landscape and place were important in shaping the production of Fremont rock art, and that these places remained spiritualized for centuries because of continuity in heritage and worldview.[53]

Pictographs in rock shelter overlooking Great Salt Lake, Willard, Utah. Concentric circles and a wavy line in red paint, about 60 centimeters long.

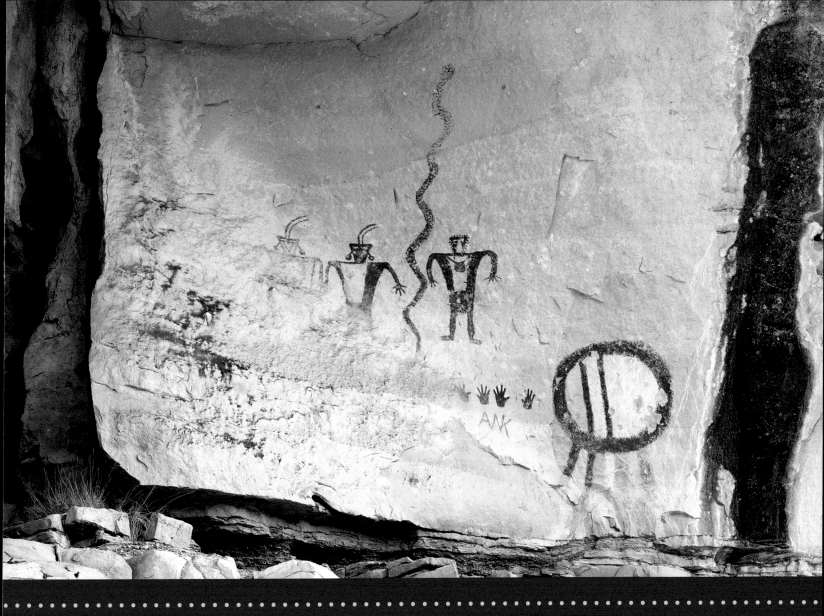

ROCK ART AND FREMONT SOCIETY

Pictograph panel, Ivie Creek, near Emery, Utah. This colorful panel features anthropomorphs individualized by facial markings, ornaments, and clothing. The snake is over four meters long. Not far away is the Old Woman site, where beautiful clay figurines were excavated.

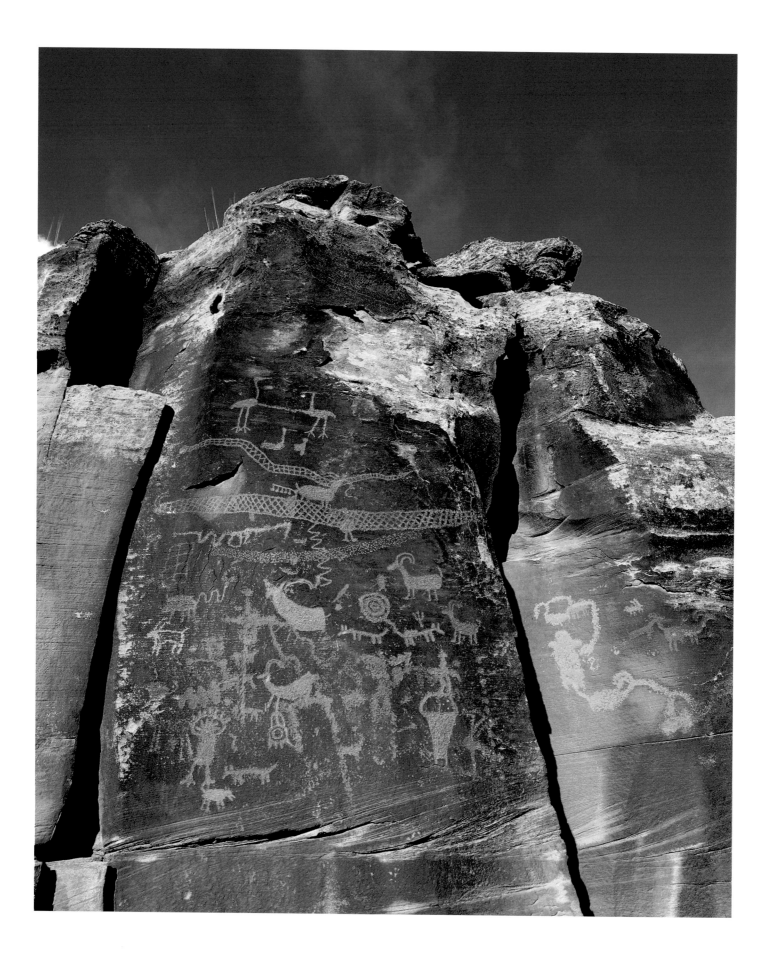

The Heron panel, Nine Mile Canyon, Utah. Typical of the Northern San Rafael style, the scene is busy with geometrics, anthropomorphs, and animal representations ranging from birds to bighorn sheep, snakes, and dogs—all in handsome composition.

The contexts of Fremont rock art production—and hence the possible motives and meanings of Fremont rock art—occur on several levels. The most foundational is that of landscape. Fremont farming required a portfolio of arable plots, and the rights of use and the labor invested in the farms were likely kin-based. The episodic nature of farm production would have resulted in the movement of people among dispersed communities, not only in response to surplus and shortage, but to the labor needs of farming. Good farming areas also would have attracted people from other places. This was not the type of movement of egalitarian hunter-gatherers who simply packed up for new foraging grounds in the face of domineering individuals. The Fremont required arable lands, but these were controlled by people, and the lands were so spatially and temporally variable in productivity that it led to residential cycling among fixed settlements. It was a territorialized system of related people and group alliances, all given force through social memory, ritual, and myth.

Leadership, authority, and decision making were not hierarchical and linear, but occurred sequentially across the dispersed community among associations of farmsteads, hamlets, and small and large villages. Nor was influence strictly linear according to the size of settlements. The importance of small places could at times have been amplified by alliances among settlements of different sizes. For instance, an aggrandizing leader at a Fremont hamlet may for a time have possessed excess labor or surplus maize. His direct authority would expand only temporarily when he distributed his surplus, but his influence would persist beyond his episodic benevolence through the networks of obligation.

The trio of circumstances of shifting farm labor, fluctuations in farm production, and the networks among the smaller and larger segments of the dispersed community fostered residential cycling across the landscape on temporal scales of years, decades, and beyond human life spans. This pattern of life was fundamental to Fremont society, worldview, and, consequently, the production of rock art.

The power of leaders arose not only from economic and political influence, but also from the control of ceremonies and ritual life. The connection of leaders to the supernatural world would have provided continuity over times of shortage and surplus, each of which produces a distinct set of tensions.

At times, some farms would have done well, while others struggled. The resulting inequities would have offered the greatest opportunities to aspiring leaders from both large and small places. This inequity would have produced alliances, but also differences in wealth among places and corporate groups. At times such asymmetry would have led to conflict. The ritual life expressed in rock art may reflect both common bonds, as in the portrayals of linked individuals known as daisy chains, or conflict, as represented by depictions of trophy heads.

Inevitably there were droughts that gripped entire regions for years at a time. In one sense everyone was in the same sinking boat, and sheer inequality in wealth might actually have been less during such times. On the other hand, these were dire times. The power would have resided in those who controlled the best farmland,

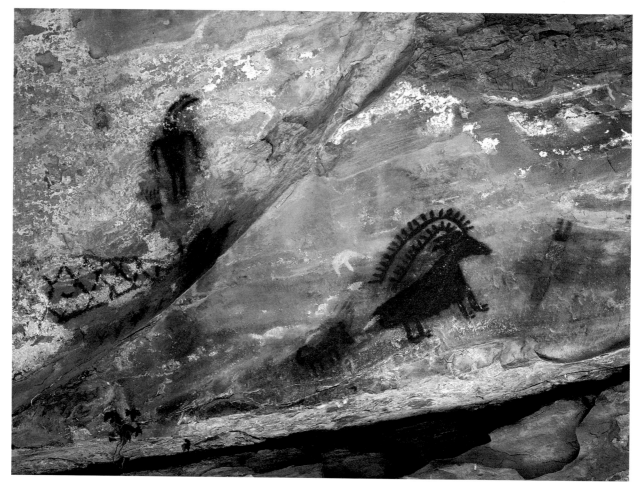

Anthropomorph and animals, Jones Hole, Dinosaur National Monument, Utah.

regulated the performance of rituals, and made alliances among segments of the dispersed community. They would have controlled access to stores, determined who would be subject to raiding, and perhaps most significantly, who would be forced to abandon and emigrate.

In one sense, Fremont society was small in the sense that dispersed communities would have responded to local circumstances. The practice of rituals and expressions of religion would have involved individuals, local groups, and local places. Much of the rock art conveys this aspect of the Fremont worldview. In another sense, however, ritual and religion were expressed across dispersed communities and regions, thus superseding individuals. The common themes in Fremont rock art across a substantial

geographic range show a level of heritage well beyond the individual and, for that matter, the ethnic group. Indeed, the geographic extent of the Fremont as a shared culture is substantially larger than that of the Anasazi.

The nature of Fremont religion also shaped rock art production. At the individual level, Fremont rock art sometimes appears shamanistic. Individual shamans may have appealed to their spirit helpers—whether in the form of bighorn sheep, snakes, or birds—to aid them in their life pursuits. The best-known shamans are the curers. No matter how deep a shaman's knowledge of illness, medicinal plants and minerals, and curing, they would not have been successful unless their efforts were entwined with the spirit world.

In the same way, a shaman might have provided spiritual assistance for a bighorn sheep hunt on the West Tavaputs Plateau, or a pronghorn drive in the Sevier Desert, or a bison hunt in the Great Salt Lake wetlands. These and other acts of shamans could have led to the production of rock art. In such situations, shamanism, vision questing, and sympathetic magic may have been combined.

Another individualistic expression suggested for Fremont rock art is the biographical, both real and mythical. This may or may not be associated with shamanism, but signals that Fremont rock art was produced on different levels. Some of the most intriguing Fremont rock art seems to depict events, often in heroic proportions, and sometimes with symbols of violence—perhaps in ways that link the actions of the ancestors with people of the present. The rock art panels labeled as biographical, such as those in McConkie/Dry Fork in the Uintah Basin, imply mythical narrative. These place the individual, a personage of heroic stature, into a sociality with a temporal dimension. If those rock art depictions are indeed biographical, they could be people who had shamanic power. They might also be economic, political, and military leaders who at the same time functioned as ritual leaders. All of these are forms of leadership on scales beyond the shamanic.

Even the production of rock art by individuals need not be shamanistic, or even tied to ritualized behaviors. Rock art can still be spiritually charged even if it was produced in the course of the mundane activities of everyday life. It is often found in locations of group activities, such as areas where women would gather roots and seeds, or a group of men would quarry stones for making tools.[54]

Recognition of multiple pathways to Fremont complexity shifts our understanding of the role of shamanism in Fremont society and in rock art. This can be illustrated with some examples. A shaman may have been limited to the role of spiritual mediator in a bighorn sheep hunt that involved people from several communities and was organized and led by village political leaders. Rock art might also have marked certain farm plots or storage facilities to signify identity and perhaps territoriality, and have nothing to do with shamanism, vision questing, and spirit helpers. These hypothetical examples provoke the notion that some Fremont rock art, perhaps a great deal of it, was produced not so much in terms of shamanism, but either in the course of mundane everyday expression or on behalf of leaders, lineages, and corporate groups.[55]

Yet another context of Fremont rock art production is that of regional networks and the woven histories of different ethnic heritages. The rock art of Canyonlands, north to the Book Cliffs, and onto the Uncompahgre Plateau of western Colorado may reflect borderlands where cultural differences in terms of space and time were less crisp and more commingled. The rock art there occasionally mixes the elements and themes of seemingly different heritages, even within the confines of individual elements. In other instances the diversity is expressed by the creation of distinct rock art styles across the same panel. Some of the rock art does not neatly match the typologies of material culture at nearby archaeological sites.

This region is a patchwork of arable lands scattered across a landscape dissected by enormous expanses of waterless slickrock, unfarmable saline plains, and high

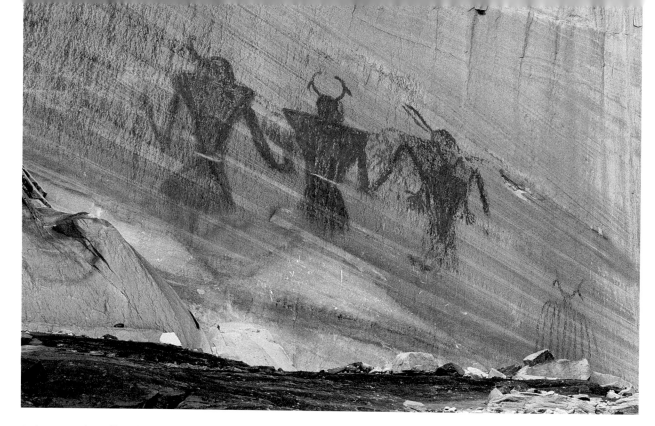

Anthropomorphs, Calf Creek, near Escalante, Utah. This area was used by both the Fremont and Anasazi.

country. This patchiness may have given rise to networks and movement among peoples of different heritages. Thus the boundaries that archaeologists are prone to draw may be illusory, failing to show how people were entwined in ways other than mere trade or interaction. Rock art may reflect this complexity in some instances.

The commingling of people and ideas may have been going on elsewhere as well, such as the Parowan Gap in southwest Utah, even though the archaeology there, as well as in central Utah near Escalante, suggests a fairly crisp boundary between Fremont and Anasazi, with each using the same places, but at different times. The distinction is less clear in the area near Moab, although our knowledge of Fremont archaeology east of the San Rafael Swell and along the base of the Book Cliffs to Grand Junction, Colorado, is meager.

At the most abstract level, Fremont rock art depicts cosmology: the fundamental nature of the world. Such foundational meaning is not determined by the whims of individual shamans, or by lineage elders or the leaders of villages. It is pervasive and runs through all of the rock art. It is heritage. That is how we recognize it as Fremont, and thus borne of the indigenous cultures of the Archaic as well as those of the Puebloan Southwest.

TRACES OF FREMONT: POSTSCRIPT

Mixed-technique petroglyph, Echo Park, Dinosaur National Monument, Colorado. This image includes elements
that were drilled, pecked, and polished, and it may have been finished with paint.

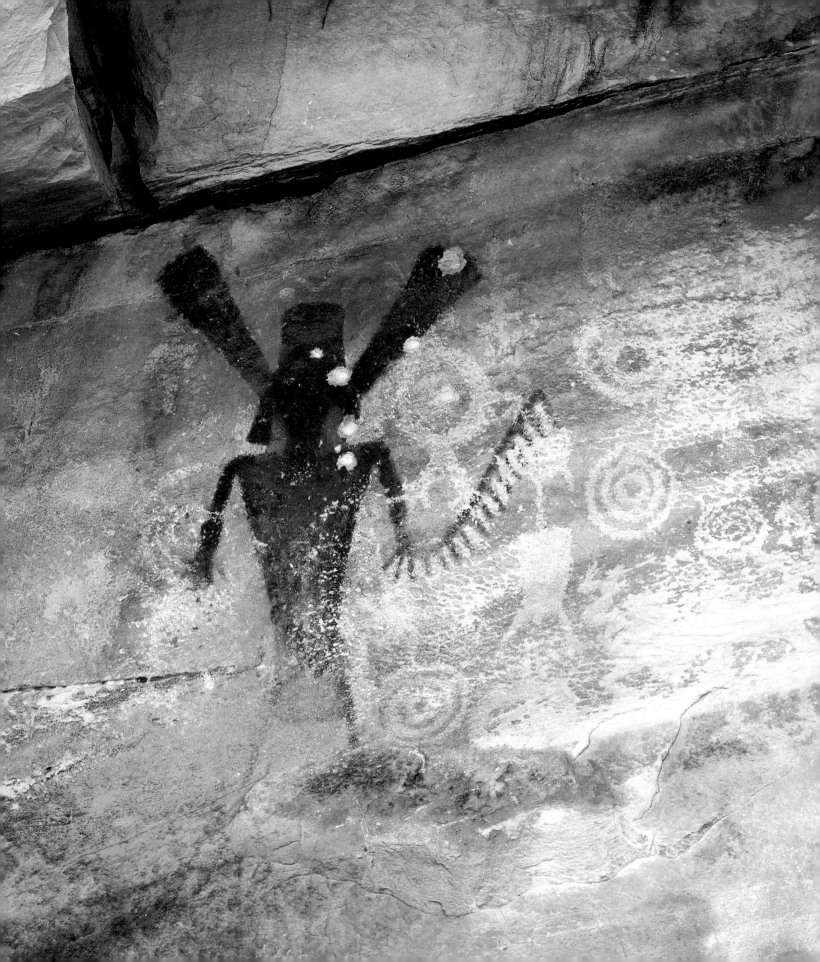

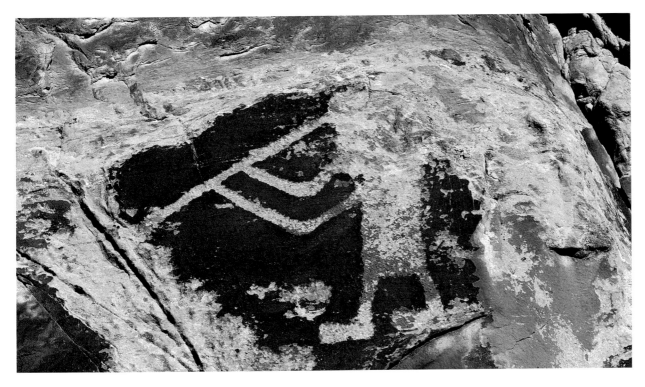

Flute player, Cub Creek, Dinosaur National Monument, Utah.

The spectacular photographic images of rock art and fabulous objects displayed in this book can transport us into a facet of Fremont culture that we understand in only vague terms: their social and ideological world. Archaeologists are reluctant to write about such things, and I am old enough to remember the days when proper archaeologists did not take the study of rock art very seriously. It was seen as too speculative, too difficult to understand through empirical means, and attempts at interpretation led to bloody battles, mostly because the images are subject to the vicissitudes of artistic interpretation. Archaeologists now investigate rock art, but the challenges of comprehending the ancient world of social and political organization—let alone ritual, symbolism, and cosmology—remain significant. Surely objectivity in the purest sense is a will o' the wisp, but I believe that archaeology and our tool kit of anthropological analogy tell us about these things, just not in a very straightforward manner. People want to know about the life of the mind. They want to be carried into the past. They want the rest of the story. The proposition I have pursued here is that to know the Fremont, one must include the rock art. But to know the rock art, one must know the Fremont.

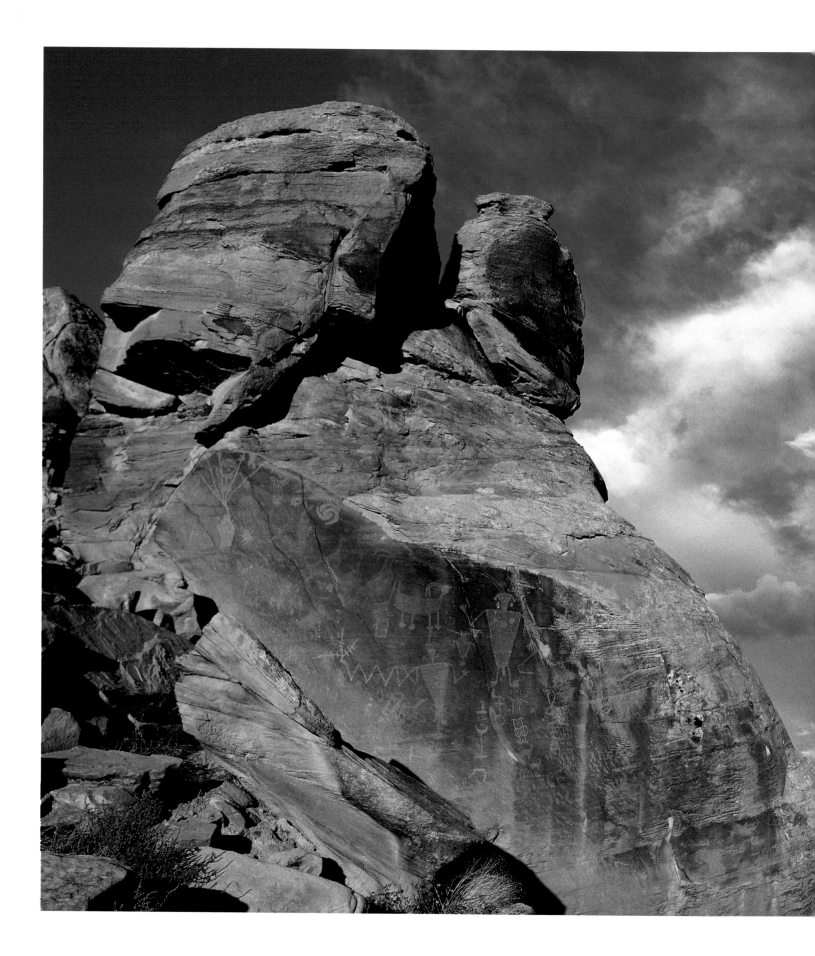

The photographer and the publisher thank the following institutions or individuals for permission to use artifacts or other materials from their collections. All photographs are by François Gohier.

Courtesy Fremont Indian State Park, Utah, pages 6, 7, 11, 20, 21, 22, 32, 38, 57.

Courtesy Mark Stuart, pages 4, 49.

Courtesy Dinosaur National Monument, Utah, page 6.

Courtesy University of Colorado Museum of Natural History, Boulder, page 19: flicker-feather headdress, UCM 6178; page 28: fishing hooks, UCM 5960; page 30: hafted knife, UCM 5990; page 62: necklace, UCM 5976; page 64: deer-scalp headdress, UCM 6102; page 74: basket, UCM 5957.

Courtesy Utah Museum of Natural History, page 22: right moccasin, 42Bo36 FS47.3 UMNH.AR.12455; left moccasin, 42Bo36 FS47.2 UMNH.AR.12454.

Courtesy of E. P. and Dorothy Hickman Pectol Family Organization, pages 4, 29, 44, 66-67, 101.

Courtesy Museum of the San Rafael, page 30.

Courtesy Museum of Peoples and Cultures, Brigham Young University and the Bureau of Land Management, Ely District Office, Nevada, pages 31, 33.

Courtesy College of Eastern Utah Prehistoric Museum, pages 47, 54, 98-99, 122.

Courtesy ATK Launch Systems/Thiokol, pages 58, 84, 124.

Boulder petroglyph panel, Cub Creek, Dinosaur National Monument, Utah.

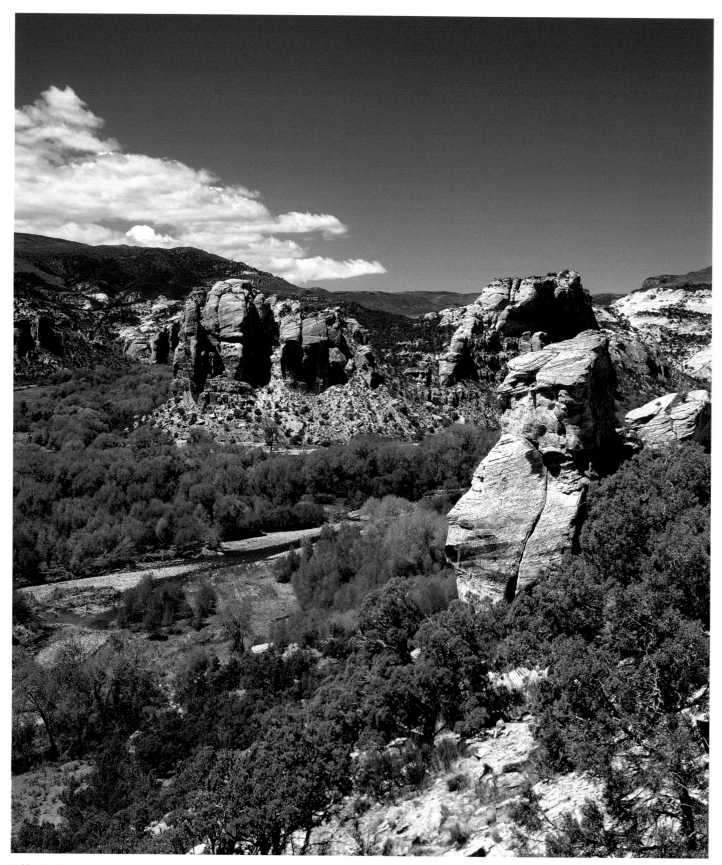

Ashley Creek near Vernal, Utah. This photograph was taken from the bottom of the cliffs bearing Fremont petroglyphs.

NOTES

1. Introductions to the Fremont are provided by Madsen (1989) and Janetski (2008). Simms (2008) devotes a detailed chapter to the Fremont. Madsen and Simms (1998) is an academic synthesis of the archaeology up to that time.

2. Gunnerson ([1969] 2009) speculates on Fremont social organization and religion. Simms (1990) proposes that large Fremont sites are underrepresented in the archaeological literature because they are hidden under towns and cities. Barker (1994) explicitly proposes social complexity for the Fremont in the form of sequential hierarchies (heterarchies). Hockett (1998) argues for social ranking on the basis of faunal evidence. Janetski et al. (2000) present the results of excavation at large sites in Clear Creek Canyon and lay the empirical ground for a discussion of Fremont social complexity. Simms (2008) presents the case in a synthesis of the Fremont.

3. I follow the contemporary anthropological realization that there are multiple pathways to, and expressions of, social complexity. Johnson (1982) is a pivotal paper showing that social complexity has vertical and horizontal dimensions, and that hierarchy can be simultaneous or sequential. The latter has come to be called heterarchy, and it "involves horizontal social divisions between lineages, co-resident groups, or other collectives whereby decision making is sequential and consensus based and is not centralized or institutionalized" (Sassaman 2004:232).

4. Bettinger (1999) discusses cultural intensification in the western Great Basin after two thousand years ago and compares it to the Fremont. Thomas (1981) first cracked the door to variation in group size, territoriality, and social organization among Great Basin foragers. McGuire and Hildebrandt (2005) explore complexity in the western Great Basin in terms of competition, costly signaling, and prestige hunting.

5. For a review see Prentiss and Kuijt (2004) and Sassaman (2004).

6. Madsen (1979) describes the struggle to define the Fremont. Mills (2000) reviews variability in southwestern social organization.

7. Comparison is the lifeblood of anthropological method, and there is a vast literature drawing distinctions between traditional, "sacred" societies and secular, "profane" societies, as well as the patterning that runs among these social forms.

For the Southwest, some classic studies of social organization include Eggan (1950) whose model draws from the work of Steward (1937) on clan structure, Dozier (1970), and Ortiz (1969). Changes in southwestern sociopolitical organization since Anasazi times is discussed in, for example, Rushforth and Upham (1992), and Ware (2002) speaks to geographic variation in social organization among ancient and historic northern southwestern peoples. On the anthropology of religion, the literature is equally vast, but still-worthy classics are Evans-Pritchard (1965) Wallace (1966), and Parsons (1996) on southwestern religions. A sense of society and religion among the Archaic period hunter-gatherers ancestral to the Fremont can be gleaned from Hultkrantz (1981 and 1986), and Liljeblad (1986). Great Basin rock art and religion is surveyed by Garfinkel (2006). For archaeology and religion see Whitley (2001) and Hayden (2003). For ancient southwestern religions see, for instance, VanPool, VanPool, and Phillips (2006).

8. Madsen (1979) reviews the history of Fremont taxonomy, and early attempts to define the Fremont are found in Morss ([1931] 2009) and Gunnerson ([1969] 2009).

9. Syntheses include Madsen (1989), Madsen and Simms (1998), Simms (2008), and Janetski (2008).

10. Various tools were likely used, but Turpin (2001:369) reports the use of quartz crystals.

11. Ethnoarchaeological study of food hiding by Bedouins in Jordan shows that hoarding in remote granaries similar to Fremont and Anasazi storage was almost always related to competition within families and local kin, not other ethnic groups or peoples. Further, inaccessibility had less to do with restraining thieves than with identifying them and thereby increasing the influence of those who controlled the storage structures (Simms and Russell 1996).

12. Dotty Sammons-Lohse (1981) conducted a hard-nosed analysis of the argument made by some for Fremont "villages." My intent here is not to pick this apart, but to move the discussion on. A careful reading of her work reveals the nature of the debate. I excavated at the Evans Mound while attending the University of Utah archaeology field school in 1973. The excavation was directed by Jesse Jennings with the assistance of John "Jack" Marwitt and Claudia Berry. Jennings was an insistent

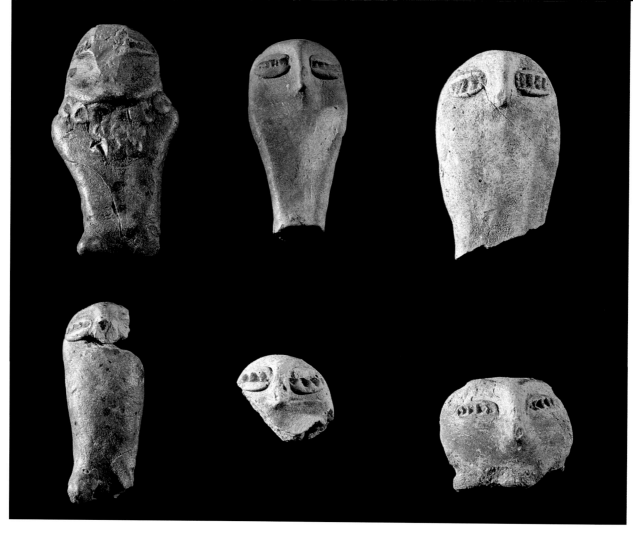

Small figurines of unbaked clay have been recovered from numerous sites throughout the Fremont region. Collections of the College of Eastern Utah Prehistoric Museum.

stratigrapher, and all features had to be physically associated in the dirt in order to determine their relative placement. After three seasons (Berry 1972, Dodd 1982), the excavation had opened less than 15 percent of the mound itself. Near the end of the third season, a backhoe dug long trenches on the flats adjacent to the mound and crossed pithouse after pithouse. A conservative calculation is that three years of excavation evaluated less than 2 percent of the mound and the flats immediately around the mound. The sheer number of structures (dozens and dozens, perhaps hundreds) at a site occupied for three centuries, with huge granaries, and only minimally excavated, leaves me skeptical that it amounts to nothing more than three pithouses occupied at a time, as if each Fremont family queued up to await their turn every three or four years at building the mound.

13. Coltrain 1993, 1997.

14. Simms (1990:9) proposes that we miss Fremont big villages because they are most likely underneath modern cities and towns, and are thus masked from investigation. The Clear Creek Canyon work began to document the reality of Fremont settlements from small to large (see especially Talbot 2000a and 2000b). See Simms (2008:191, 217–222) for a review of the argument for large villages among the Fremont and an investigation of social complexity beyond the farmstead. Violence and mutilation at Five Finger Ridge are indicated by a sizable collection of fragmentary, cut, burned, and pot-polished human bone embedded in zooarchaeological assemblages. This occurs at other large Fremont sites as well, but remains a mostly unstudied and unreported phenomenon, but see Novak and Kollmann (2000).

15. Open areas among structures that were seen as "plazas" are noted by Judd (1919, 1926) and Gunnerson ([1969] 2009). See Marwitt (1970) and Dodd (1982) on the Median and Evans sites, respectively. For village planning see Wilde and Soper (1999) and Hockett (1998).

16. Janetski et al. 2000 and Talbot et al. 2000.

17. See note 2. The view of Schaafsma (1980:180), like that of most rock art specialists, is consistent with the traditional views of archaeologists regarding Basketmaker and Fremont social organization: "Neither culture, however, had large organized villages"; "Fremont settlements ... were slightly larger ... but the settlement pattern was not structured, and a loose political organization is probable"; "The social structure would have been such that religious activities would have rested in the hands of specialized religious practitioners like shamans, and not in an organized priesthood of the kind that exists among the Pueblos." Fremont archaeology increasingly leads us to expect much more complexity than this without concluding that the Fremont are the same as the Western Pueblos of history.

18. The concept of dispersed community was first developed for the Anasazi of southwestern Colorado as part of the Dolores project (Kane 1986). It has been applied to Fremont settlement by Talbot (2000b).

19. The importance of recruitment among foragers (e.g., Lee 1982) highlights the contradictions of egalitarianism and inequality. With increasing complexity, individual "aggrandizers" further spur recruitment to serve their needs and the needs of those who support them (e.g., Hayden 1994).

20. The Medieval Climatic Anomaly (sometimes erroneously called the Medieval Warm Period) produced different responses around the globe and was hardly uniformly warm, but it did produce decades of summer rainfall favorable to maize agriculture on the Colorado Plateau (e.g., Lamb 1982 and Dean 1994, but see Internet sources for current evidence and discussion). This fostered the spread of new strains of maize to more northern latitudes on the Colorado Plateau; however, the temptations of pushing farming to its temperature limits weighed against the frequent droughts that also characterized this period.

21. Hayden 1994. On heterarchy in the Puebloan Southwest see McGuire and Saitta (1996), comment by Rautman (1998), and rejoinder by McGuire and Saitta (1998). Kantner (2004:64) argues that rows of linked individuals in southwestern rock art indicate communalism rooted in the transition to agriculture. Similarly, Neal (2009) argues that rows of linked individuals in the rock art of the Moab area are expressions of social solidarity.

22. McGuire and Saitta (1996:203) describe the relationship between clan power, control of ritual life, and how these things affect Anasazi land, labor, and human activities in times of scarcity. Although Fremont dispersed communities were not as nucleated or structured as many pueblos, the analogy is useful in considering how authority and leadership among the Fremont might respond to times of shortage.

23. We should not dismiss Fremont complexity by reference to stereotypes of Great Basin hunter-gatherers. Thomas (1981, 1983:37–38) discusses variability in social organization, leadership, and territoriality among Great Basin hunter-gatherers, as does Shapiro (1986). Even Great Basin foragers displayed various group sizes and political categories, as suggested by ethnographies such as those by Willard Park for Pyramid Lake, Nevada (Fowler 1989), and the Ute of Utah Valley (Janetski 1991); see also McGuire and Hildebrandt (2005).

24. Hegmon 2005:228–229.

25. Hays-Gilpin 2006:71.

26. Hays-Gilpin 2006:75–78.

27. Madsen and Simms 1998.

28. Simms 2008:195–205.

29. On early maize in the Southwest and dietary intensification by the first millennium A.D., see Diehl and Waters (2006). Geib and Spurr (2002) argue for Basketmaker II reliance on maize by 300 B.C. in northern Arizona, consistent with earlier evidence of the same (Matson and Chisolm 1991), while Coltrain et al. (2007) report evidence that Basketmaker II maize reliance may have occurred as early as 400 B.C. Maize was clearly in Fremont country by A.D. 0 (Wilde and Newman 1989), and there is evidence under analysis from the Prison site in the Salt Lake Valley that it might have been even earlier.

30. Matson 1991, 2002.

31. Cole (2008:119–124, 250–251) discusses scalps and rock art for Basketmaker II and Fremont. Howard and Janetski (1992) describe scalps and scalp stretchers from southeastern Utah, most likely Basketmaker II, and discuss the contexts in which scalps occur in the Southwest other than violence and warfare.

32. Matson 2002.

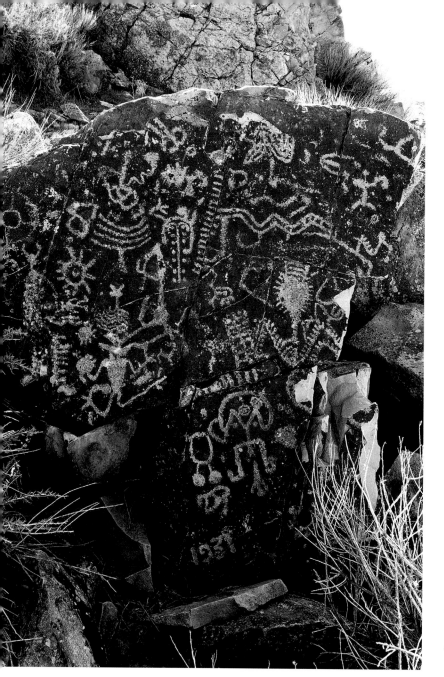

Connor Spring rock art site, near Corinne, Utah. This rocky ridgeline offers a panoramic view of Great Salt Lake to the south and is decorated with rock art from the Archaic, Fremont, Late Prehistoric, and Historic periods. Other, similar ridges nearby contain no rock art, indicating the uniqueness of this place.

37. Robins 2002.

38. Schaafsma (1971:2–3) summarizes the concept of style and the history of defining rock art styles in the Great Basin and northern Southwest.

39. Reviews of the Barrier Canyon style include Cole (2004 and 2008:59–67), and Schaafsma (1971:65–79). Schaafsma (1971:131–135) argues for affiliation with the Archaic Pecos River style in Texas, raising an important point: the Barrier Canyon style does not coincide with any one archaeological or ethnographic cultural unit and persisted through considerable cultural change. Manning (1990) argues for the persistence of some Barrier Canyon symbols into the Historic period. Robins's (2002) discussion of social power and prestige is relevant to the Barrier Canyon style.

40. Cole 2008:121–124.

41. Cole (2008) refers to them as keyhole-shaped images. Manning (1992a), who calls them "lobed-circles," believes they represent the uterus, and identifies the different contexts in which it occurs. Cole (1994) argues that Basketmaker II rock art is a foundational heritage to both Anasazi and Fremont.

42. Schaafsma and Young (1983) and Cole (1993) discuss masking.

43. Cole 2008: 119–124, 250–251; Howard and Janetski 1992; Simms 2008:210–211.

44. See Cole (2008:248–252) on the Classic Vernal style, masks, scalps, and shields, and Schaafsma (1971:8–25) on the Classic Vernal style. Francis and Loendorf (2002:132–148) present an excellent overview of the shield and shield-bearing warrior motifs; also see Keyser (1975). Schaafsma (1971:143) discusses the Weeping Eye motif and the claim of connection to Eastern Woodland cultures and the "Southern cult." It is appropriate to note that the iconography found in Eastern Woodland cultures stretches across so much space and time that it transcends the concept of cult. Such things are a reminder that although Fremont is distinctive, it is also a product of Native American cosmology on a continental scale.

45. Talbot and Richens 2004:111–112, Jantz and Owsley 2007.

46. Geib and Fairley 1992, Noxon and Marcus 1985, Schaafsma 1971:41–52.

33. Bellwood and Renfrew (2002) explore the relationship between farming and migration in various cases around the world.

34. Talbot and Richins 1996, 2004; Wormington 1955; Gunnerson [1969] 2009:97–104.

35. Talbot 2000a.

36. Hartley (1992) has conducted one of the few systematic spatial analyses of rock art in southern Utah. For arguments that rock art can be embedded in everyday activities, see, for instance, Cannon and Woody (2007) and Cannon and Ricks (2007).

47. Schaafsma 1971:50–52; Cole 2008, 1992; Manning 1992b. Neal and Simms (2008) employed a study of rock art near Moab to explore an understanding of rock art style at the level of landscape rather than in terms of ethnic badges of peoples at fixed times. Neal (2009) deepens this exploration.

48. Matheney et al. 2004.

49. The individualism of Great Basin shamanism, which "prevented the development of fixed ritual patterns and standardized shamanistic song texts," did not apply to "communal antelope drives" (Liljeblad 1986:645). This shows that shamanism can be subsumed by larger social dimensions, even among Great Basin hunter-gathers. Willard Park observed for the hunter-gatherer Pyramid Lake Paiute that "A chief was a bigger man than the Indian doctors. The chief was over the shaman" (Fowler 1989:133). The association of shamanism and hunting does not obviate evidence that the production of rock art was hunting related (Gilreath and Hildebrandt 2008). Shamanism and hunting success were probably associated. For an expansive discussion of rock art and hunting in the Great Basin, see Garfinkel (2006). For the relationship between shamanism and religion, see Hayden (2003).

50. Schaafsma 1971:84–108.

51. Schaafsma 1971:139.

52. See Simms 2008:224 for a discussion of Fremont-Anasazi interaction in south-central Utah and references to recent archaeological study there.

53. Writing of the Zuni, Young (1988:173) shows that the act of making rock art can make a place sacred through imagery. Sometimes sacred places are named in myths, but no one knows where these places are geographically. Thus, the creation of rock art, shrines, and the placement of offerings can establish this connection.

54. Critiques of the interpretation of shamanism, or calls for some balance in interpretation, include those from Hedges (2001) and Quinlan (2000, 2001), with rebuttal by Whitley (2000, 2003). While rock art in the context of everyday activities and landscape is widely mentioned, Hartley (1992) and Cannon and Woody (2007) are explicit examples.

55. Schaafsma (1994) offers an excellent discussion of shamanism on the northern Colorado Plateau. Her argument is that Basketmaker rock art was strongly shamanistic. She notes the gulf between the socially complex and much-changed historic Pueblos of the Southwest, and warns against simply extending the modern Pueblos back into time. She reminds us that shamanism does not disappear with increasing complexity. I agree, and argue that if we find that the Fremont are more complex than we thought, then the contexts of Fremont shamanism change, and the differences in Basketmaker II and Fremont rock art parallel differences between the two cultures in social complexity.

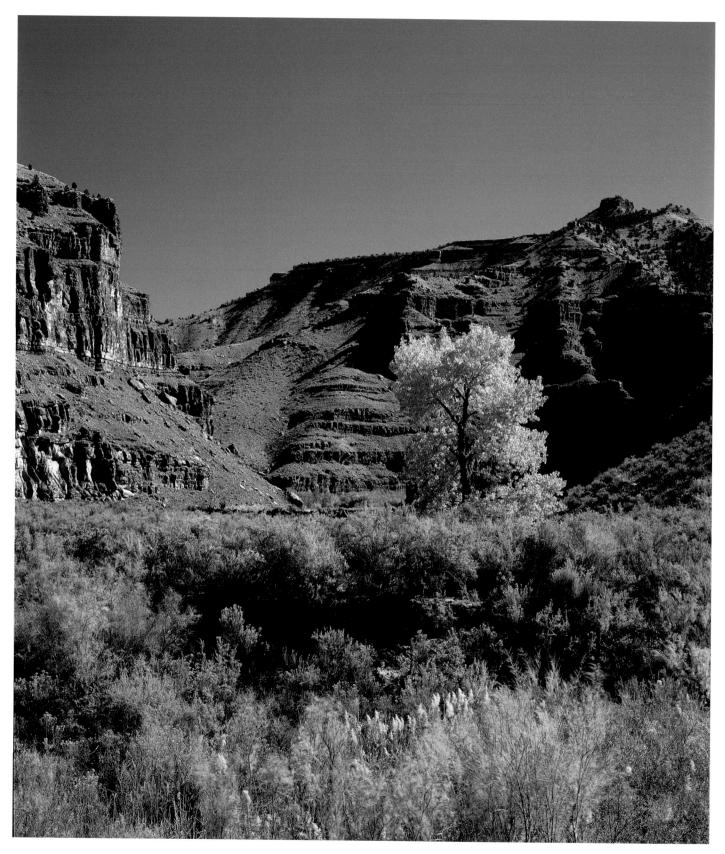

Autumn in Nine Mile Canyon, Utah.

Barker, J. Pat
1994 Sequential Hierarchy and Political Evolution along the
 Western Fremont Frontier. Paper presented at the 24th
 Biennial Great Basin Anthropological Conference, Elko,
 Nevada.

Bellwood, Peter, and Colin Renfrew (editors)
2002 *Examining the Farming/Language Dispersal Hypothesis.*
 McDonald Institute Monographs, Oxbow Books, Oxford.

Berry, Michael S.
1972 *The Evans Site.* Special report, University of Utah
 Department of Anthropology. Salt Lake City.

Bettinger, Robert L.
1999 What Happened in the Medithermal. In *Models for the
 Millennium: Great Basin Anthropology Today,* edited by C.
 Beck, pp. 62–74. University of Utah Press, Salt Lake City.

Cannon, William, and Mary F. Ricks
2007 Contexts in the Analysis of Rock Art: Settlement and Rock
 Art in the Warner Valley Area, Oregon. In *Great Basin Rock
 Art: Archaeological Perspectives,* edited by A. Quinlan, pp.
 107–125. University of Nevada Press, Reno.

Cannon, William, and Alana Woody
2007 Toward a Gender-Inclusive View of Rock Art in the Northern
 Great Basin. In *Great Basin Rock Art: Archaeological
 Perspectives*, edited by A. Quinlan, pp. 37–51. University of
 Nevada Press, Reno.

Cole, Sally
1992 Rock Art Wall Paintings and Figurines of the Pueblo II–
 Pueblo III Period: Evidence of the Anasazi and Fremont
 Interaction. *Canyon Legacy: A Journal of the Dan O'Laurie
 Museum* 16:20–26. Moab, Utah.
1993 Basketmaker Rock Art at the Green Mask Site, Southeastern
 Utah. In *Anasazi Basketmaker: Papers from the 1990
 Wetherill-Grand Gulch Symposium,* edited by V. M. Atkins,
 pp. 193–222. Bureau of Land Management, Utah, Cultural
 Resource Series No. 24. Salt Lake City.
1994 Roots of Anasazi and Pueblo Imagery in Basketmaker II Rock
 Art and Material Culture. *Kiva* 60:289–311.
2004 Origins, Continuities, and Meaning of Barrier Canyon Style
 Rock Art. In *New Dimensions in Rock Art Studies*, edited
 by R. T. Matheney, pp. 7–78. Brigham Young University

Museum of Peoples and Cultures, Occasional Paper No. 9.
 University of Utah Press, Salt Lake City.
2008 *Legacy On Stone: Rock Art of the Colorado Plateau and
 Four Corners Region.* Johnson Books, Boulder, Colorado.

Coltrain, Joan B.
1993 Corn Agriculture in the Eastern Great Basin: A Pilot Stable
 Carbon Isotope Study. *Utah Archaeology 1993* 6:49–56.
1997 Fremont Economic Diversity: A Stable Carbon Isotope
 Study of Formative Subsistence Practices in the Eastern
 Great Basin. Unpublished Ph.D. dissertation, Department of
 Anthropology, University of Utah.

Coltrain, Joan Brenner, Joel C. Janetski, and Shawn W. Carlyle
2007 The Stable- and Radio-isotope Chemistry of Western
 Basketmaker Burials: Implications for Early Puebloan Diets
 and Origins. *American Antiquity* 72:301–321.

Conkey, Margaret W.
1984 To Find Ourselves: Art and Social Geography of Prehistoric
 Hunters and Gatherers. In *Past and Present Hunter Gatherer
 Studies,* edited by C. Schrire, pp. 253–276. Academic Press,
 Orlando, Florida.

Dean, Jeffery S.
1994 The Medieval Warm Period on the Southern Colorado
 Plateau. *Climatic Change* 26:225–241.

Diehl, Michael, and Jennifer A. Waters
2006 Aspects of Optimization and Risk During the Early
 Agricultural Period in Southeastern Arizona. In *Behavioral
 Ecology and the Transition to Agriculture*, edited by
 D. J. Kennett and B. Winterhalder, pp. 63–86. University
 of California Press, Berkeley.

Dodd, Walter A., Jr.
1982 *Final Year Excavations at the Evans Mound Site.*
 Anthropological Papers No. 106. University of Utah Press,
 Salt Lake City.

Dozier, Edward P.
1970 *The Pueblo Indians of North America.* Waveland Press,
 Prospect Heights, Illinois.

Eggan, Fred
1950 *Social Organization of the Western Pueblos.* University of
 Chicago Press.

128

Evans-Pritchard, E. E.
1965 *Theories of Primitive Religion.* Clarendon, Oxford, United Kingdom.

Fowler, Catherine S.
1989 *Willard Z. Park's Ethnographic Notes on the Northern Paiute of Western Nevada, 1933–1940.* Anthropological Papers No. 114. University of Utah Press, Salt Lake City.

Francis, Julie E., and Lawrence L. Loendorf
2002 *Ancient Visions: Petroglyphs and Pictographs of the Wind River and Bighorn Country, Wyoming and Montana.* University of Utah Press, Salt Lake City.

Garfinkel, Alan P.
2006 Paradigm Shifts, Rock Art Studies, and the "Coso Sheep Cult" of Eastern California. *North American Archaeologist* 27:203–244.

Geib, Phil R., and Helen C. Fairley
1992 Radiocarbon Dating of Fremont Anthropomorphic Rock Art in Glen Canyon, South-Central Utah. *Journal of Field Archaeology* 19:155–168.

Geib, Phil R., and Kimberly Spurr
2002 The Forager to Farmer Transition on the Rainbow Plateau. In *Traditions, Transitions, and Technologies: Themes in Southwestern Archaeology,* edited by S. Schlanger, pp. 224–244. University Press of Colorado, Boulder.

Gilreath, Amy, and William Hildebrandt
2008 Coso Rock Art Within Its Archaeological Context. *Journal of California and Great Basin Anthropology* 28(1):1–22.

Gunnerson, James H.
[1969] *The Fremont Culture: A Study in Culture Dynamics on the*
2009 *Northern Anasazi Frontier.* University of Utah Press, Salt Lake City.

Hartley, Ralph J.
1992 *Rock Art on the Northern Colorado Plateau: Variability in Content and Context.* Worldwide Archaeology Series. Avebury, Ashgate Publishing Company, Brookfield, Vermont.

Hayden, Brian
1994 Competition, Labor, and Complex Hunter-Gatherers. In *Key Issues in Hunter-Gatherer Research,* edited by E. S. Burch Jr.

and L. J. Ellanna, pp. 223–230. Berg, Washington, D.C.
2003 *Shamans, Sorcerers, and Saints: A Prehistory of Religion.* Smithsonian Books, Washington, D.C.

Hays-Gilpin, Kelley
2006 Icons and Ethnicity: Hopi Painted Pottery and Murals. In *Religion in the Prehispanic Southwest,* edited by C. S. VanPool, T. L. VanPool, and D. A. Phillips Jr., pp. 67–80. Altamira Press, Walnut Creek, California.

Hedges, Ken
2001 Traversing the Great Gray Middle Ground: An Examination of Shamanistic Interpretation of Rock Art. In *American Indian Rock Art,* edited by S. M. Freers and A. Woody, 27:123–136. American Rock Art Research Association, Tucson, Arizona.

Hegmon, Michelle
2005 Beyond the Mold: Questions of Inequality in Southwest Villages. In *North American Archaeology,* edited by T. R. Pauketat and D. DiPaolo Loren, pp. 212–234. Blackwell Publishing, Malden, Massachusetts.

Hockett, Bryan
1998 Sociopolitical Meaning of Faunal Remains from Baker Village. *American Antiquity* 63:289–302.

Howard, Julie, and Joel C. Janetski
2002 Human Scalps from Eastern Utah. *Utah Archaeology* 5:125–132.

Hultkrantz, Ake
1981 *Belief and Worship in Native America.* Syracuse University Press, New York.
1986 Mythology and Religious Concepts. In *Handbook of North American Indians,* Vol. 11: *Great Basin,* edited by W. L. d'Azevedo, pp. 630–640. Smithsonian Institution Press, Washington, D.C.

Janetski, Joel C.
1991 *The Ute of Utah Lake.* Anthropological Papers No. 116. University of Utah Press, Salt Lake City.
2008 The Enigmatic Fremont. In *The Great Basin: People and Place in Ancient Times,* edited by C. S. and D. D. Fowler, pp. 105–115. School for Advanced Research Press, Santa Fe, New Mexico.

Janetski, Joel C., Richard K. Talbot, Deborah E. Newman, Lane D. Richens, James D. Wilde, Shane A. Baker, and Scott E. Billat
2000 *Clear Creek Canyon Archaeological Project: Results and Synthesis*. BYU Museum of Peoples and Cultures Occasional Papers, Vol. 7. University of Utah Press, Salt Lake City.

Jantz, Richard L., and Douglas W. Owsley
2007 Metric Assessment of Fremont Crania for NAGPRA Compliance. Report to the U.S. Bureau of Reclamation, Upper Colorado Region, Salt Lake City.

Johnson, Gregory
1982 Organizational Structure and Scalar Stress. In *Theory and Explanation in Archaeology*, edited by C. Renfrew, M. Rowlands, and B. Segraves, pp. 389–342. Academic Press, New York.

Judd, Neil M.
1919 *Archaeological Investigations at Paragonah, Utah*. Smithsonian Institution Miscellaneous Collections 70:1–22.
1926 *Archaeological Observations North of the Rio Colorado*. Bulletin No. 82. Bureau of American Ethnology, Smithsonian Institution, Washington, D.C.

Kane, Allen E.
1986 Prehistory of the Dolores River Valley. In *Dolores Archaeological Program: Final Synthetic Report*, compiled by D. A. Breternitz, C. K. Robinson, and G. T. Gross, pp. 353–435. U.S. Bureau of Reclamation, Denver.

Kantner, John
2004 *Ancient Puebloan Southwest*. Cambridge University Press.

Kelly, Robert L.
1995 *The Foraging Spectrum: Diversity in Hunter-Gatherer Lifeways*. Smithsonian Institution Press, Washington, D.C.

Keyser, James
1975 A Shoshonean Origin for the Plains Shield Bearing Warrior Motif. *Plains Anthropologist* 20:207–215.

Lamb, Hubert H.
1982 *Climate, History and the Modern World*. Methuen, London.

Lee, Richard B.
1982 Politics, Sexual and Non-Sexual, in an Egalitarian Society. In *Politics and History in Band Societies*, edited by E. Leacock and R. Lee, pp. 37–59. Cambridge University Press.

Liljeblad, Sven
1986 Oral Tradition: Content and Style of Verbal Arts. In *Handbook of North American Indians*, Vol. 11: *Great Basin*, edited by W. L. d'Azevedo, pp. 641–659. Smithsonian Institution Press, Washington, D.C.

Madsen, David B.
1979 The Fremont and the Sevier: Defining Prehistoric Agriculturalists North of the Anasazi. *American Antiquity* 44:711–722.
1989 *Exploring the Fremont*. Utah Museum of Natural History. University of Utah Press, Salt Lake City.

Madsen, David B., and Steven R. Simms
1998 The Fremont Complex: A Behavioral Perspective. *Journal of World Prehistory* 12:255–336.

Manning, Steven J.
1990 Barrier Canyon Style Pictographs of the Colorado Plateau. Part One: Hypothesis and Evidence for the Existence of Post Circa A.D. 1300 Panels. *Utah Archaeology* 3:43–84.
1992a The Lobed-Circle Image in the Basketmaker Petroglyphs of Southeastern Utah. *Utah Archaeology* 5:1–38.
1992b Colorado-Green River: Prehistoric Pathway. *Canyon Legacy: A Journal of the Dan O'Laurie Museum* 16:12–19. Moab, Utah.

Marwitt, John P.
1970 *Median Village and Fremont Culture Regional Variation*. Anthropological Papers No. 95. University of Utah Press, Salt Lake City.

Matheny, Ray T., Deanne G. Matheny, Pamela W. Miller, Blaine Miller
2004 Hunting Strategies and Winter Economy of the Fremont as Revealed in the Rock Art of Nine Mile Canyon. In *New Dimensions in Rock Art Studies*, edited by R. T. Matheney, pp. 145–194. Brigham Young University Museum of Peoples and Cultures, Occasional Paper No. 9. University of Utah Press, Salt Lake City.

130

Matson, R. G.
1991 *The Origins of Southwest Agriculture.* University of Arizona Press, Tucson.
2002 The Spread of Maize Agriculture in the U.S. Southwest. In *Examining the Farming/Language Dispersal Hypothesis,* edited by P. Bellwood and C. Renfrew, pp. 341–356. McDonald Institute Monographs. Oxbow Books, Oxford.

Matson, R. G., and Brian Chisolm
1991 Basketmaker II Subsistence: Carbon Isotopes and Other Dietary Indicators from Cedar Mesa, Utah. *American Antiquity* 56:444–459.

McGuire, Kelly R., and William R. Hildebrandt
2005 Re-Thinking Great Basin Foragers: Prestige Hunting and Costly Signaling During the Middle Archaic Period. *American Antiquity* 70:695–712.

McGuire, Randall H., and Dean J. Saitta
1996 Although They Have Petty Captains, They Obey Them Badly: The Dialectics of Prehispanic Western Pueblo Social Organization. *American Antiquity* 61:197–216.
1998 Dialectics, Heterarchy, and Western Pueblo Social Organization. *American Antiquity* 63:334–336.

Mills, Barbara J. (editor)
2000 *Alternative Leadership Strategies in the Prehispanic Southwest.* University of Arizona Press, Tucson.

Morss, N.
[1931] *The Ancient Culture of the Fremont River in Utah.*
 2009 University of Utah Press, Salt Lake City.

Neal, Leticia A.
2009 Moving beyond Boundaries: Fremont and Anasazi Archaeology and Rock Art in Southeastern Utah. Master's thesis, University of Nevada, Reno.

Neal, Leticia A., and Steven R. Simms
2008 Cloudrock Project First Stage Mitigation, Grand County, Utah. Report to the Utah School and Institutional Trust Lands Administration (SITLA) and the Cloudrock Land Company LLC. On file at SITLA, Salt Lake City.

Novak, Shannon A., and Dana D. Kollmann
2000 Perimortem Processing of Human Remains Among the Great Basin Fremont. *International Journal of Osteoarchaeology* 10:65–75.

Noxon, John S., and Deborah A. Marcus
1985 Significant Rock Art Sites in the Needles District of Canyonlands National Park, Southeastern Utah. Native American Rock Art Research Associates, Monticello. On file at the Midwest Archaeological Center, Lincoln, Nebraska.

Ortiz, Alfonso
1969 *The Tewa World: Space, Time, Being, and Becoming in a Pueblo Society.* University of Chicago Press.

Parsons, Elsie Clews
[1939] *Pueblo Indian Religion.* 2 vols. Bison Books edition.
 1996 University of Nebraska Press, Lincoln.

Prentiss, William C., and Ian Kuijt
2004 *Complex Hunter-Gatherers: Evolution and Organization of Prehistoric Communities on the Plateau of Northwestern North America.* University of Utah Press, Salt Lake City.

Quinlan, Angus R.
2000 The Ventriloquist's Dummy: A Critical Review of Shamanism and Rock Art in Far Western North America. *Journal of California and Great Basin Anthropology* 22:92–108.
2001 Smoke and Mirrors: Rock Art and Shamanism in California and the Great Basin. In *Shamanism: Uses and Abuses of a Concept,* edited by H. Francfort and R. N. Hamayon, 10:189–205. Bibliotheca Shamanistica, Akademiai Kiado, Budapest.

Rautman, Allison
1998 Hierarchy and Heterarchy in the American Southwest: A Comment on McGuire and Saitta. *American Antiquity* 63:325–333.

Robins, Michael R.
2002 Status and Social Power: Rock Art as Prestige Technology Among the San Juan Basketmakers of Southeast Utah. In *Traditions, Transitions, and Technologies: Themes in Southwestern Archaeology*, edited by S. H. Schlanger, pp. 386–400. University Press of Colorado, Boulder.

Rushforth, Scott, and Steadman Upham
1992 *A Hopi Social History*. University of Texas Press, Austin.

Sammons-Lohse, Dorothy
1981 Households and Communities. In *Bull Creek*, by J. D. Jennings and D. Sammons-Lohse, pp. 111–136. Anthropological Papers No. 105. University of Utah Press, Salt Lake City.

Sassaman, Kenneth E.
2004 Complex Hunter–Gatherers in Evolution and History: A North American Perspective. *Journal of Archaeological Research* 12:227–280.

Schaafsma, Polly
1971 *The Rock Art of Utah*. University of Utah Press, Salt Lake City.
1980 *Indian Rock Art of the Southwest.* University of New Mexico Press, Albuquerque.
1994 Trance and Transformation in the Canyons: Shamanism and Early Rock Art on the Colorado Plateau. In *Shamanism and Rock Art in North America,* edited by S. Turpin, pp. 45–71. Special Publication 1. Rock Art Foundation, Inc., San Antonio, Texas.

Schaafsma, Polly, and M. Jane Young
1983 Early Masks and Faces in Southwest Rock Art. In *Collected Papers in Honor of Charlie Steen*, edited by N. Fox, pp. 11–34. Papers of the New Mexico Archaeological Society, Albuquerque.

Shapiro, Judith
1986 Kinship. In *Handbook of North American Indians*, Vol. 11: *Great Basin*, edited by W. L. d'Azevedo, pp. 620–629. Smithsonian Institution Press, Washington, D.C.

Simms, Steven R.
1990 Fremont Transitions. *Utah Archaeology* 3:1–18.
2008 *Ancient Peoples of the Great Basin and Colorado Plateau*. Left Coast Press, Walnut Creek, California.

Simms, Steven R., and Kenneth W. Russell
1996 *Ethnoarchaeology of the Bedul Bedouin of Petra, Jordan: Implications for the Food Producing Transition, Site Structure, and Pastoralist Archaeology*. Utah State University Contributions to Anthropology, Logan.

Steward, Julian H.
1937 Ecological Aspects of Southwestern Society. *Anthropos* 32:87–104.

Stuart, Mark
2006 A Shaman's Pipe/Sucking Tube from the Great Salt Lake Region. *Utah Archaeology* 19:37–40.

Talbot, Richard K.
2000a Fremont Architecture. In *Clear Creek Canyon Archaeological Project*, Vol. 5: *Results and Synthesis*. BYU Museum of Peoples and Cultures Occasional Papers, Vol. 7. University of Utah Press, Salt Lake City.
2000b Fremont Settlement Patterns and Demography. In *Clear Creek Canyon Archaeological Project,* Vol. 5*: Results and Synthesis*. BYU Museum of Peoples and Cultures Occasional Papers, Vol. 7. University of Utah Press, Salt Lake City.

Talbot, Richard K., and Lane D. Richens
1996 *Steinaker Gap: An Early Fremont Farmstead*. Museum of Peoples and Cultures Occasional Papers No. 2. Brigham Young University, Provo, Utah.
2004 *Fremont Farming and Mobility on the Far Northern Colorado Plateau.* Museum of Peoples and Cultures Occasional Papers No. 10. Brigham Young University, Provo, Utah.

Talbot, Richard K., James D. Wilde, Lane D. Richens, Deborah E. Newman, and Joel C. Janetski
2000 *Excavations at Five Finger Ridge, Clear Creek Canyon, Central Utah*. BYU Museum of Peoples and Cultures Occasional Papers, Vol. 5. University of Utah Press, Salt Lake City.

Thomas, David H.
1981 Complexity Among Great Basin Shoshoneans: The World's Least Affluent Hunter-Gatherers? In *Affluent Foragers: Pacific Coasts East and West*, edited by S. Koyama and D. H. Thomas, pp. 19–52. Senri Ethnological Studies No. 9. National Museum of Ethnology, Osaka.
1983 *The Archaeology of Monitor Valley,* Vol. 1: *Epistemology.* Anthropological Papers of the American Museum of Natural History, Vol. 58, Pt. 1. American Museum of Natural History, New York.

132

Turpin, Solveig
2001 Archaic North America. In *Handbook of Rock Art Research*, edited by D. S. Whitley, pp. 361–413. Altamira Press, Walnut Creek, California.

VanPool, Christine S., Todd L. VanPool, and David A. Phillips, Jr. (editors)
2006 *Religion in the Prehispanic Southwest*. Altamira Press, Walnut Creek, California.

Wallace, Anthony F. C.
1966 *Religion: An Anthropological View*. Random House, New York.

Ware, John A.
2002 Descent Group and Sodality: Alternative Pueblo Histories. In *Traditions, Transitions, and Technologies: Themes in Southwestern Archaeology*, edited by S. H. Schlanger, pp. 94–112. University Press of Colorado, Boulder.

Whitley, David R.
2000 Reply to Quinlan. *Journal of California and Great Basin Anthropology* 22:108–129.
2001 Science and the Sacred: Interpretive Theory in U.S. Rock Art Research. In *Theoretical Perspectives in Rock Art Research*, edited by K. Helsko, pp. 124–151. Instituttet for Sammenlignende Kulturforskning, Oslo, Norway.

2003 What is Hedges Arguing About? In *American Indian Rock Art*, edited by A. Woody, J. T. O'Connor, and A. McConnell, 29:83–104. American Rock Art Research Association, Tucson, Arizona.

Wilde, James D., and Deborah E. Newman
1989 Late Archaic Corn in the Eastern Great Basin. *American Anthropologist* 91:712–720.

Wilde, James D., and Reed A. Soper
1999 *Baker Village: Report of Excavations, 1990–1994*. Museum of Peoples and Cultures Technical Series No. 99-12. Brigham Young University, Provo, Utah.

Wormington, H. Marie
1955 *A Reappraisal of the Fremont Culture*. Proceedings No. 1. Denver Museum of Natural History.

Young, M. Jane
1988 *Signs from the Ancestors: Zuni Cultural Symbolism and Perceptions of Rock Art*. University of New Mexico Press, Albuquerque.

ABOUT THE AUTHORS

Steven R. Simms is a professor of anthropology at
Utah State University, Logan, where he has taught since
1988. He has been doing archaeological fieldwork across
the United States and in the Middle East for nearly forty
years. Many of his earliest archaeological experiences
were at Anasazi and Fremont sites, and he attended the
University of Utah's archaeology field school in 1973 at
the large Fremont site the Evans Mound, under the di-
rection of Jesse D. Jennings. Simms has authored more
than a hundred scientific publications, technical reports,
and monographs, and was president of the Great Basin
Anthropological Association from 2004 to 2008. His book
Ancient Peoples of the Great Basin and Colorado Plateau
was published in 2008.

Photograph by Lynett Gillette

François Gohier grew up in the Basque Country in
southwest France. After studying mathematics and phys-
ics at the university at Bordeaux, he worked for a few
years as a land surveyor. A class of natural history pho-
tography at the National Museum in Paris brought a
change in direction, and traveling and documenting the
natural world became François's passion. Beginning in
South America, he photographed landscapes and wild-
life from the high Andes of Chile and Peru to the rain
forest of Bolivia, the plains of Brazil and Venezuela, and
the steppes and shores of Patagonia in Argentina. Later
the magic of close encounters with gray whales in the
lagoons of Baja California, Mexico, led to years of work
with other species of whales and dolphins from Alaska
to the South Pacific. François's early interest in European
prehistory led him to search for traces of prehistoric
Native Americans. This has resulted in his rich collection
of images of rock art of the U.S. Southwest, with an em-
phasis on the Fremont culture of Utah. Since 1988 his
home has been in San Diego, California.